Japanese Ch...

Fabrics

1950s-1970s

Anita Yasuda

Schiffer Publishing Ltd

4880 Lower Valley Road, Atglen, PA 19310 USA

Dedication

Dedicated to the memory of my father-in-law, Masahiro Yasuda, who encouraged me in my interest of Japanese culture. He is deeply missed by all those who knew and loved him.

Copyright © 2004 by Anita Yasuda
Library of Congress Control Number: 2003112960

Designed by Bonnie M. Hensley
Cover design by Bruce Waters
Type set in Ren & Stimpy/Lydian BT

ISBN: 0-7643-1967-1
Printed in China
1 2 3 4

Published by Schiffer Publishing Ltd.
4880 Lower Valley Road
Atglen, PA 19310
Phone: (610) 593-1777; Fax: (610) 593-2002
E-mail: Info@schifferbooks.com
Please visit our web site catalog at **www.schifferbooks.com**
We are always looking for people to write books on new and related subjects. If you have an idea for a book, please contact us at the above address.

This book may be purchased from the publisher.
Include $3.95 for shipping. Please try your bookstore first.
You may write for a free catalog.

In Europe, Schiffer books are distributed by
Bushwood Books
6 Marksbury Avenue
Kew Gardens
Surrey TW9 4JF England
Phone: 44 (0) 20 8392 8585; Fax: 44 (0) 20 8392 9876
E-mail: Bushwd@aol.com
Free postage in the UK. Europe: air mail at cost.

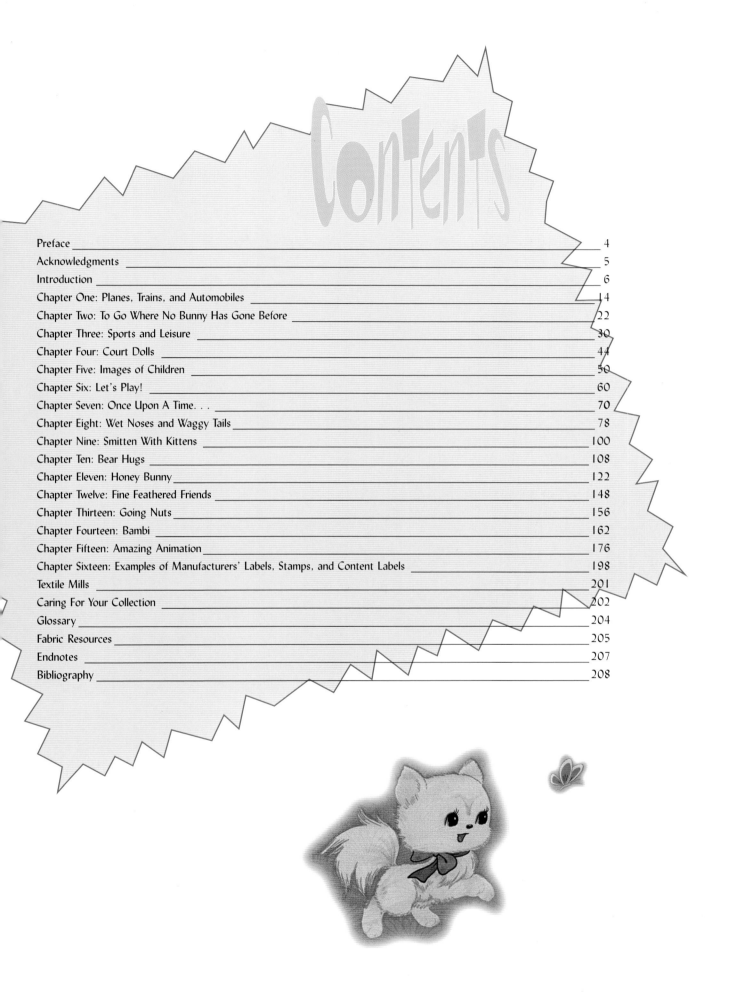

Contents

PREFACE

Vintage Japanese children's fabric is creative, vibrant, and optimistic. In this book, I have tried to show a variety of designs which best represent the period from the 1950s through the 1970s. The information contained in this book is based upon observation, collection, research, and discussions with dealers and museum professionals. I hope that my observations will act as a general guideline to help you organize your own collection. Although not all fabrics can be precisely dated, I have drawn on several years of research to present them.

The book is organized according to the most popular thematic trends over the thirty-year span, with each fabric section arranged chronologically to show the progression in design. The beginning chapters explore transportation, space, sports, children, and children's toys. The next section features fabrics decorated with anthropomorphic animals. These animals with humanized qualities dominated fabric design from the mid-1960s through the 1970s. I end with animation, which inspired fabric designers for the next two decades. It is no exaggeration to say that animation subsequently became the chief focus of Japanese designers and customers in the 1970s.

I also draw attention to broadly categorized trends in design. In all areas of design, there is some overlap in style and color from one year to the next. The progression in design from the controlled patterns of the 1950s to the elaborate 1960s through to the minimal layouts of the 1970s is traced.

Your collection simply must include intact garments or futon covers. Covers in mint condition are difficult to find as they were used by children, which does suggest wear. Occasionally, a remnant will turn up in mint condition, but a complete article is unlikely.

My most treasured pieces have original labels, manufacturing stamps, and are in mint condition. The personal connection to each piece is important in any collection and I do not buy anything that I would not want in my home.

Complete garments from the 1950s or earlier seldom come on the market, especially prints with a war theme or aircraft, which are very popular. However, there are dealers at large antique fairs in Japan who specialize in this period, and also dealers in North America with lovely examples.

Locating prints from the 1960s and 1970s is comparatively easy. The wild colors, cute designs, and animated figures that characterize fabric of this period have captured the imagination of young and old alike. The demand for prints featuring easily-recognizable characters, especially for Disney's *Bambi* or Osamu Tezuka's *Kimba The White Lion*, has grown at a staggering rate.

Whether you have access to virtual auctions or antique markets, be ready to hunt and bid! Many people are snapping up precious fabrics as the renewed interest in this time period builds. Currently, semi-autobiographical books reminiscing about the 1960s and 1970s are very popular in Japan. These books contain passages about everything from memories of school lunches to a particular stuffed animal. Further indications of this trend are the appearance of retro-themed stores, cafés, and even mini malls popping up all over Tokyo and smaller Japanese cities.

Collecting textiles is my passion. I am intrigued by the story behind the fabrics – the previous owners, the designer's thoughts, and what occasion a particular garment was made for. Fabric surrounds, clothes, and covers us. The fabrics we choose reflect who we are. These vintage treasures have added so much depth, color and warmth to my own life. I hope you enjoy discovering this wonderful period of Japanese fabric design. Above all, have fun in your quest.

—Anita Yasuda

Acknowledgments

Many facts about the history of these wonderful textiles have been lost over time. Thank you to all those companies and antique dealers who provided information to me. I have enjoyed corresponding with many collectors; please keep writing. A thank you to Janice, Libby, and Fatima for their valuable input. To Sumiko, my mother-in-law, for sourcing and sending fabrics. To my husband Koji and daughter Kaylee Emi for their patience. Without the help and support of my family and friends this book would not have been possible.

Introduction

Vintage Japanese children's textiles offer a unique glimpse into the imagination of fabric designers and consumers during the 1950s, 1960s, and 1970s. Most of all, they are a key to childhood. Each piece holds clues to the dreams, wishes, and thoughts of a small child.

Lighthearted images abound with anthropomorphic animals that decorate the majority of the bolts. From high-flying bunnies to skateboarding dogs and from parachuting squirrels to giraffes piloting helicopters, adventures were always to be had on these playful fabrics. Fantastical worlds were created by skilled design houses just for children. Now more then ever they are enjoyed by adults from collectors to designers and home seamstresses to fabric artists alike.

The subdued patterns of the post-war years, the elaborate designs of the 1960s, and the vibrant and animated prints of the 1970s are guaranteed to brighten up every corner of your life. The extraordinary range of color and imagery reflects the Japanese skill in fabric design.

Currently, these fabrics are enjoying a period of renewed interest, with collectors paying special attention to the mid-1960s. I believe they conjure up a perceived time of relative innocence and simplicity, in contrast to our rapid, changing pace of life. This wave of nostalgia has drawn people back to the fabrics of the 1950s, 1960s and 1970s. With their playful motifs and fanciful designs, these prints are capturing the imagination of a new generation.

These whimsical patterns, with their humble beginnings as mass-produced goods and treasured articles, are now highly coveted by collectors. Influenced by television, cinema, and magazines, these fabrics cannot help but engage the imagination. They continue to excite me with their exuberant designs and pulsating colors. I hope you find them as inspiring as I do.

Image & Theme

Throughout the 1950s, 1960s, and 1970s, fabric designers took inspiration from traditional motifs and patterns, as well as from popular figures and icons of innovation. Many prints featured images combined to form a general theme of childhood. Prints commemorating a special historic event, such as Apollo 12, or prints representing folktales were rarer.

The fabrics of the 1950s are decorated by a mixture of traditional images, such as pine trees, cherry blossoms, geometric shapes, and newer elements, such as toys and automobiles. The fabric is gender-specific with popular images for boys including automobiles, lighthouses, sailing ships, horses, and toy train sets. For fabrics aimed at girls, kokeshi dolls, cute animals and toys such as spinning tops, balls, and xylophones are used.

In the fabrics of the 1950s, animals looked like toy creatures, generally in side profile with stubby legs, arched bodies, and little facial detail. By the late 1950s and into the early 1960s, they developed many human characteristics. There were three distinct developments: human-like poses, the portrayal of children's daily life, and thematic representations of children's wishes and dreams. Anthropomorphic animals dominated the landscape of children's fabrics throughout the 1960s and 1970s. Whether ringing up a friend on a rotary phone, driving the family sedan, or piloting a rocket, these anthropomorphic friends were always on the cutting edge. What child would not have wanted to sleep beneath these fantastical scenes?

Young girls' fabrics from the 1960s and 1970s were filled with animals watching the action from a safe distance. They did not man spaceships or zoom off in cars. The fabrics featured a variety of domestic scenes, like serving tea or pushing a pram. With downward gazes, flushed cheeks, and other bashful poses, they communicated traditional characteristics for young girls to emulate. Other prints fell into a "cute" category with frolicking kittens or sweetly posed pets.

In contrast, prints for young boys were filled with adventure and sports. Space scenes and rockets were favorite images in the late 1960s. One sport which spans the 1950s, 1960s, and 1970s is baseball. The prints transformed from static images of baseballs and bats in the 1950s, to players hitting and fielding balls by the 1960s. With the push towards healthier living in 1970s Japan, roller-skating, skateboarding, and rugby themes emerged. The incorporation of animated television characters in sports theme fabric became a trend in fabric design.

The first animation fad was based on Disney's *Bambi*. Beginning in 1955 with the release of *Bambi* in Japan, a huge boom in Bambi-inspired prints emerged, lasting through the 1970s with each subsequent re-release. Images of Bambi were not exactly like the Disney original, though. In terms of color and treatment, they were influenced by kimono patterns and sensibility.[1]

Designs were also based on many Japanese masterpieces, such as *Astro Boy*. The large volume of anime- and manga-inspired prints makes it impossible to list them all here. Many of the prints I have come across are not licensed images, but take their inspiration from a particular animation or manga. Sometimes characters are dressed in recognizable costumes, with their faces left blank so as not to infringe upon copyright.

In general, animation influenced the look of the prints, with simpler formats, streamlined images with thick, black outlines, and even designs blocked into frames to resemble a comic book. In this new landscape, recognizable characters took center stage. Dictating the choice of color and layout, the character's image became all-important to the finished piece.

Design Layout

The most striking difference between fabric from the 1950s and that which followed was that the figures were not central to the design. Instead, during the '50s, animal motifs were but a component of the entire layout.

Mainly, motifs featured animals, toys, or automobiles placed within a circle. The images resembled stuffed animals and were rather static. Their "character" status was still years away.

Solid background colors with the picture isolated in this manner was the most common placement. Other arrangements included alternating diamonds or bands in a single color. Large color blocks were also utilized when the designer wished to split the fabric into different vignettes.

Occasionally, 1950s muslin prints featured scattered images less than one inch in height. One image, such as a rabbit or a *kokeshi*, would have been used repeatedly in a "tossed," or scattered layout, with only slight changes in color combinations.

Designs of the 1960s were most elaborate with bright colors and fantastical images. These charming designs involved multiple anthropomorphic animals, intertwining foliage, curving roads, and plenty of movement. The playful images reflect the fun designers had in creating dream-like worlds full of charming characters.

By the mid-1960s, fabric designers reached their peak in terms of experimentation with color, texture, and image. Later prints were more refined, with simpler images and an emphasis on thematic prints.

During the late 1960s right up into the early 1970s, event prints came into vogue. Animals frolicked at picnics, picked apples, gathered flowers, and played in amusement parks (the last is a much sought-after example). The sequence of events from top to bottom or left to right was easy to follow, as designers engaged the eye, moving a viewer smoothly through the piece.

Towards the mid-1970s, the riotous rococo trend in Japanese fabrics came to an end. Overlapping images were eliminated and, as a cost-saving measure, repeated images were often used instead for visual effect. These were laid out in a columnar style for use as futon covers and other household articles. The repeat was spread out every four to six inches. In addition, solid ground colors replaced patterned backgrounds. To take the place of the intertwining vines so favored in the 1960s, designers used stylized silhouettes of flowers, fruit, or hearts to highlight the image.

Complete figurative scenes disappeared by the mid-1970s, replaced instead by characters in pair groupings. The female was distinguished from her male counterpart by bows, caps, head scarves, or ribbons.

Manufacturers split into two camps, those who concentrated on the cute genre of prints, and those who produced character fabrics. These character fabrics resemble stills from animation, defying the trend towards simple patterns.

By the end of the 1970s, popular culture began to dictate what juvenile fabric was produced.

Color trends of the 1950s, 1960s, and 1970s are well documented from a fashion point of view. Fashion was a popular influence upon the textile design houses, though it did not always mirror what happened in the household textile sector. You will be impressed by how fabrics kept pace with prevailing cultural trends.

A subdued palette of colors in the 1950s reflected an occupied Japan on the cusp of the post-war recovery. Popular shades included moss green, brown, taupe, gray, and navy blue — predominantly a sober palette, with bright reds reserved for celebratory kimonos.

Note the distinct softness of the fabrics from this period, reflecting the printing process and color dyes. Primarily all hand-screened prints, the fabrics from the 1950s in this collection consist of silk, synthetic silk, and muslin.

In the 1960s, the Japanese department stores launched into vibrant color campaigns. Fashion and household goods on the shelves intentionally reflected the distinct style of a particular store and, in turn, its consumer. Textile manufacturers followed suit, so the stylish consumer could incorporate these looks into her own home. Consumers weary of comfort colors eagerly greeted these new textiles. The '60s wife and mother enlivened her child's room by choosing light-hearted and colorful fabrics.

One of the first color trends in the early 1960s was nicknamed "Vitamin C"[2]. All shades of lime green reflected the mood of optimism and newfound prosperity in Japan. Although lime green was not popular as a ground color on fabric, it was an important secondary color used for details such as ribbons, flowers, hats, clothing, or even books.

Sherbert tones appeared in 1962, signaling the beginning of a long trend.[3] Predominately used on juvenile fabrics throughout the 1960s, this palette of colors was associated with sweet and gentle characteristics. Soft pastel colors such as pale yellow, aqua blue, peach, and pink were the design houses' choices. They were reserved for gentle themes such as delivering mail, collecting flowers, or caring for a baby. No color better epitomizes the world of children's fabric design than pink. It is the most widely-used color on textiles of the 1960s. All shades of pink are found, ranging from a pale shell pink to a bubble gum pink.

A most interesting development was the use of fluorescent colors. From 1965 until the early 1970s, fluorescent pink, orange, and yellow became quite popular. They were used as accent colors to add a little punch to otherwise dreamy prints.

You can date the entry of strong colors onto the design stage to the late 1960s. Turquoise blue made a big impression on fabric destined for futon covers, sometimes as a ground color, but also as a favorite choice for characters. The landscape was dotted with blue bunnies and chicks. Blue was often used in combination with a rust red, which also started appearing in the late 1960s.

Rust soon gave way to a true red. The 1968 Mexican Olympics inspired true reds, oranges, and blues (the colors of the Mexican flag).[4] Red and orange appeared on fabrics aimed at older juvenile boys, or even adolescents.

Animation prints and sports themes utilized red and orange. These were used as background colors on several football theme fabrics shown in this book. Strong colors such as red and orange effectively conveyed the aggressiveness on the field.

On futon fabrics destined for young girls in the 1960s, red and orange were primarily used as accent colors. Red continued to be reserved for ceremonial kimonos. Instead of the strong orange which we see on boys' prints, a softer, almost tangerine color was favored beginning around the mid-1960s. It was not until the end of the 1970s when red was used as a background color on futon fabrics for girls. Once again, red was on prints inspired by animated characters.

Primary yellow is another favorite from the mid-1970s. It was the perfect color for creating dynamic textiles with images from animation or adorable animals. As images were simplified and decorative details practically dropped, mere color filled in the gaps. Red and yellow were effective in communicating a new modern mood.

Whether creating tone or setting for the anthropomorphic animals of Japanese textile design, the importance of color cannot be underestimated. Not simply a backdrop for the images, color enabled the designer to imbue his designs with innocence, strength, or gentle qualities. To see the powerful effect color has on a design, look through the examples contained in this book of the same pattern in different color treatments.

With unprecedented strides made in the printing process, designers were able to realize their vision — fabrics with layers and layers of textures. To set the mood and fuse together all the design elements into a harmonious whole on the prints of the 1950s, 1960s, and 1970s, nothing does it quite like color.

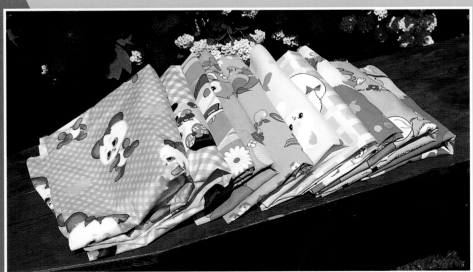

Design Influences

Sadly, it is not known who exactly designed the fabric in this book. It is likely that teams of designers were responsible for particular lines, with one head designer who oversaw the operation. There are no records detailing this process. However, it is possible to see the influence of popular illustrators whose bold designs were extremely suitable for futon covers.

Below I discuss two of the outstanding illustrators of this time whose influence extended to the fabric produced for children. There are many others, but it was not possible to include them in this format. Individual animators are credited in the animation section.

Rune Naito

Rune Naito was an influential illustrator, graphic artist, and doll designer whose creations were used on everything from stationery and dishes to textiles. His work coincided with the new growing post-war economy. During the 1960s, he worked as a designer for Ohtake Toki, Nakajima, Hiroshi Sangyo, Nemoto, and Shinbido – all fabric manufacturers. He also worked as a textiles designer for Roman Yoshitada and Hamadashoten. His designs appeared on scarves and other textiles including yukatas.[5]

The use of the thick outlines, vivid colors, and simplified faces were all attributes of his design that set Rune Naito apart from his contemporary illustrators.[6] In 1952, he began working at Himawari (Sunflower) girls' magazine, which later became Junior Soreiyu, where many of his designs appeared from 1954 until 1960. With this platform reaching such a large audience, he is credited with starting fashion trends. Perhaps inspired by Rune Naito's vision of the stylish girl, many animals are dressed and coiffed as meticulously and colorfully as females.

Rune Naito's work has also been credited with changing the female ideal from shy to cute.[7] On children's fabric, boy figures are stereotypically bold or adventurous, the girl figures are bashful and, above all, cute.

Osamu Tezuka

Osamu Tezuka was a prolific writer and illustrator after World War II. His style of animation influenced the marketing and selling of characters or manga.[8] Characteristics of Osamu Tezuka's style include a round body type with curves, smooth actions, and three dimensional designs.[9] One of the most dramatic changes he inspired in children's fabric images was the transformation of very stiff images with little or no movement, to creatures that literally bounded off the cloth.

Tezuka's drawing style really captured the imagination of all people, especially children. By stretching the boundaries of what was considered the "norm," he challenged other designers to come up with comparably exciting images.

One of Tezuka's goals was to create characters capable of being as popular as figures in entertainment. Indeed, his characters' appearance in the fabrics of the late 1960s is indicative of their popularity, which only gathered strength in the 1970s. Walt Disney inspired Tezuka in his search to create cute and adorable small animals.

We can see Tezuka's influence in fabric design with the transformation from the stiff, one-dimensional figures of the 1950s to the rounded, moving, charismatic creations of the 1960s and 1970s. This character fabric style that spawned countless imitations remains immensely popular right up to the present day. New characters crop up with each new season. Their appeal seems timeless and only limited by the imagination of the designer.

The Design Houses

Since most fabrics are not marked, it is not possible to trace all of the prints in this collection. I was lucky to acquire a number from the 1960s and 1970s which still had original labels and manufacturing stamps on them. By studying these prints, I began to see distinct patterns and styles emerge.

Some of the large design houses are still producing fabric today. Unfortunately, some of the smaller, more obscure manufacturers were untraceable. I hope this information has not been lost; perhaps it is just waiting to be discovered in an archive somewhere.

At the back of this book, I list design houses and their marks, if known. You should be able to identify pieces in your collection through these marks and the design characteristics given below. Fabrics before 1960 lacked any identifiable marks.

With so many manufacturers eager to compete in the post-construction consumer spending boom, there must have been a lot of pressure to come up with distinctive patterns. Design houses used quality, execution of design, and color to compete. Below, I have highlighted a few design houses which stood out during the 1960s and 1970s.

Kurokawa Ltd.

Kurokawa Ltd. is an extremely important printer and dyer. The history of Kurokawa Ltd., part of the Shikibo Ltd. Group, stretches back to 1920.[10] Fabrics with its stamp are recognizable by their amazing color combinations and engaging animals. More important are the high-quality screened prints from Kurokawa Ltd., which set the company apart from its contemporaries. It produced many children's prints on cottons with a polished finish. The company's fabrics were sturdy enough to withstand the wear of a small child's energetic romps.

It is easy to spot Kurokawa Ltd. prints. They are characterized by embossed backgrounds with polka dots or flowers. Other decorative images included happy chicks, flower pots, and cherries. Figures were often in groupings of two, with large silhouettes of hearts or blossoms behind them.

In the mid-1960s, Kurokawa Ltd. prints created depth and shadows on the principal images using three colors: white, gray, and brown. With this technique, softer and even gentler-looking animals were created. They were embellished with wonderful flourishes such as mounds of flowers for hats, or elaborate ribbons with garlands of flowers for collars.

Instead of the popular method of outlining the entire image in black, only the tips of certain features were highlighted; for example, a dog's ear or paw would be accentuated with a pencil-thin black line. The outline became a thick, black line by the 1970s, following the trend towards images which more closely resembled comic characters.

Kasugano Honzome Ltd.

In complete contrast to Kurokawa Ltd. was Kasugano Honzome Ltd., whose prints favored intricate designs with small, delicate images and multi-directional layouts. Unfortunately, this company does not exist now. It might have been bought out by a larger manufacturer and changed its name.

All of the examples in this book from Kasagano Honzome Ltd. are on muslin. There are a few sateen prints with very similar-looking images and layout; unfortunately, there are no marks on the fabric to confirm conclusively that they were indeed produced by the same manufacturer. Primarily using muslin, this design house's style of prints also lent itself to garments.

Kasagano Honzome Ltd. did not follow the trend towards larger-sized characters. Animals usually measured between one and two inches in height. Although images were seldom unframed, those that were framed used circles and alternated with geometric bands like those seen in the fabrics of the 1950s.

Animals with open mouths, as if permanently surprised, are a defining feature of all Kasagano Honzome Ltd. prints. The images have exaggerated, balloon-like curved limbs. Never looking directly at the viewer, their heads are either in profile or looking down. Unlike other houses, which used large puppy dog eyes, Kasagano Honzome Ltd. featured animals with longer eyes – made of a black crescent with a small dot for the iris, and two exaggerated lashes. All images were completely outlined in black.

The animals, such as squirrels, are always featured in motion, scurrying about the fabric or carrying an object. Even seated images seem to have just bounded into a circle frame, with paws extended in front or behind. These prints are never short of energy or movement.

Layers of patterns add a rich, detailed substance to the prints from Kasagano Honzome Ltd. White lattices, scattered flowers, circles, diamonds, small polka dots, and glittering silver threads are used together to create wonderfully intricate designs.

Toyobo Ltd.

Large images measuring six inches in height, rich textured backgrounds, and historical motifs are characteristics of the design house Toyobo Ltd. This company began as a spinning mill in 1832 and is still manufacturing fabric today.[11] Though the company did venture into synthetic fibers in the 1960s, the examples in this book are 100% cotton prints, some with a polished finish.

The designers at Toyobo Ltd. favored a rich mix of historical images, such as court dolls (Gosho Ningyo), but with a twist – they appeared on modern fabric. They made ample use of delightful colors, such as turquoise, apple greens, and sunny yellows. Look at how they achieved depth, with pine trees, fans, and cherry blossoms framing the image in the extreme foreground.

Kanebo Ltd.

Unlike Toyobo Ltd., Kanebo Ltd. created simple prints heavily influenced by popular Western trends. Prints labeled Kanebo Ltd. are relatively easy to date, as the company adopted this name in 1971. Established in 1887 as a cotton trading company, Kanebo Ltd. has expanded into a conglomerate producing cosmetics, pharmaceuticals, and chemical products.[12]

The prints in this collection from Kanebo Ltd. are from the mid- to late 1970s. You can expect to see many sweet images of the "Holly Hobby" or "Sun Bonnet Sue" characters. These fabrics, designed primarily for use on futons, contained large-scale images measuring six or more inches in height.

Kanebo Ltd. designs favored simple layouts with much negative space. People wanted these popular prints with calico-looking backgrounds, quilt-inspired layouts, and solid colors. The company's niche was in recognizing current trends going on in Japan and abroad, and producing fashionable prints. They deliberately dressed their images in mod clothes like bell bottoms and angel-sleeved blouses.

By combining traditional motifs with modern techniques, images, and color, a wide range of playful fabric emerged on the fabric scene in the 1960s and 1970s. The sheer variety is sure to delight collectors and designers alike.

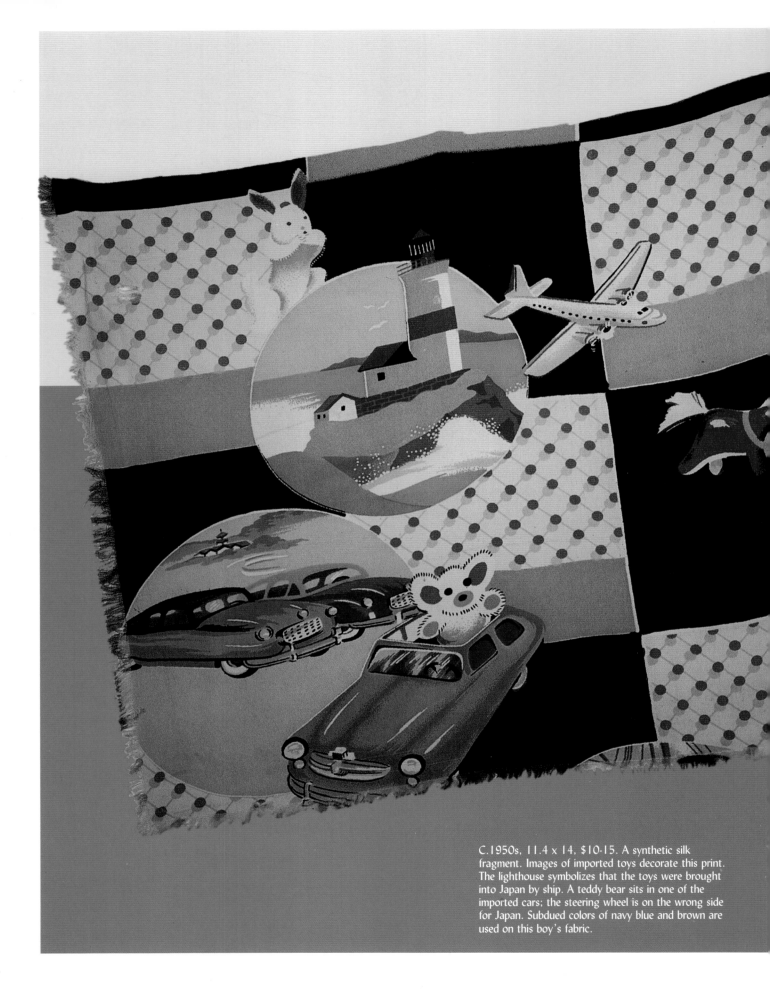

C.1950s, 11.4 x 14, $10-15. A synthetic silk
fragment. Images of imported toys decorate this print.
The lighthouse symbolizes that the toys were brought
into Japan by ship. A teddy bear sits in one of the
imported cars; the steering wheel is on the wrong side
for Japan. Subdued colors of navy blue and brown are
used on this boy's fabric.

PLANES, TRAINS, AND AUTOMOBILES

A detail of the previous print.
Showing the airplane.

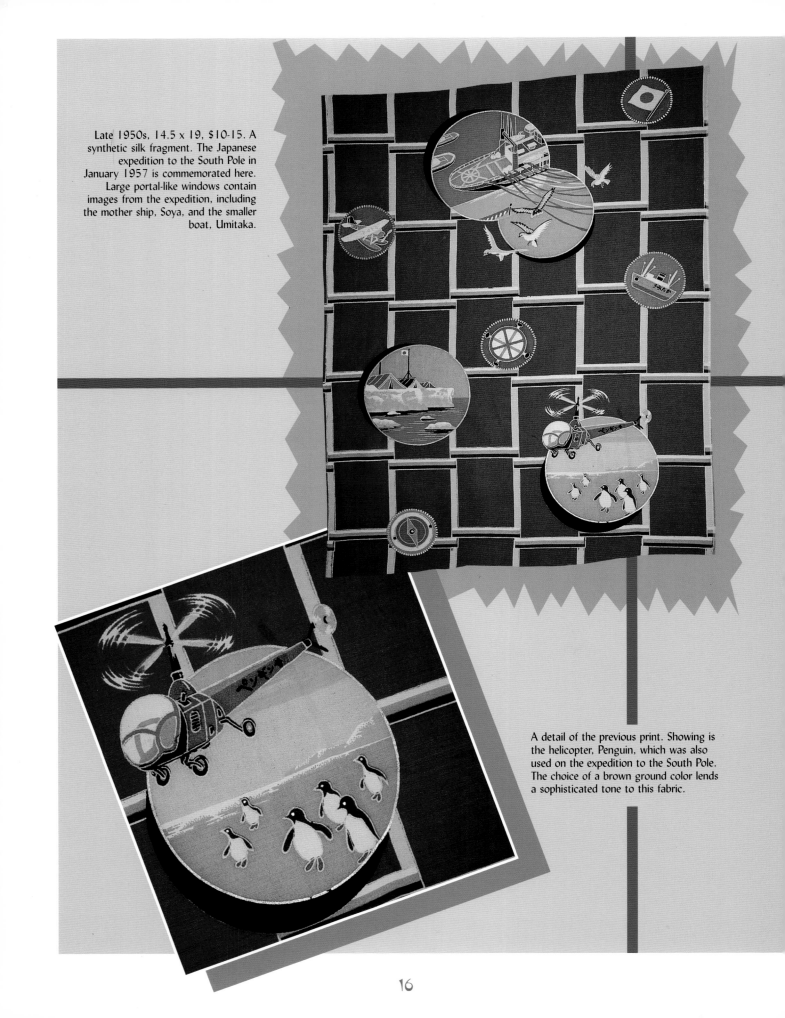

Late 1950s, 14.5 x 19, $10-15. A synthetic silk fragment. The Japanese expedition to the South Pole in January 1957 is commemorated here. Large portal-like windows contain images from the expedition, including the mother ship, Soya, and the smaller boat, Umitaka.

A detail of the previous print. Showing is the helicopter, Penguin, which was also used on the expedition to the South Pole. The choice of a brown ground color lends a sophisticated tone to this fabric.

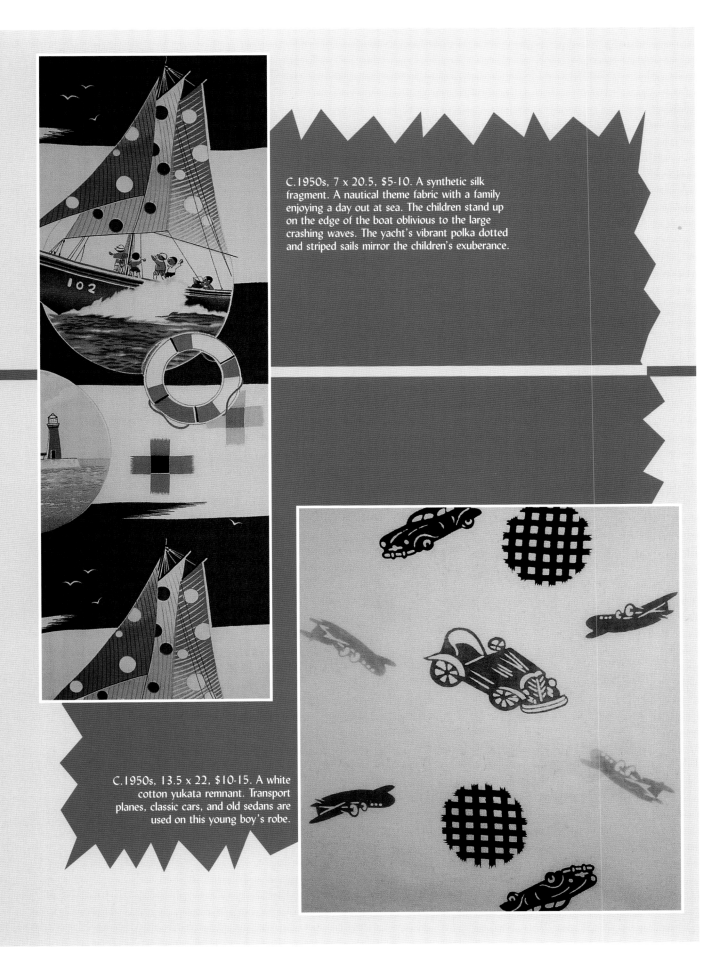

C.1950s, 7 x 20.5, $5-10. A synthetic silk fragment. A nautical theme fabric with a family enjoying a day out at sea. The children stand up on the edge of the boat oblivious to the large crashing waves. The yacht's vibrant polka dotted and striped sails mirror the children's exuberance.

C.1950s, 13.5 x 22, $10-15. A white cotton yukata remnant. Transport planes, classic cars, and old sedans are used on this young boy's robe.

C.1950s, 13 x 9, $2-5. A white cotton yukata remnant. A simple design with a caboose, tram, and dog in muddied gray and green colors. The images are angled to create the illusion of a moving pattern.

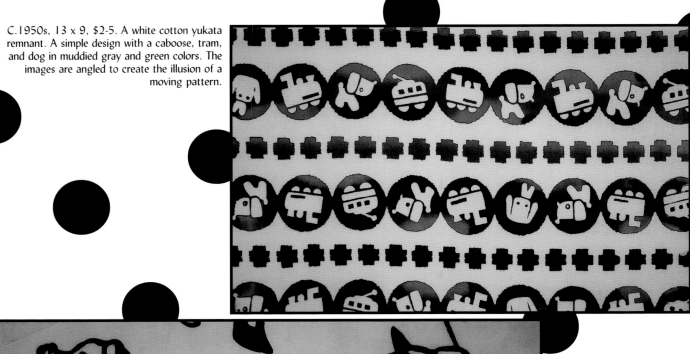

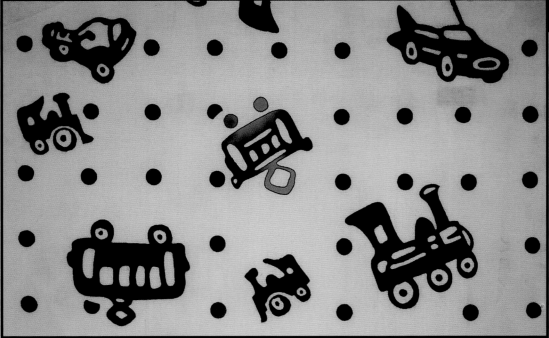

Mid-1960s, 13 x 9, $2-5. A white cotton yukata remnant. An active print with toy cars, cabooses, and trams intermingled with polka dots.

C.1970s, 8.5 x 16, $5-10. A white seersucker yukata remnant. This fabric was designed for a juvenile boy. Soft grays, greens, and blues are used for the various images including no parking and no entry signs. The automobiles have been rendered with considerable detail.

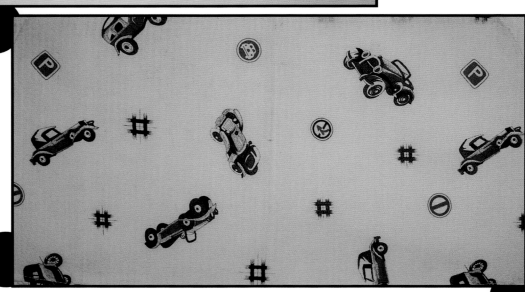

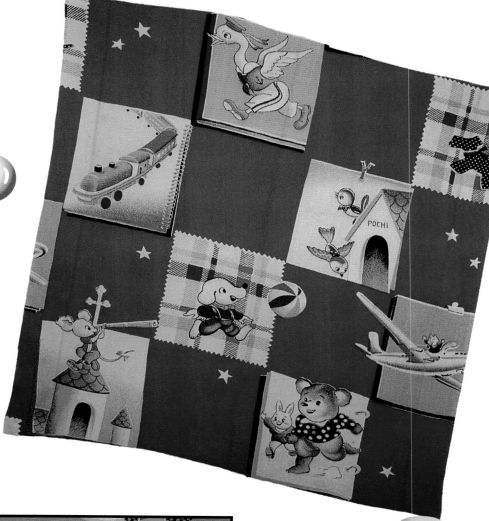

Early 1960s, 14 x 14, $20-25. A red muslin kimono fragment. Pages from a story book come to life. Pink, blue, and tartan squares represent pages from the spiral notebook on the far left. Images include: a mouse high atop a turret roof with a telescope, a squirrel waving from a plane to his friends below, and a cheerful bear and bunny running to greet their friends.

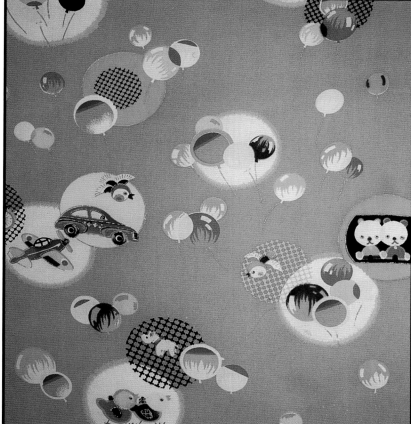

C.1960s, 14 x 14, $10-15. A pink muslin futon remnant. With no apparent theme, this fabric is embellished with colorful balloons, a propeller plane, a "love bug" like car, chickens, and teddies. Balloons were popular decorative images due to their obvious association with birthdays and other celebrations.

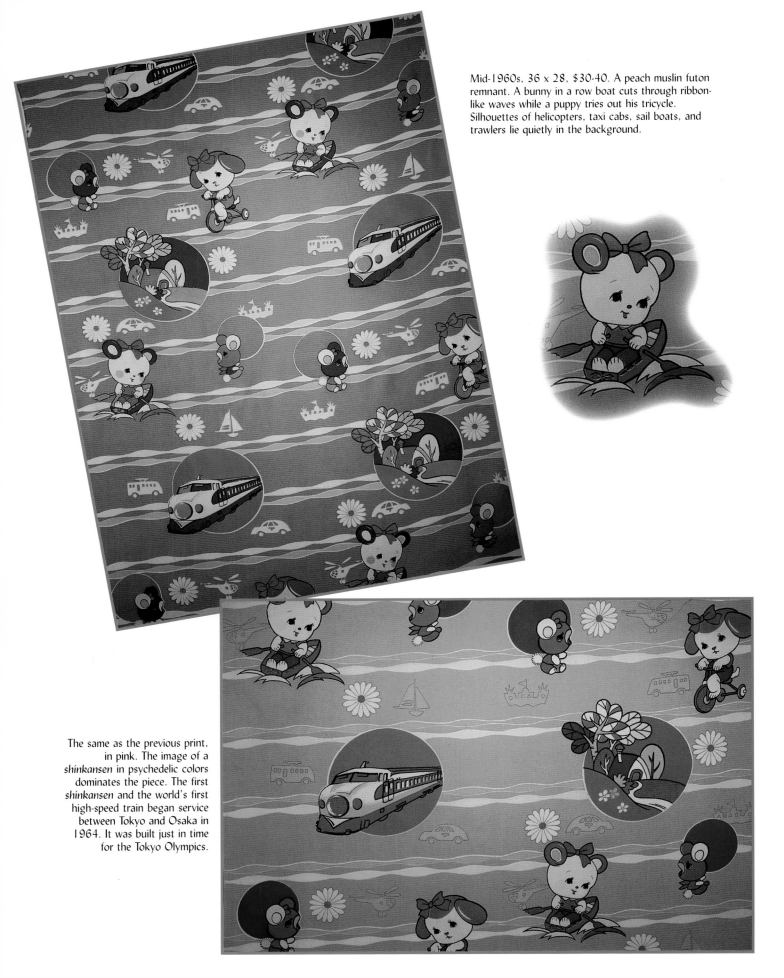

Mid-1960s, 36 x 28, $30-40. A peach muslin futon remnant. A bunny in a row boat cuts through ribbon-like waves while a puppy tries out his tricycle. Silhouettes of helicopters, taxi cabs, sail boats, and trawlers lie quietly in the background.

The same as the previous print, in pink. The image of a *shinkansen* in psychedelic colors dominates the piece. The first *shinkansen* and the world's first high-speed train began service between Tokyo and Osaka in 1964. It was built just in time for the Tokyo Olympics.

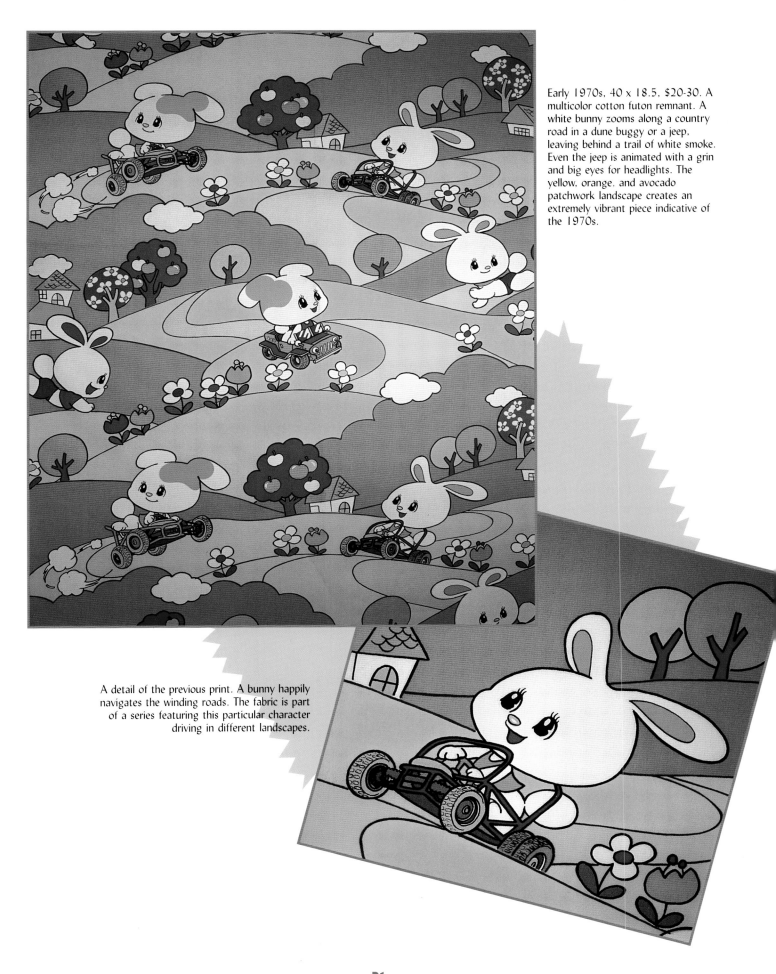

Early 1970s, 40 x 18.5, $20-30. A multicolor cotton futon remnant. A white bunny zooms along a country road in a dune buggy or a jeep, leaving behind a trail of white smoke. Even the jeep is animated with a grin and big eyes for headlights. The yellow, orange, and avocado patchwork landscape creates an extremely vibrant piece indicative of the 1970s.

A detail of the previous print. A bunny happily navigates the winding roads. The fabric is part of a series featuring this particular character driving in different landscapes.

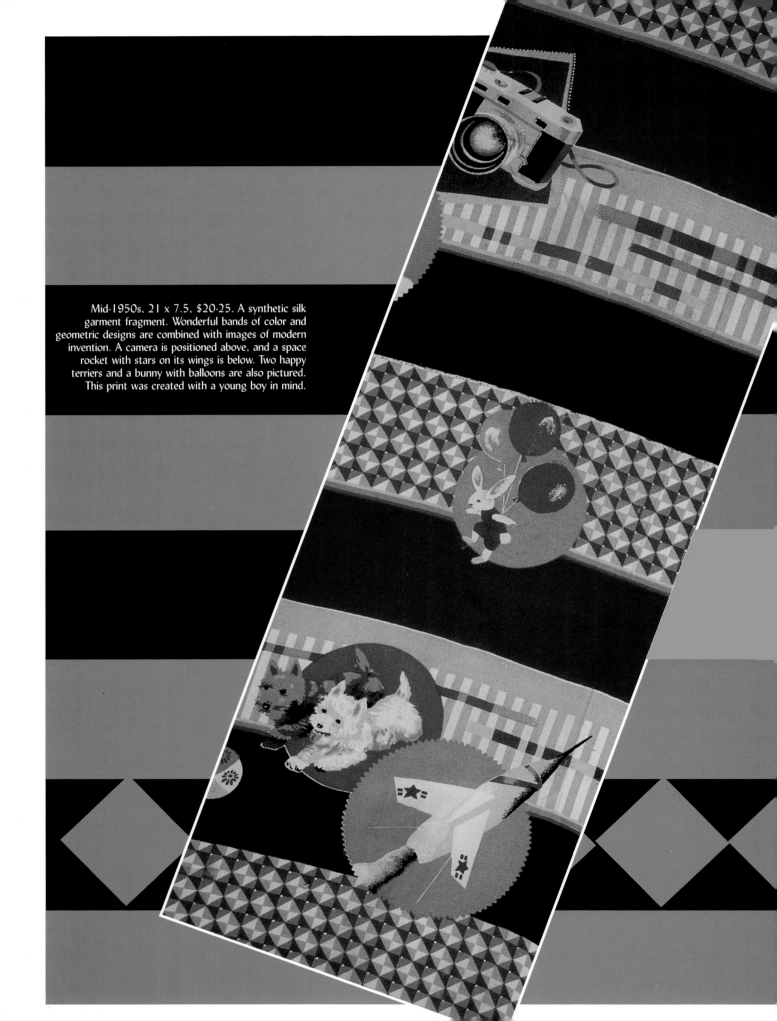

Mid-1950s, 21 x 7.5, $20-25. A synthetic silk
garment fragment. Wonderful bands of color and
geometric designs are combined with images of modern
invention. A camera is positioned above, and a space
rocket with stars on its wings is below. Two happy
terriers and a bunny with balloons are also pictured.
This print was created with a young boy in mind.

To Go
Where No Bunny Has Gone Before

Early 1960s, 17.5 x 10, $10-15. A brown flannel remnant from the sleeve of a boy's pajamas. The brave puppy and elephant astronauts fly off into the stars. The most commonly used color combination on sleepwear for boys during the 1960s was brown and cream.

Opposite page: Mid-1960s, 14 x 18.5, $20-25. A green muslin futon remnant. Wondrous vehicles soar across the fabric. A giraffe, chick, and teddy bravely poke their heads out of various flying machines. During the 1960s, space was considered to be the new frontier. The limitless possibilities space travel presented is reflected in innovative designs such as these.

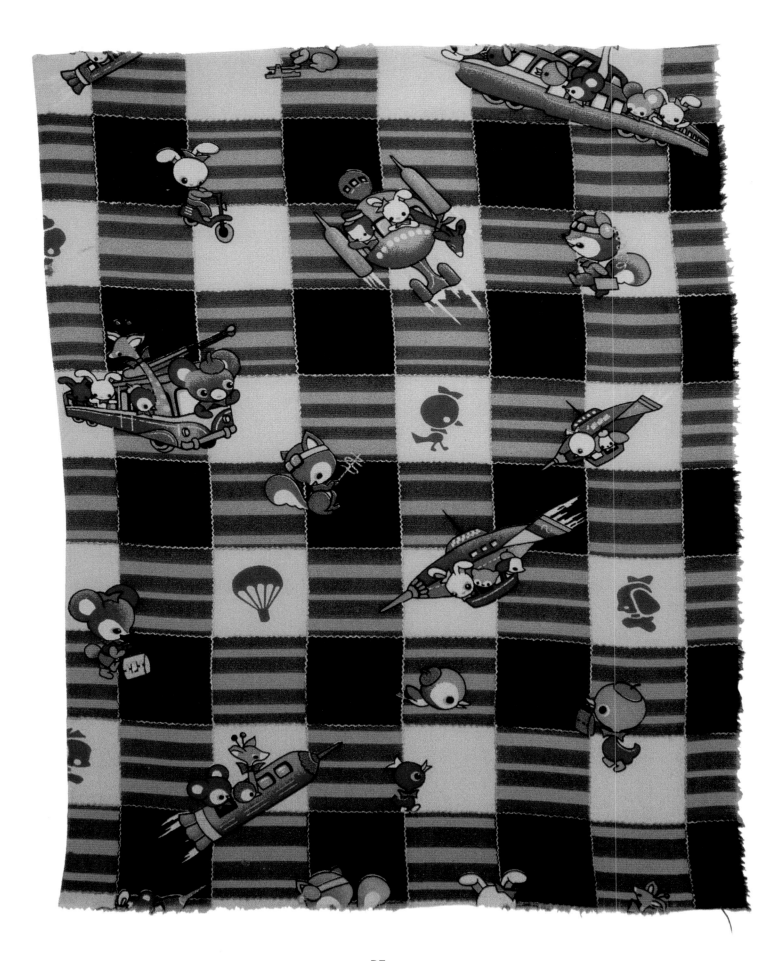

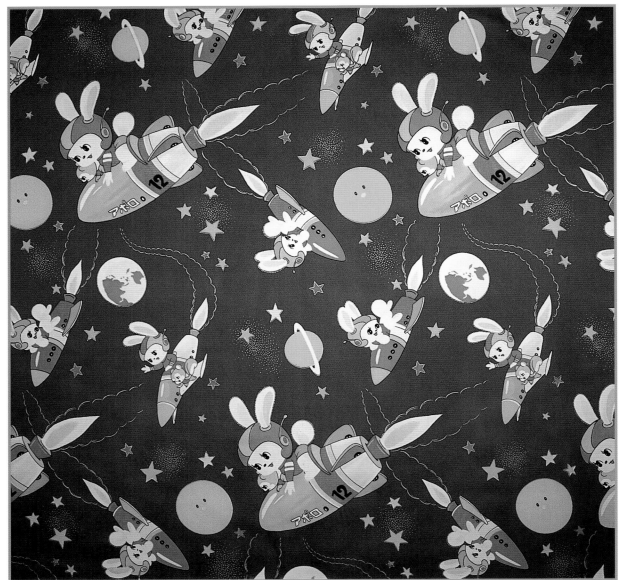

Late 1960s, 36 x 36, $80-100. A green poly cotton futon remnant. A rare print commemorating the voyage of the Apollo 12. Apollo 12 is written on the side of the rocket in Japanese *Katakana* lettering. The brave bunny and squirrel astronauts chart a course to go where no bunny has gone before. Below the astronauts, the continents of Asia and Australia are visible. The smiling sun, planet Saturn, and countless stars also embellish this fabric.

A detail of the previous print. The bunny and squirrel ride off into space on the Apollo 12. The Apollo missions spawned many space theme prints. Dreams of becoming an astronaut, even if just for bedtime, were made possible through these beautiful fabrics.

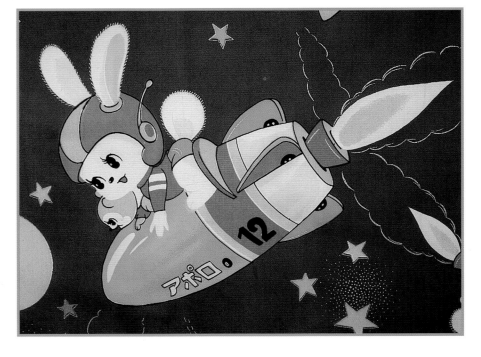

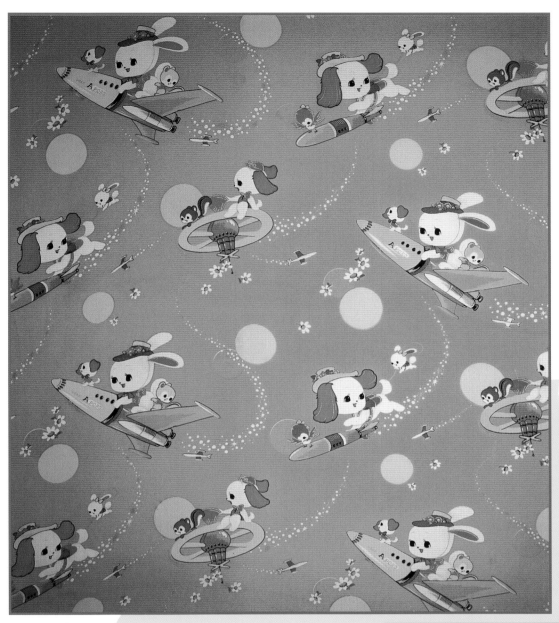

Late 1960s, 36 x 36, $80-100. An orange muslin futon remnant. A super print commemorating the Apollo 12 space mission. Humorously, the word Apollo 12 is misspelled "Aporo 12." The bunny pilot, his fearless dog, and an intrepid squirrel are ready to investigate space.

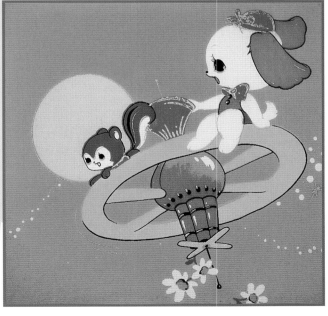

A detail of the previous print showing an orbiting space station. How imaginative to use one on this print, as the first space station, Salyut 1, was not launched until 1971 by the former Soviet Union.

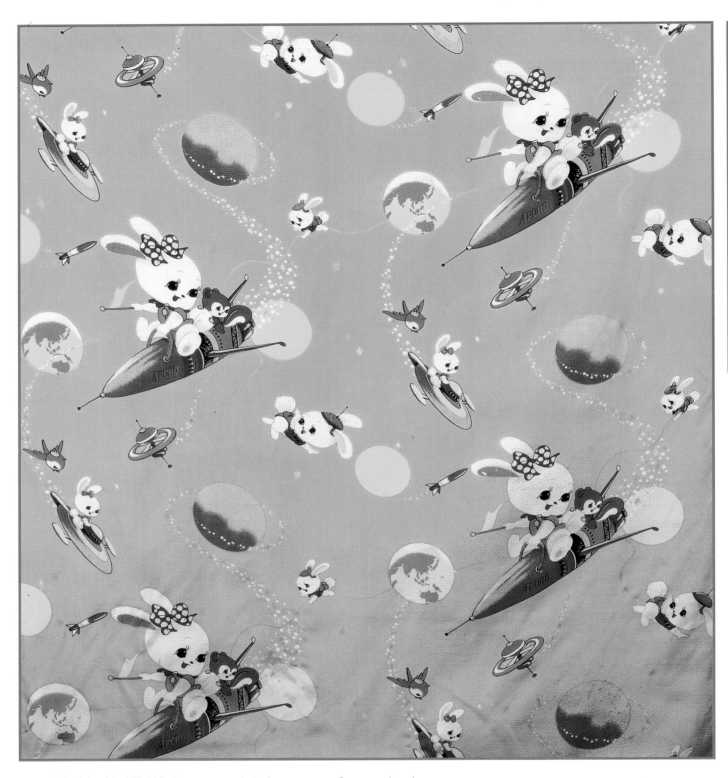

Late 1960s, 36 x 36, $80-100. An orange synthetic futon remnant. Orange, red, and gold colors combine to make a stunning print. Once again, the word Apollo is misspelled on the side of the rocket ship. Unlike the previous print, the red planet Mars and the continents on Earth are visible. The rocket engines leave behind sparkling gold stars.

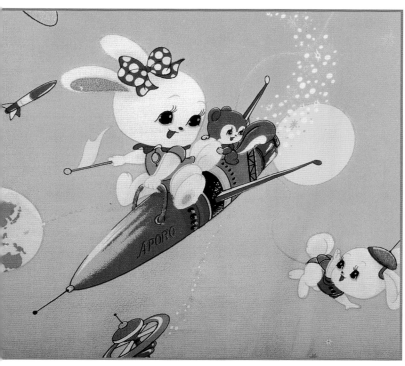

A detail of the previous print. *Girls In Space!* The rocket is equipped with red reins, which the bunny holds tightly. She waves a small yellow flag as the rocket ship soars above the sun. How wonderful to see a female character in outer space, generally considered a male domain.

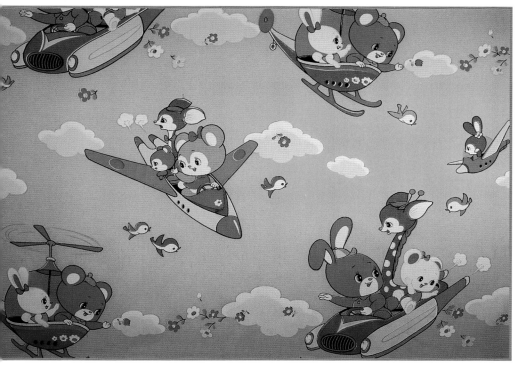

Mid-1960s, 19 x 15, $25-30. An orange muslin futon remnant. A teddy and bunny in an open-air helicopter wave to friends below. Pink fluffy clouds and floating flowers add to the dream-like quality of the design. This fabric was also produced in pink and green.

C.1970s, 29 x 5, $5-10. A white seersucker yukata fragment. A rocket ship piloted by a young boy soars off into the clouds. He waves happily to passing birds. Behind the rocket are lines of blue to indicate speed, but amazingly, the boy's baseball cap stays on. It is interesting to see how commonplace space had become by the 1970s.

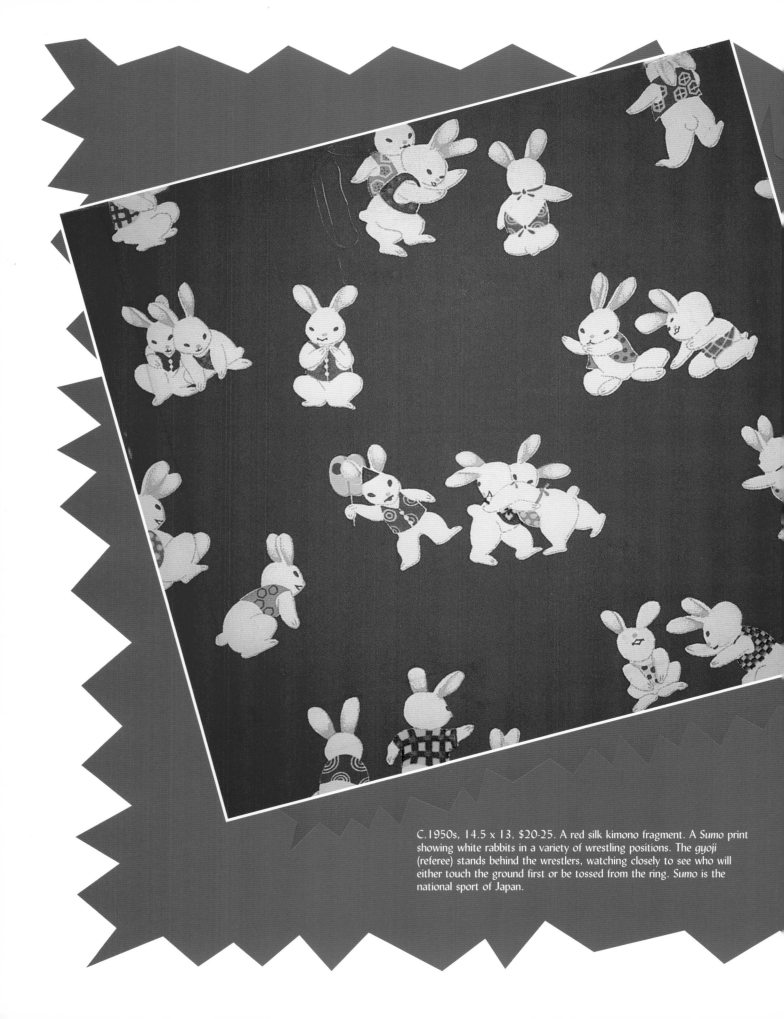

C.1950s, 14.5 x 13, $20-25. A red silk kimono fragment. A *Sumo* print showing white rabbits in a variety of wrestling positions. The *gyoji* (referee) stands behind the wrestlers, watching closely to see who will either touch the ground first or be tossed from the ring. *Sumo* is the national sport of Japan.

Chapter Three

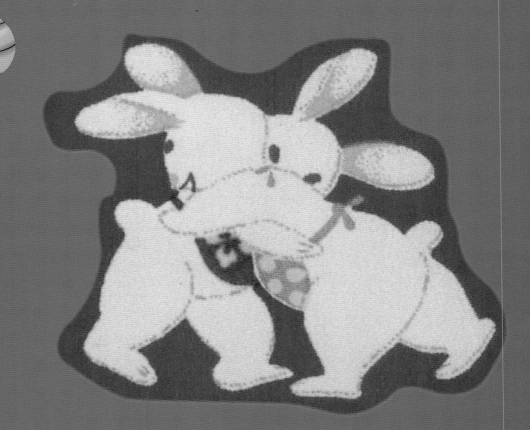

Sports and Leisure

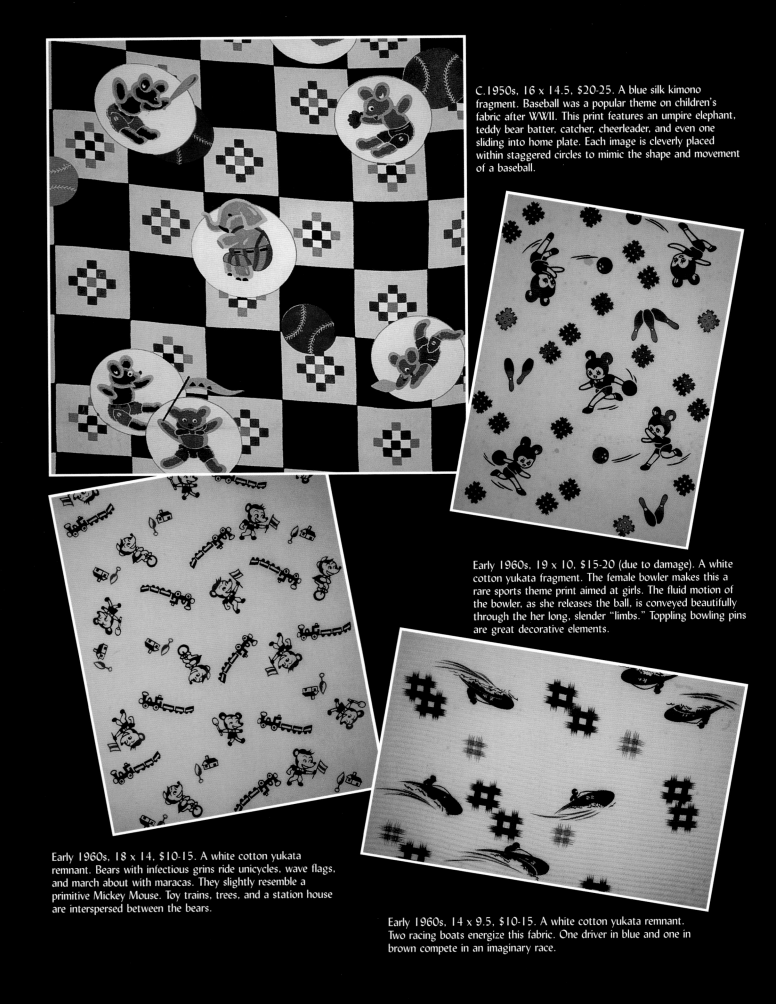

C.1950s, 16 x 14.5, $20-25. A blue silk kimono fragment. Baseball was a popular theme on children's fabric after WWII. This print features an umpire elephant, teddy bear batter, catcher, cheerleader, and even one sliding into home plate. Each image is cleverly placed within staggered circles to mimic the shape and movement of a baseball.

Early 1960s, 19 x 10, $15-20 (due to damage). A white cotton yukata fragment. The female bowler makes this a rare sports theme print aimed at girls. The fluid motion of the bowler, as she releases the ball, is conveyed beautifully through the her long, slender "limbs." Toppling bowling pins are great decorative elements.

Early 1960s, 18 x 14, $10-15. A white cotton yukata remnant. Bears with infectious grins ride unicycles, wave flags, and march about with maracas. They slightly resemble a primitive Mickey Mouse. Toy trains, trees, and a station house are interspersed between the bears.

Early 1960s, 14 x 9.5, $10-15. A white cotton yukata remnant. Two racing boats energize this fabric. One driver in blue and one in brown compete in an imaginary race.

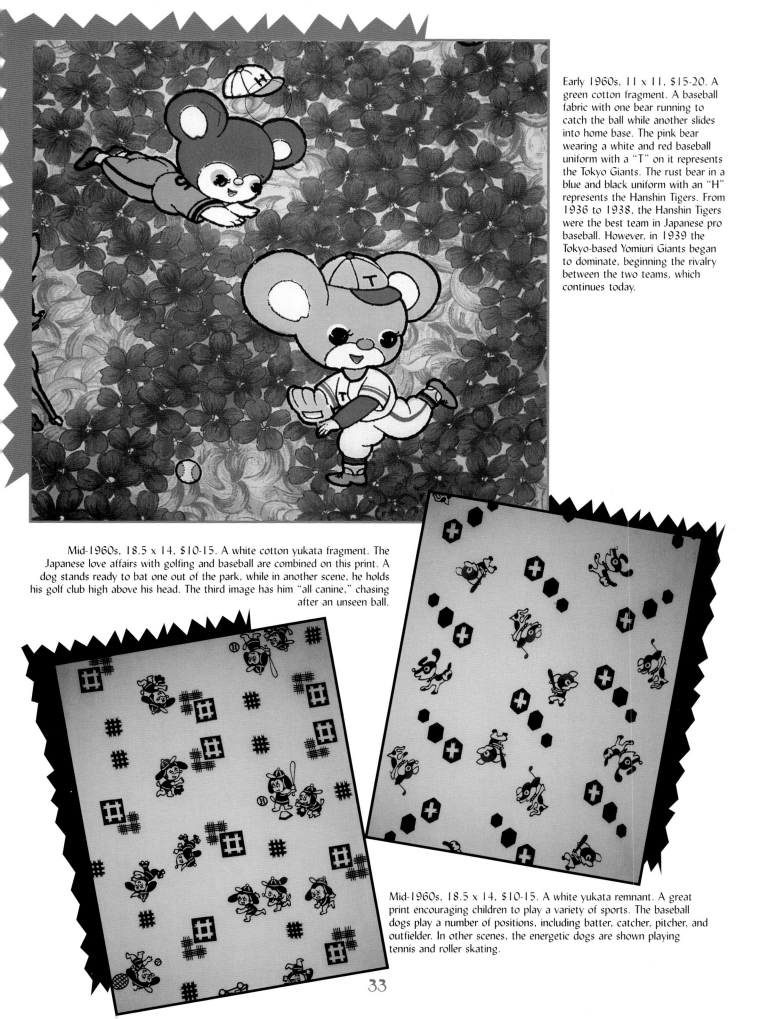

Early 1960s, 11 x 11, $15-20. A green cotton fragment. A baseball fabric with one bear running to catch the ball while another slides into home base. The pink bear wearing a white and red baseball uniform with a "T" on it represents the Tokyo Giants. The rust bear in a blue and black uniform with an "H" represents the Hanshin Tigers. From 1936 to 1938, the Hanshin Tigers were the best team in Japanese pro baseball. However, in 1939 the Tokyo-based Yomiuri Giants began to dominate, beginning the rivalry between the two teams, which continues today.

Mid-1960s, 18.5 x 14, $10-15. A white cotton yukata fragment. The Japanese love affairs with golfing and baseball are combined on this print. A dog stands ready to bat one out of the park, while in another scene, he holds his golf club high above his head. The third image has him "all canine," chasing after an unseen ball.

Mid-1960s, 18.5 x 14, $10-15. A white yukata remnant. A great print encouraging children to play a variety of sports. The baseball dogs play a number of positions, including batter, catcher, pitcher, and outfielder. In other scenes, the energetic dogs are shown playing tennis and roller skating.

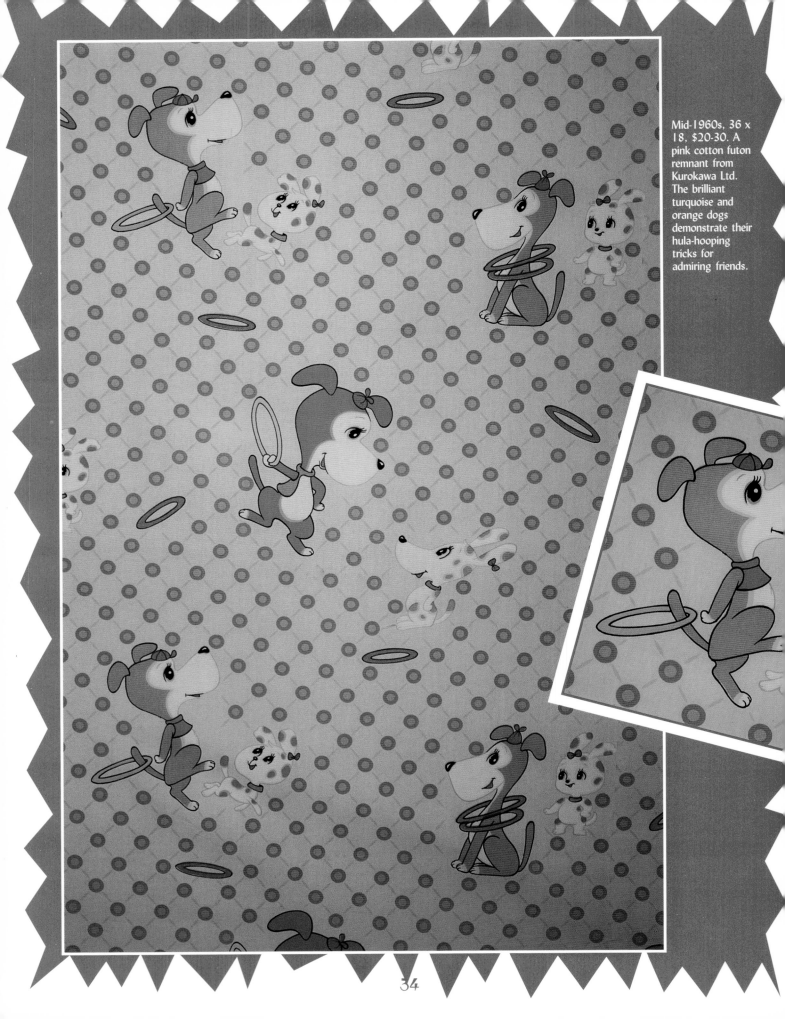

Mid-1960s, 36 x 18, $20-30. A pink cotton futon remnant from Kurokawa Ltd. The brilliant turquoise and orange dogs demonstrate their hula-hooping tricks for admiring friends.

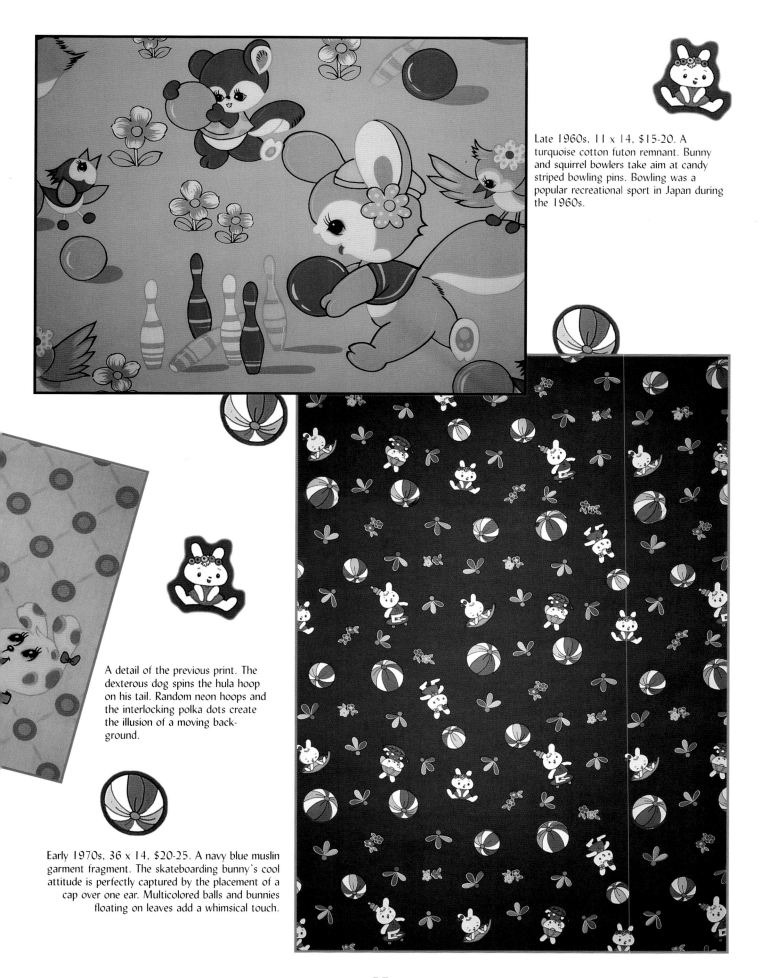

Late 1960s, 11 x 14, $15-20. A turquoise cotton futon remnant. Bunny and squirrel bowlers take aim at candy striped bowling pins. Bowling was a popular recreational sport in Japan during the 1960s.

A detail of the previous print. The dexterous dog spins the hula hoop on his tail. Random neon hoops and the interlocking polka dots create the illusion of a moving background.

Early 1970s, 36 x 14, $20-25. A navy blue muslin garment fragment. The skateboarding bunny's cool attitude is perfectly captured by the placement of a cap over one ear. Multicolored balls and bunnies floating on leaves add a whimsical touch.

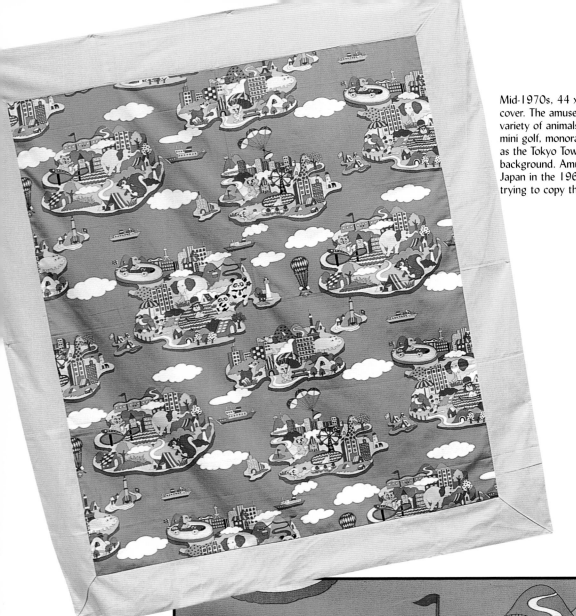

Mid-1970s, 44 x 52, $40-50. A pink cotton futon cover. The amusement park setting is filled with a variety of animals enjoying the go karts, roller coaster, mini golf, monorail, and Ferris wheel. Landmarks, such as the Tokyo Tower (built in 1958), are visible in the background. Amusement parks enjoyed a boom in Japan in the 1960s, with many private companies trying to copy the success of Disneyland.

A detail of the previous print, with a daring cat riding the roller coaster alone. Prints with amusement parks, especially from the 1960s, are highly prized by collectors in Japan.

36

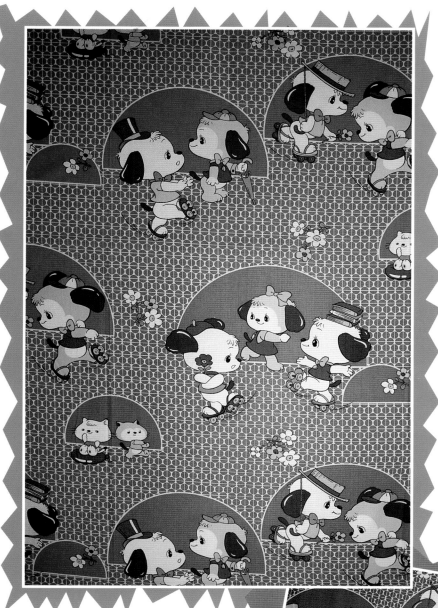

Mid-1970s, 36 x 36, $30-40. A red poly cotton futon remnant. Two dogs are learning how to roller skate. A humorous fabric with one dog trying to balance books on his head and skate while his friend wobbles, managing to keep his top hat on. A wonderful geometric backdrop behind the principle images is created through interlocking half-moon shapes.

The same print as the previous, in blue.

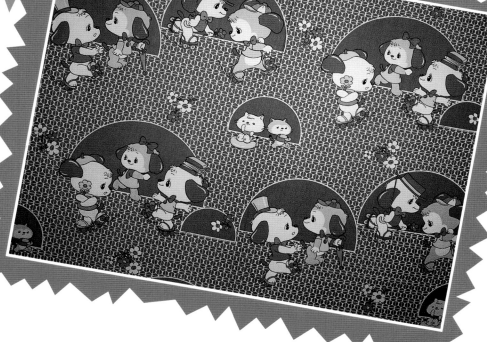

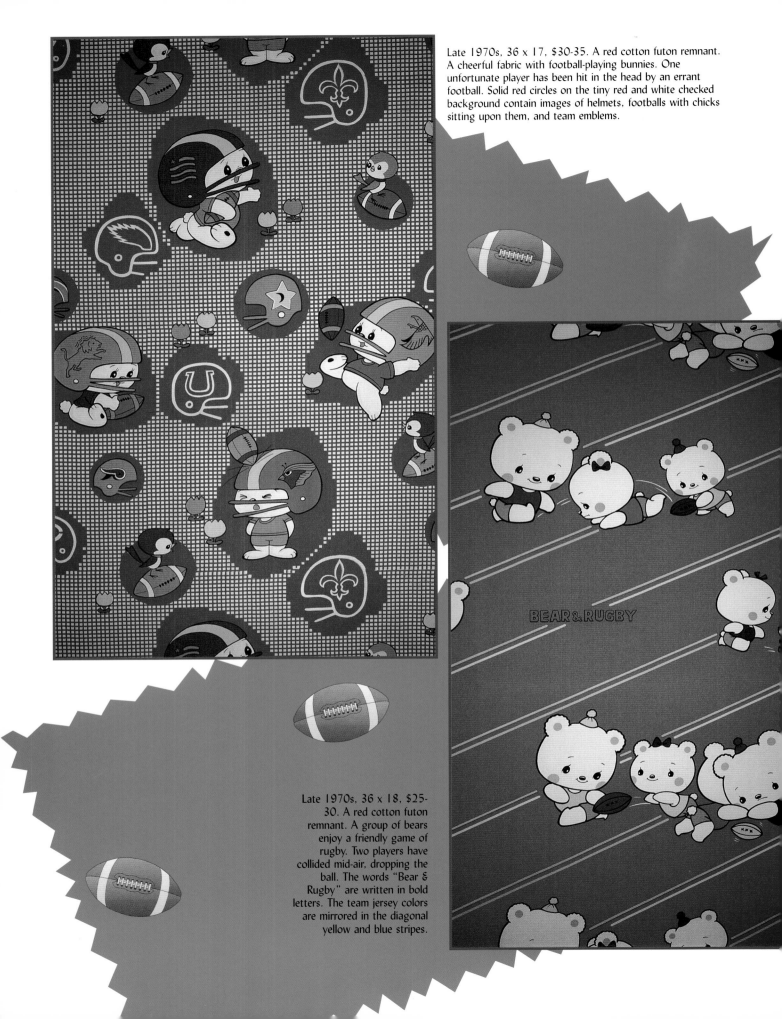

Late 1970s, 36 x 17, $30-35. A red cotton futon remnant. A cheerful fabric with football-playing bunnies. One unfortunate player has been hit in the head by an errant football. Solid red circles on the tiny red and white checked background contain images of helmets, footballs with chicks sitting upon them, and team emblems.

Late 1970s, 36 x 18, $25-30. A red cotton futon remnant. A group of bears enjoy a friendly game of rugby. Two players have collided mid-air, dropping the ball. The words "Bear & Rugby" are written in bold letters. The team jersey colors are mirrored in the diagonal yellow and blue stripes.

BEAR & RUGBY

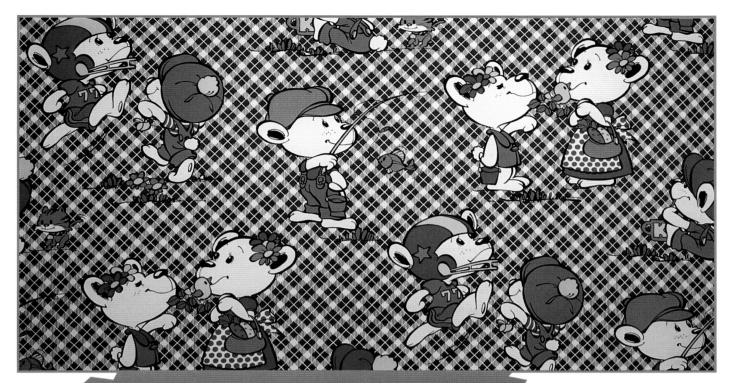

Late 1970s, 36 x 36, $25-30. A navy blue cotton futon remnant. A leisure theme fabric with four repeating scenes: a bear with a fishing rod, a football player, two girl bears back from shopping, and one bear having a snack in the grass. The fresh background is comprised of navy blue and white diagonal checks.

A detail of the previous print. Dressed in green dungarees and that essential 1970s fashion accessory, the cap, a white bear returns from fishing. Both the bear and the fish exchange smiles.

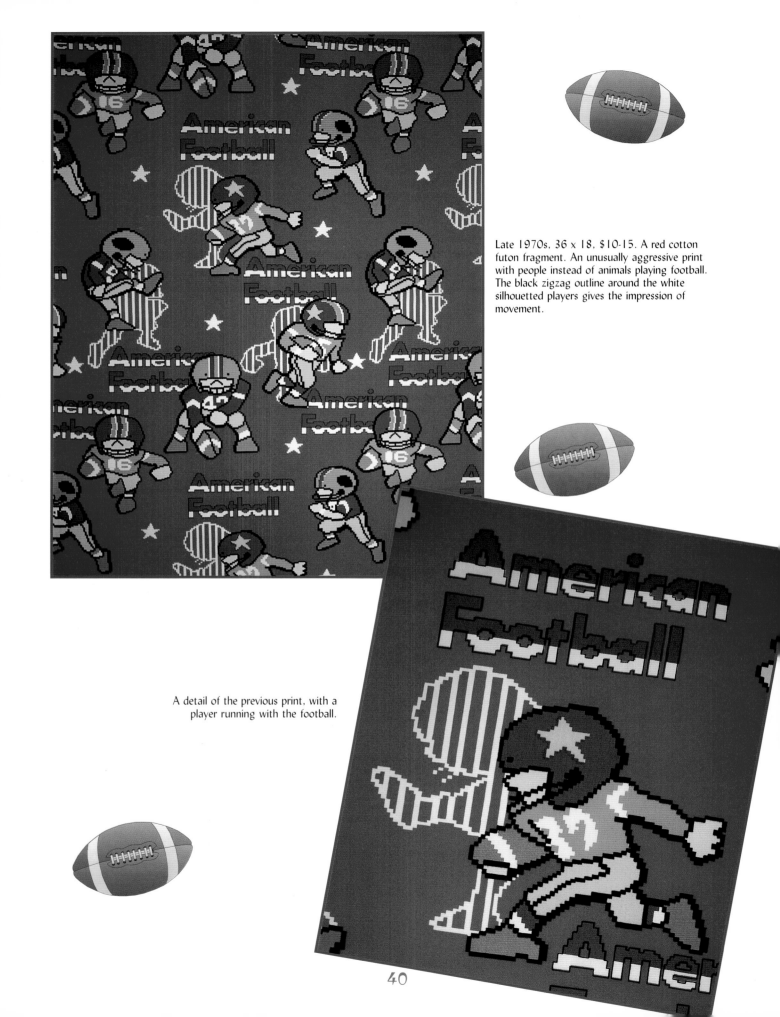

Late 1970s, 36 x 18, $10-15. A red cotton futon fragment. An unusually aggressive print with people instead of animals playing football. The black zigzag outline around the white silhouetted players gives the impression of movement.

A detail of the previous print, with a player running with the football.

Late 1970s, 36 x 14, $10-15. A white cotton yukata fragment. Two odd-looking rabbits with exaggerated mouths hunt for butterflies. One carries a long pole with a net and the smaller one carries a cage. Blue, red, and green butterflies flutter about.

Late 1970s, 18 x 18, $5-10. A cotton canvas cushion cover. A young boy kicks his soccer ball up into the air while his female counterpart mistakenly kicks a poor dog. The border design is composed of a green and white trellis pattern.

41

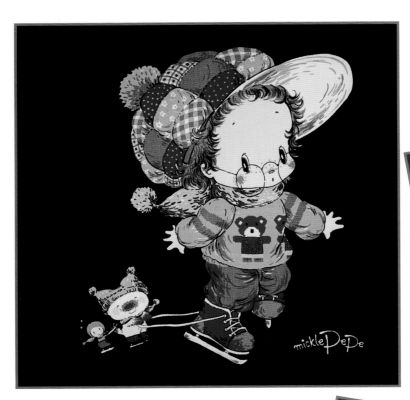

Late 1970s, 18 x 18, $5-10. A velveteen cushion cover. The *Mickle PePe* series featured this figure engaged in summer and winter sports. Here, wearing his spectacles, this comic character is trying to figure skate. The mischievous cat and grasshopper, after undoing one of his laces, are now hanging on as tight as they can.

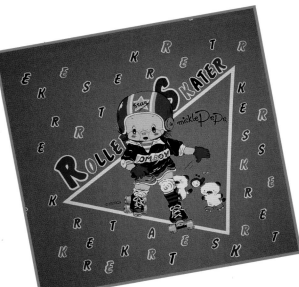

Top right: Late 1970s, 18 x 18, $5-10. A blue cotton canvas cushion cover. Part of the same series as the previous cover. This is a licensed fabric from Tomboy. Our intrepid friend tries out roller skating, with the terrified grasshopper and cat tightly holding onto his shin. In bold letters, the words "Roller Skater" are written across the pennant.

Center right: The same as the previous print, in pink.

Bottom left: Late 1970s, 18 x 18, $5-10. A blue cotton canvas cushion cover. Part of the same series as the previous print. Looking quite disheartened, our skater has tripped over spilt marbles. The cat and grasshopper enjoy a chuckle over his misfortune.

Bottom right: The same as the previous print, in pink.

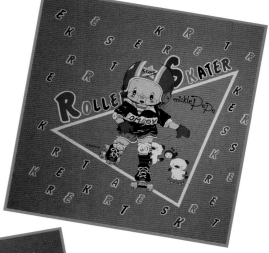

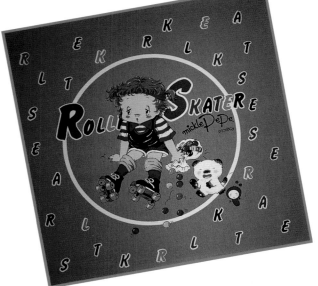

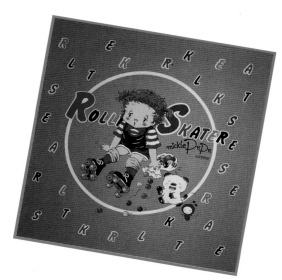

Late 1970s, 36 x 14, $5-10. A red cotton interior fabric from Kanebo, Ltd. The hapless fisherman is the subject of this print. A rabbit accidentally hooks himself instead of the big one while two ducks laugh. In another scene, he runs away with a stolen fish as an angry squirrel chases him. Stenciled letters in white create a busy, nonsense backdrop to the zany antics of this character.

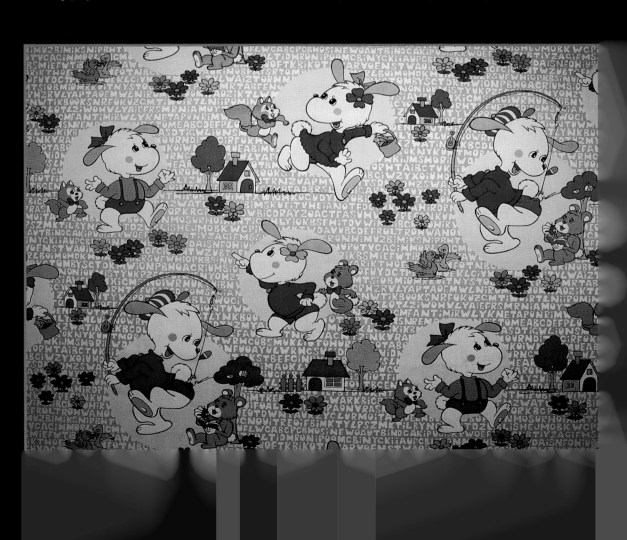

Court Dolls

Early 1960s, 18 x 13, $10-15. A pink muslin *jyuban* (slip) fragment.
White and pink cherry blossoms and tiny dolls, *Gosho Ningyos*, are
sprinkled across the fabric, creating a delicate design.

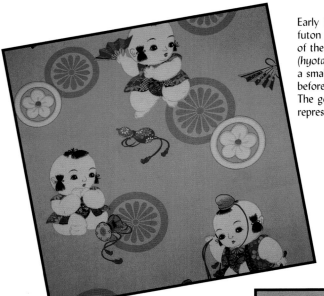

Early 1970s, 14 x 14, $15-20. A green muslin futon remnant. The *Gosho Ningyo* at the very top of the fabric holds a fan, and a sake container (*hyotan*) lies at his feet. The figure on the left plays a small hand-held drum. The bottom figure kneels before a sea bream, a fish eaten at celebrations. The gold chrysanthemum family crest, which represents the Emperor, adds depth to the design.

御歳暮

C.1970s, 7 x 39, $15-20. A peach muslin futon remnant. This fabric presents the story of "Ushiwakamaru and Benkei." Ushiwakamaru, who later became the hero Minamoto no Yoshitsune, bested Benkei, a famous monk and swordsman. After Benkei was defeated on the Gojo bridge in Kyoto, he became Ushiwakamaru's loyal and faithful servant. Shown here are Ushiwakamaru as a young boy and Benkei dressed as a monk. The family crest reads Bungo Umebachi. *Bungo* is an area in Kyushu and *ume* means plum.

The other half of the previous print with Ushiwakamaru holding a fan. A chrysanthemum family crest is at his feet. Alternatively, he holds a sword with a *sasarindo* family crest below him.

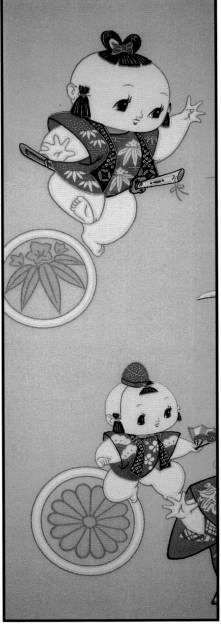

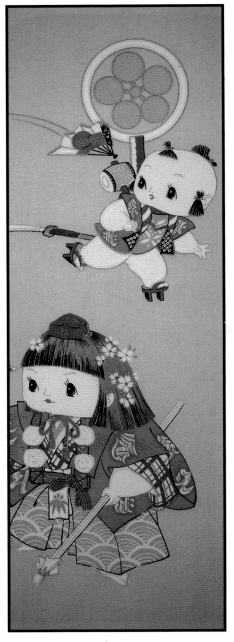

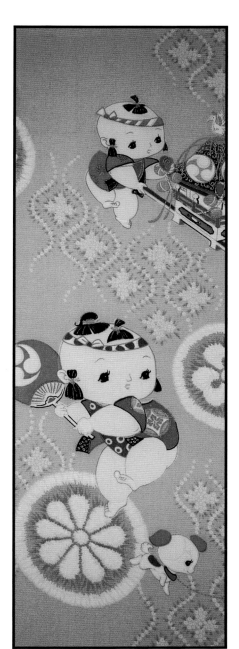

C.1970s, 7 x 39, $15-20. A pink muslin futon remnant. A summer festival theme with one of the images carrying an *Omikoshi*. The other figure, with the fan, is cheering him on. The family chrysanthemum crest is done with a *shibori*-like effect.

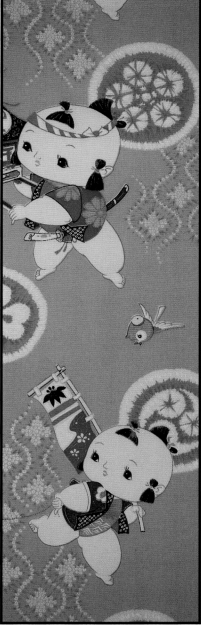

The same as the previous print, in aqua. The crest done with a *shibori*-like effect reads Bungo Umebachi.

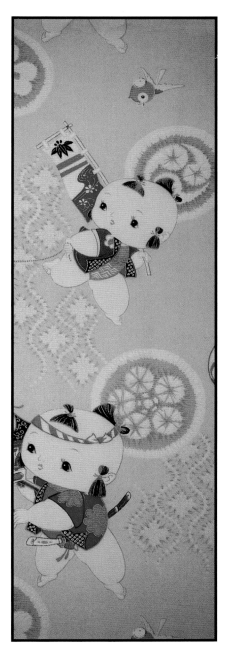

The same as the previous print, in light pink.

47

The same as the
previous print, in yellow.

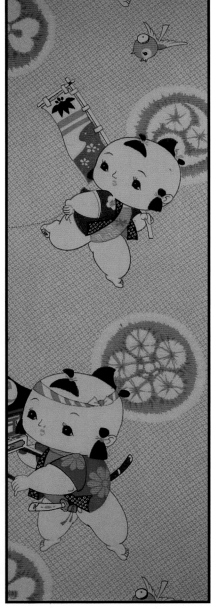

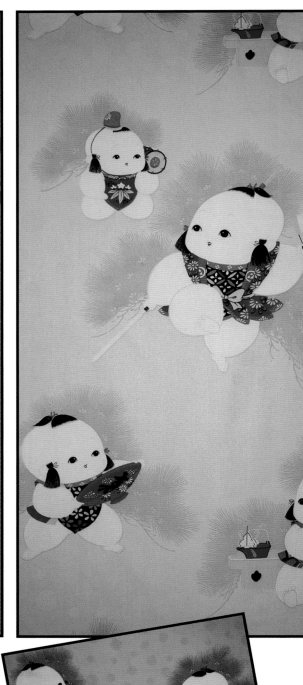

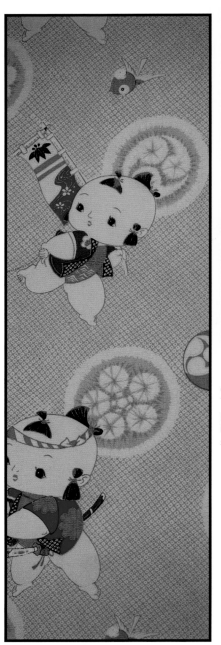

C.1970s, 7 x 39, $10-15.
The figures are the same as the
previous fabric, but the
background has a *kanoko-
shibori* design.

Late 1970s, 19 x 18, $20-25. A blue
polished cotton futon remnant from Kurokawa
Ltd. Another fabric with a New Year's
celebration theme. Pine tree needles, which are
a symbol for the New Year, are used to
highlight the image. The *Gosho Ningyo* in the
top left corner is carrying a red sake cup, with
the character kotobuki on it. This symbol is
used for celebrations. The image on the left is
kneeling beside a *Shinto* offering plate holding
a special sake called *Otoso*.

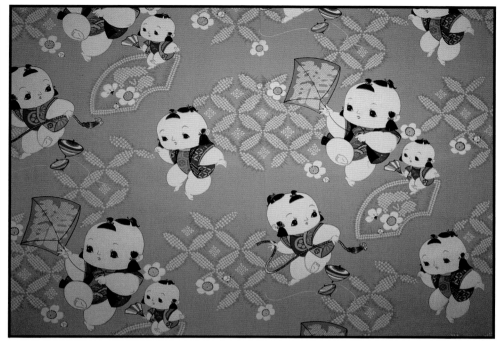

Late 1970s, 36 x 36, $25-30. A blue cotton futon remnant from Toyobo Ltd. A New Year's theme print with a large *Gosho Ningyo* flying a kite. Fans decorated with cherry blossoms and *kanoko-shibori* patterns on the background are beautiful embellishments.

The same as the previous print, in yellow. One *Gosho Ningyo* dances while the other plays a small drum.

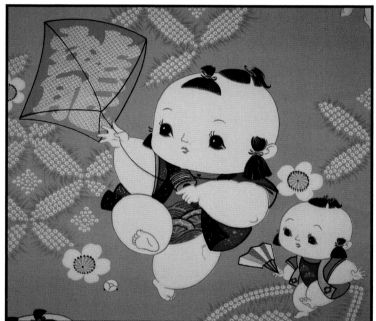

A detail of the previous print showing the Japanese character for dragon on the kite. The dragon is a popular symbol used on kites, for it symbolizes wealth, power, and nobility. Kites are flown high up in the sky in order for the gods to see them and hopefully grant the wishes of the flyer.

Late 1970s, 36 x 36, $25-30. A yellow cotton futon remnant. The *Gosho Ningyo* plays with a *temari* ball. The rich geometric backdrop is made up of arrow feathers.

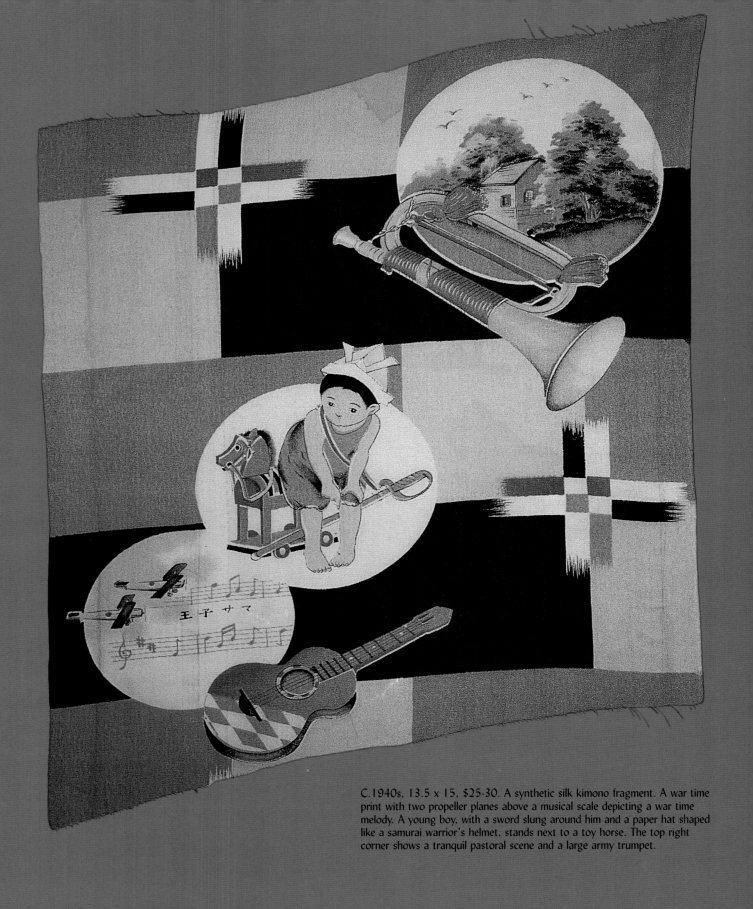

C.1940s, 13.5 x 15. $25-30. A synthetic silk kimono fragment. A war time print with two propeller planes above a musical scale depicting a war time melody. A young boy, with a sword slung around him and a paper hat shaped like a samurai warrior's helmet, stands next to a toy horse. The top right corner shows a tranquil pastoral scene and a large army trumpet.

Images of Children

Early 1950s, 14 x 14, $20-25. A synthetic silk kimono fragment. The design is split into four color block sections. At the top are snow capped mountains, with two large snowflakes flanking the corners. The second scene is of Boy's Day Festival, with kites flying in the breeze. A particularly large kite shows a gigantic carp running up a waterfall. The third plane has geometric images of arrow heads and blocks. At the bottom are children throwing snowballs while two others march, holding a banner that reads "Sho-ich-i Inari Daimyojin,"or "top-ranking," as a shrine to a fox.

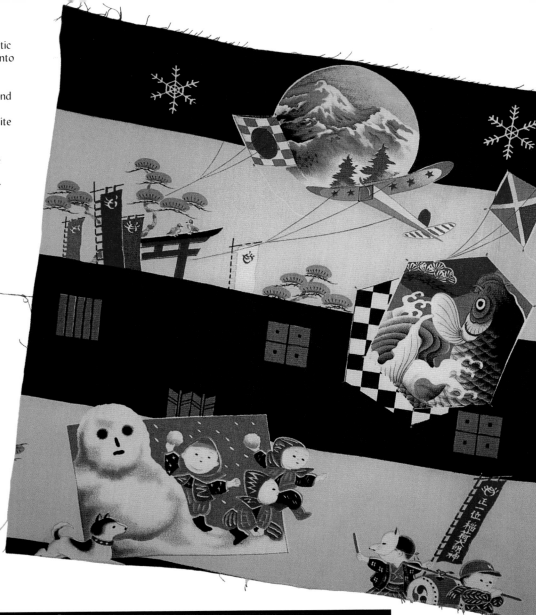

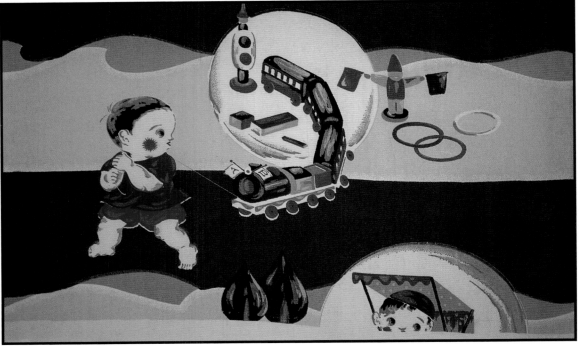

Early 1950s, 15 x 10, $25-30. A silk kimono fragment. A small child looks over his shoulder as he pulls a toy train along. The boy is drawn with incredible detail from his rosy cheeks down to his chubby legs and little toes. A traffic light, conductor, blocks, and hoops lie waiting for him to come and play.

C.1960s, 30 x 7, $10-15. A pink cotton garment fragment. A delightful fabric showing the face of a young girl peering out from a large hood. The change of the seasons is this print's theme. Autumn is represented by the large maple leaves and the young girl is the coming winter.

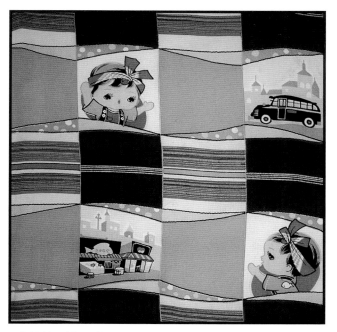

C.1960s, 18 x 18, $20-25. A mustard and purple silk futon remnant. A young boy is dressed as a fishmonger. The stall below him has a large fish sign above it and written in Japanese *Hiragana* letters is the word "*sakanaya*," or fish store. A city bus in black is also present.

Early 1960s, 27 x 7, $10-15. A muslin kimono fragment. A group of fashionable friends are going for a drive to view the cherry blossoms. One girl bids farewell to her mother. A vibrant print with solid color blocks in pink, purple, and blue intermingled with black and white tiles. This fabric was part of a series of prints produced featuring almost the same background composition, with the characters slightly altered.

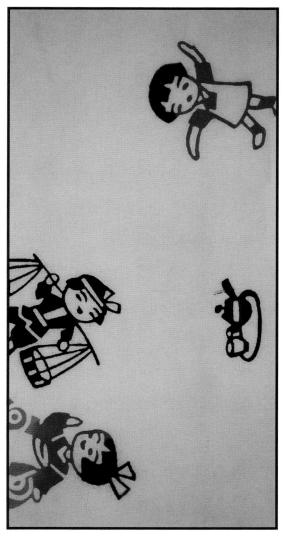

C.1960s, 10 x 5, $2-5. A white cotton yukata fragment. The simple images of a girl dressed in a smock dress or kimono are visible. She beckons to a young boy dressed as fishmonger.

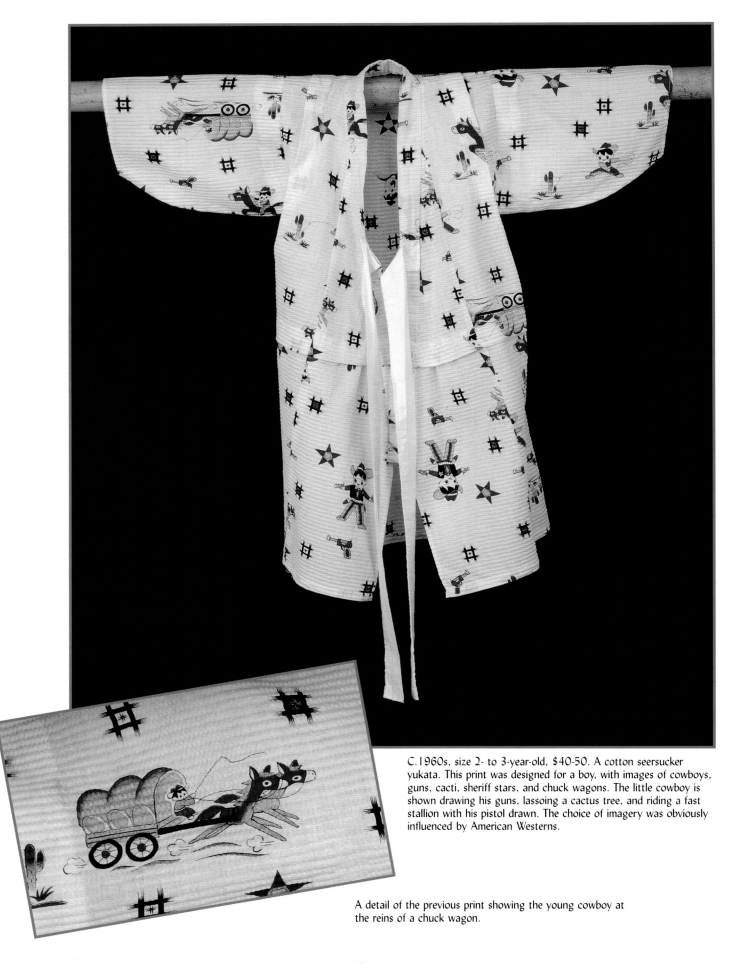

C.1960s, size 2- to 3-year-old, $40-50. A cotton seersucker yukata. This print was designed for a boy, with images of cowboys, guns, cacti, sheriff stars, and chuck wagons. The little cowboy is shown drawing his guns, lassoing a cactus tree, and riding a fast stallion with his pistol drawn. The choice of imagery was obviously influenced by American Westerns.

A detail of the previous print showing the young cowboy at the reins of a chuck wagon.

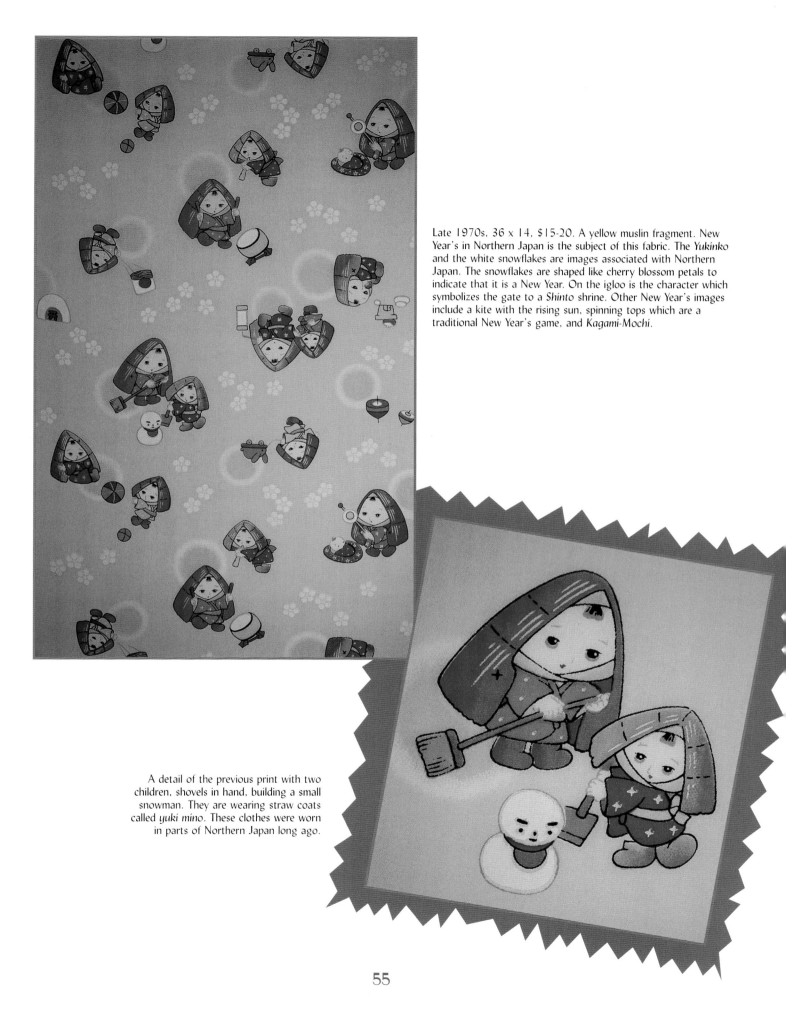

Late 1970s, 36 x 14, $15-20. A yellow muslin fragment. New Year's in Northern Japan is the subject of this fabric. The *Yukinko* and the white snowflakes are images associated with Northern Japan. The snowflakes are shaped like cherry blossom petals to indicate that it is a New Year. On the igloo is the character which symbolizes the gate to a *Shinto* shrine. Other New Year's images include a kite with the rising sun, spinning tops which are a traditional New Year's game, and *Kagami-Mochi*.

A detail of the previous print with two children, shovels in hand, building a small snowman. They are wearing straw coats called *yuki mino*. These clothes were worn in parts of Northern Japan long ago.

55

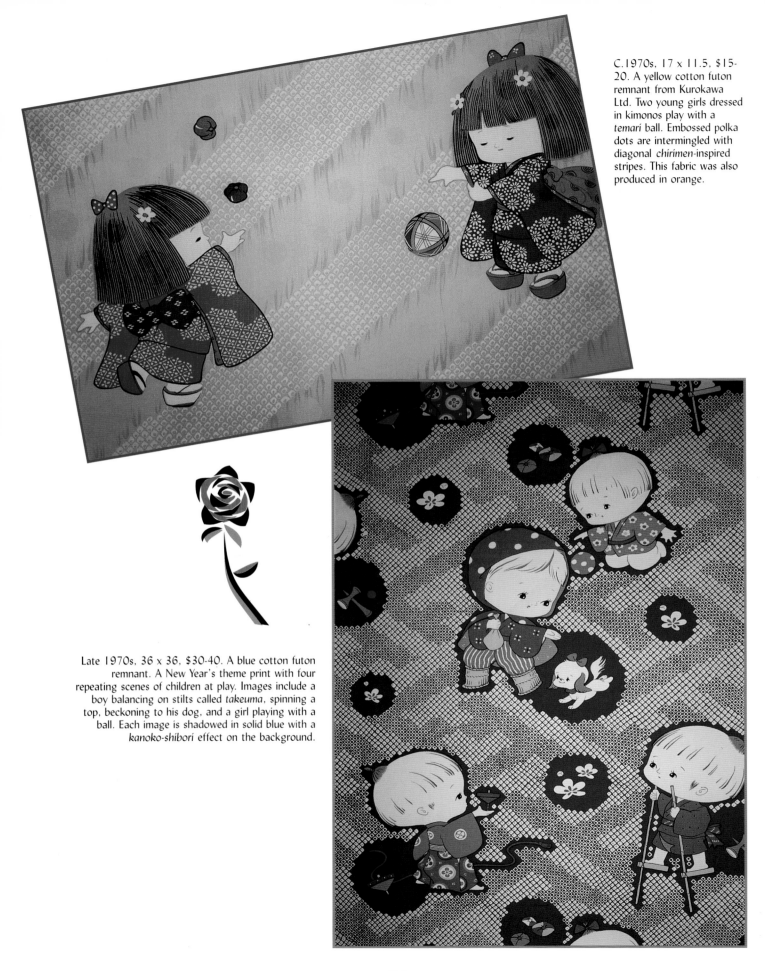

C.1970s, 17 x 11.5, $15-20. A yellow cotton futon remnant from Kurokawa Ltd. Two young girls dressed in kimonos play with a *temari* ball. Embossed polka dots are intermingled with diagonal *chirimen*-inspired stripes. This fabric was also produced in orange.

Late 1970s, 36 x 36, $30-40. A blue cotton futon remnant. A New Year's theme print with four repeating scenes of children at play. Images include a boy balancing on stilts called *takeuma*, spinning a top, beckoning to his dog, and a girl playing with a ball. Each image is shadowed in solid blue with a *kanoko-shibori* effect on the background.

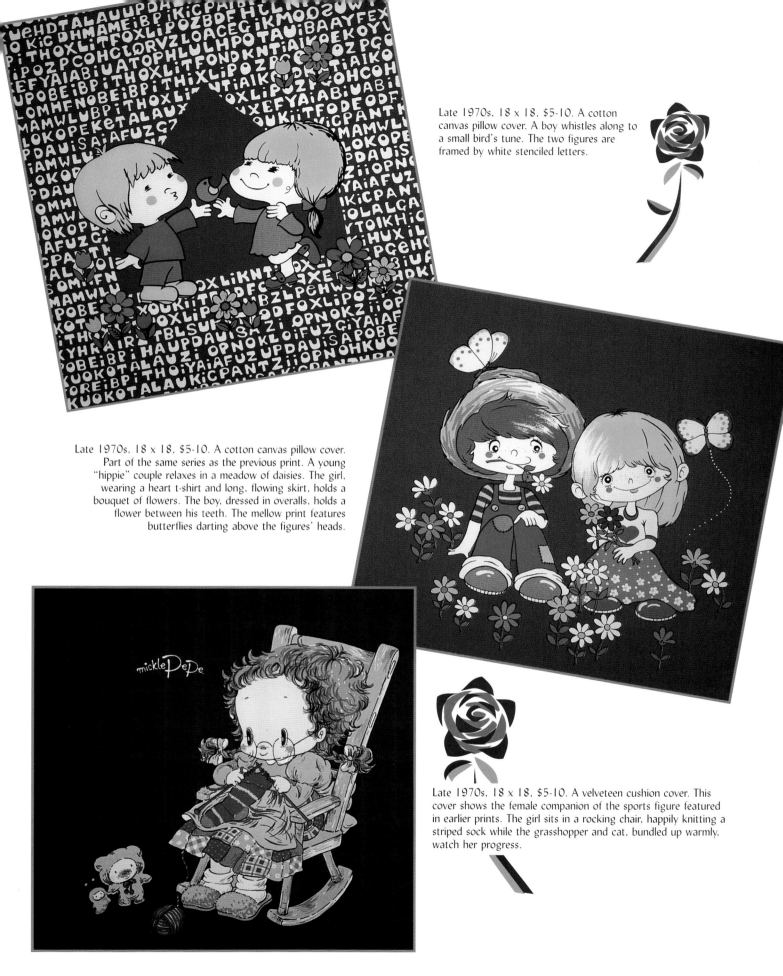

Late 1970s, 18 x 18, $5-10. A cotton canvas pillow cover. A boy whistles along to a small bird's tune. The two figures are framed by white stenciled letters.

Late 1970s, 18 x 18, $5-10. A cotton canvas pillow cover. Part of the same series as the previous print. A young "hippie" couple relaxes in a meadow of daisies. The girl, wearing a heart t-shirt and long, flowing skirt, holds a bouquet of flowers. The boy, dressed in overalls, holds a flower between his teeth. The mellow print features butterflies darting above the figures' heads.

Late 1970s, 18 x 18, $5-10. A velveteen cushion cover. This cover shows the female companion of the sports figure featured in earlier prints. The girl sits in a rocking chair, happily knitting a striped sock while the grasshopper and cat, bundled up warmly, watch her progress.

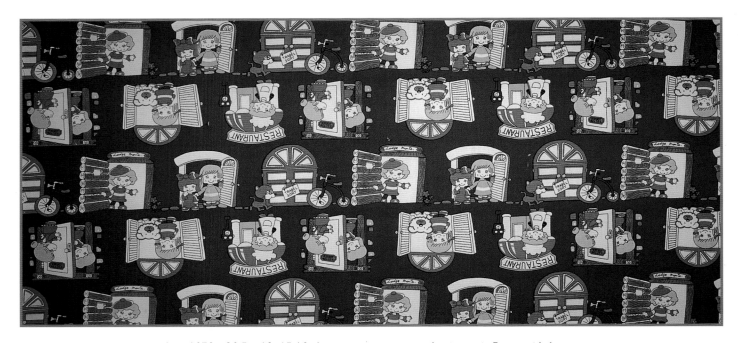

Late 1970s, 36.5 x 13, $5-10. A green cotton remnant. A print set in France with funny, misspelled English sayings, such as "Trabel Sory," on a closed shop door. Other scenes include a doctor's office and a chef standing outside a restaurant.

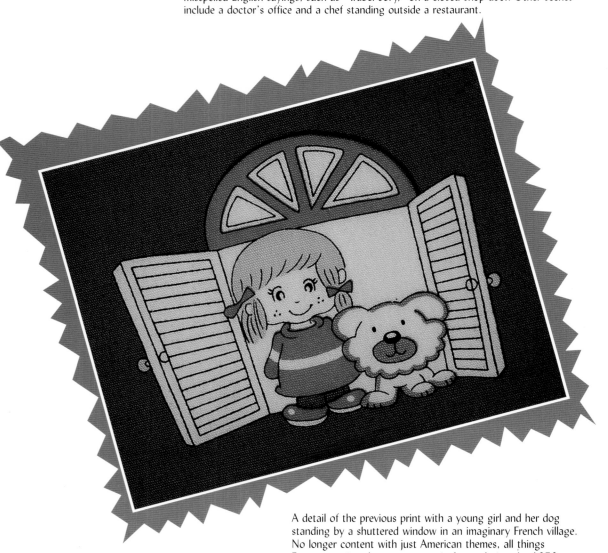

A detail of the previous print with a young girl and her dog standing by a shuttered window in an imaginary French village. No longer content with just American themes, all things European enjoyed a great vogue in Japan during the 1970s.

Late 1970s, 26 x 18, $5-10. A blue cotton remnant designed by Lemon Tree. A patchwork design with each block containing a simple image of fluffy clouds, bunnies, flower pots, a sheep in a meadow, or a young girl.

Late 1970s, 41 x 24, $10-15. An orange cotton futon remnant from Shikibo Ltd. There are four different repeating scenes of a "Holly Hobby" inspired character. She sits on a rope swing, gathers tulips, holds a bouquet of hollyhocks, and carries a basket filled with golden flowers. She is wearing a long prairie dress and an oversized straw hat or bonnet that obscures her face.

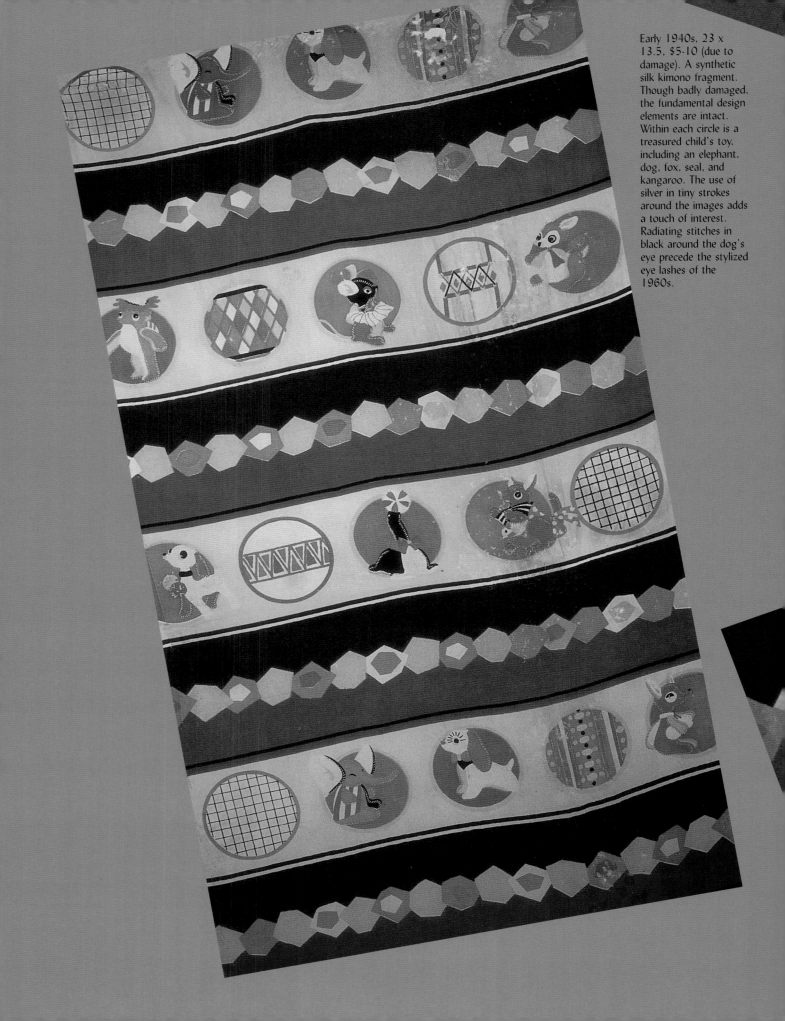

Early 1940s, 23 x 13.5, $5-10 (due to damage). A synthetic silk kimono fragment. Though badly damaged, the fundamental design elements are intact. Within each circle is a treasured child's toy, including an elephant, dog, fox, seal, and kangaroo. The use of silver in tiny strokes around the images adds a touch of interest. Radiating stitches in black around the dog's eye precede the stylized eye lashes of the 1960s.

Chapter Six
Let's Play

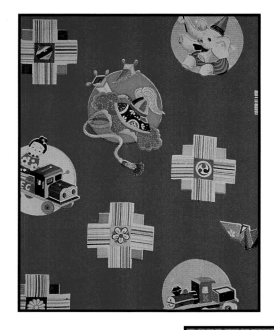

C.1950s, 10 x14, $10-15. A red muslin kimono fragment. The design is composed of a circus elephant waving a flag, a samurai hat in a red cloud with long, flowing tassels, a *kokeshi* doll going for a ride in a "cokec" truck, and a toy train.

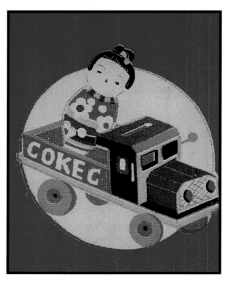

C.1950s, 3.4 x 7, $2-5. A section of the previous print. The word "cokec" on the truck is a misspelling of the word *kokeshi*. This was probably done on purpose to make the word fit on the truck.

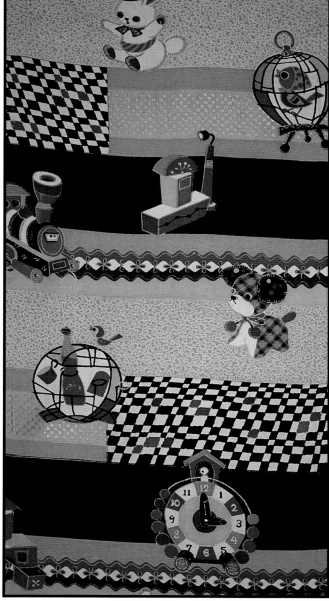

C.1950s, 19 x 10, $20-25. A silk kimono fragment. An array of visually striking children's toys, including a diamond patchwork dog, a pull train, a gas pump, a bird in a cage, and a clock.

C.1950s, 17 x 13.5, $10-15. A blue muslin kimono remnant.
A crisp design with building blocks and a little duck.

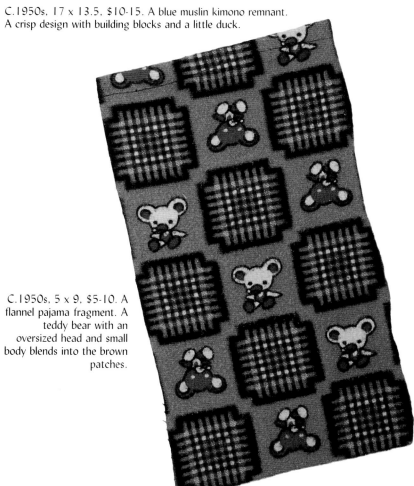

C.1950s, 5 x 9, $5-10. A
flannel pajama fragment. A
teddy bear with an
oversized head and small
body blends into the brown
patches.

C.1950s, 21 x 7, $10-15. A dark green muslin
remnant. A variety of children's toys are showcased
on this fabric, including a toy soldier, a bunny on a
tractor, and a windmill.

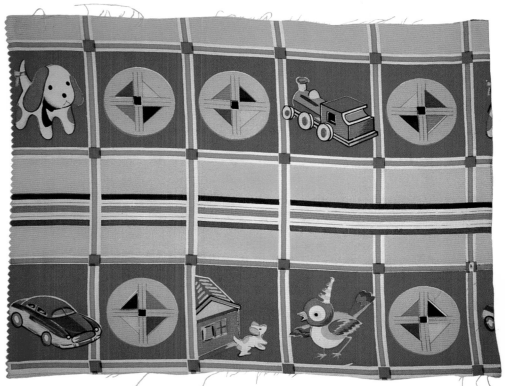

C.1950s, 14 x 11, $10-15. A yellow and red synthetic silk fragment. Brilliant blocks contain a variety of images appealing to a child, including a car, a train, and a dog.

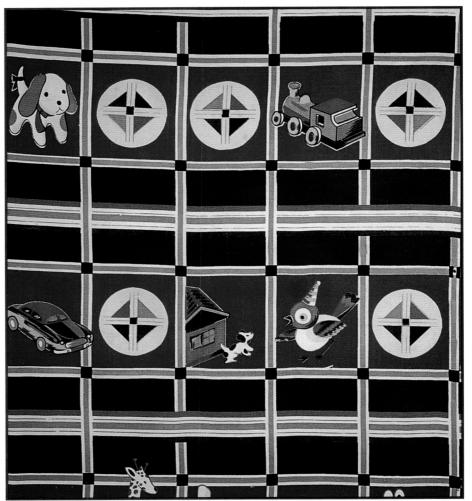

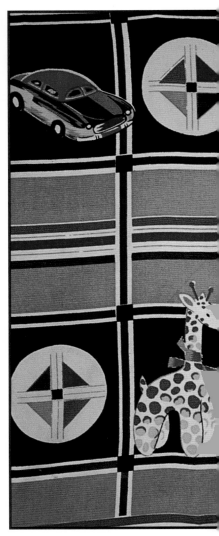

Same as the previous print, in green and mustard.

Same as the previous print, in navy and brown.

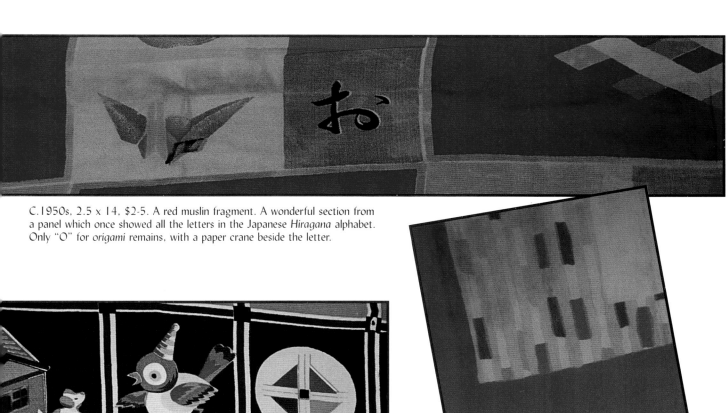

C.1950s, 2.5 x 14, $2-5. A red muslin fragment. A wonderful section from a panel which once showed all the letters in the Japanese *Hiragana* alphabet. Only "O" for *origami* remains, with a paper crane beside the letter.

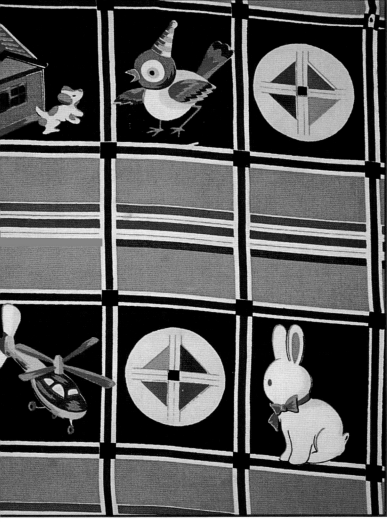

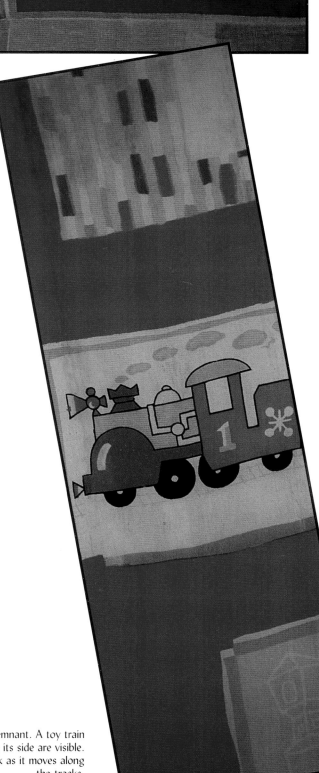

C.1950s, 15 x 4, $2. A red synthetic silk remnant. A toy train with the number one and a snowflake on its side are visible. Yellow smoke comes from the train's stack as it moves along the tracks.

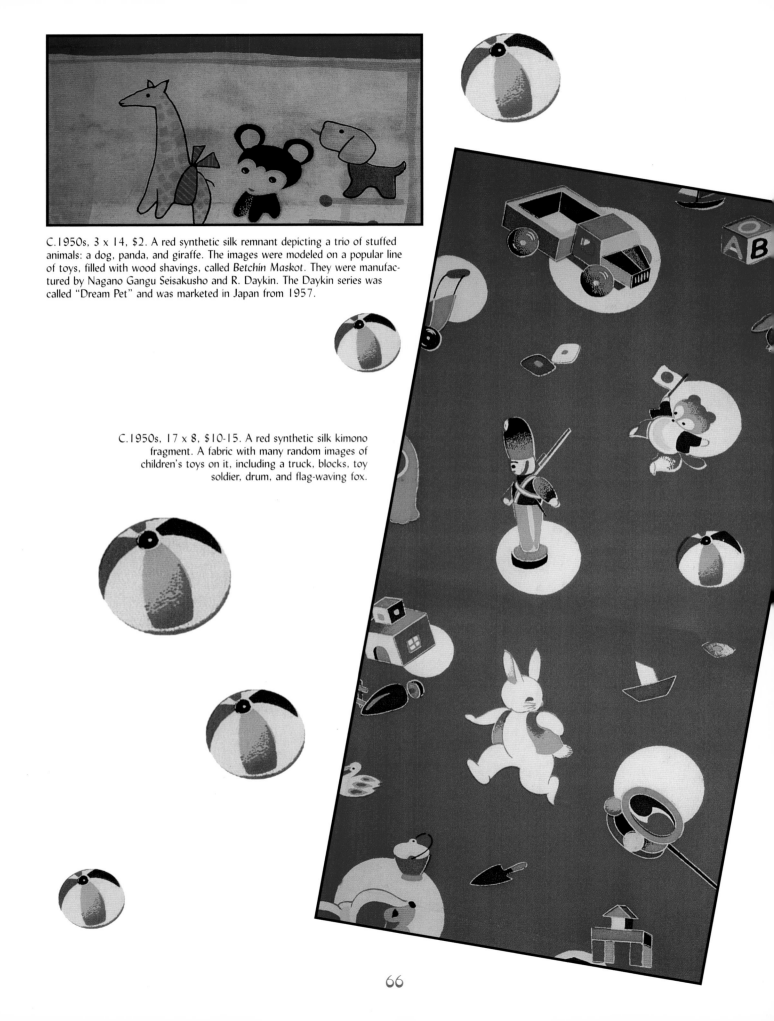

C.1950s, 3 x 14, $2. A red synthetic silk remnant depicting a trio of stuffed animals: a dog, panda, and giraffe. The images were modeled on a popular line of toys, filled with wood shavings, called *Betchin Maskot*. They were manufactured by Nagano Gangu Seisakusho and R. Daykin. The Daykin series was called "Dream Pet" and was marketed in Japan from 1957.

C.1950s, 17 x 8, $10-15. A red synthetic silk kimono fragment. A fabric with many random images of children's toys on it, including a truck, blocks, toy soldier, drum, and flag-waving fox.

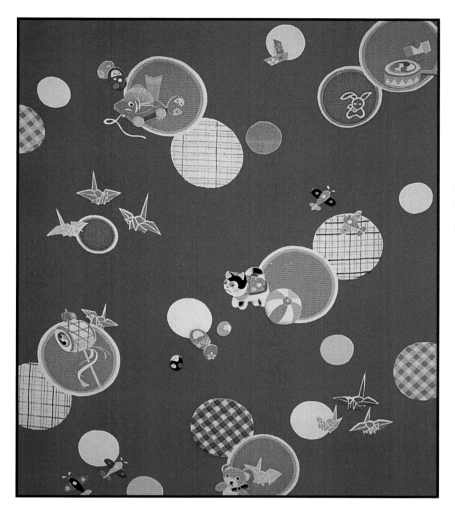

C.1950s, 15 x 13.5, $15-20. A red synthetic silk kimono remnant. Paper cranes, a *tomoe* symbol, and tumbler dolls are some of the images shown.

A detail of the previous print with a *Komainu*. These statues are found at practically every *Shinto* shrine in Japan.

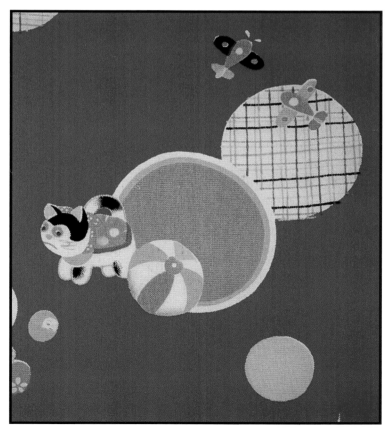

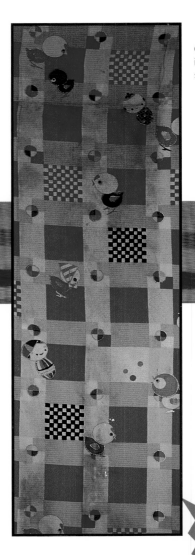

C.1950s, 20 x 7, $10-15. A muslin kimono fragment in red and pink checks. The design is composed of smiling *kokeshi* dolls and fashionable chicks with trendy 1950s head scarves.

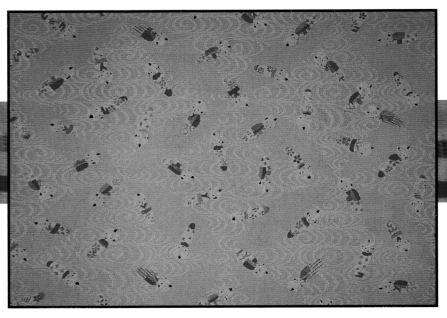

C.1960s, 13 x 9, $2-5. A pink silk kimono fragment. *Kokeshi* dolls measuring less than an inch are scattered across the fabric. The background is embossed with an elaborate swirling pattern.

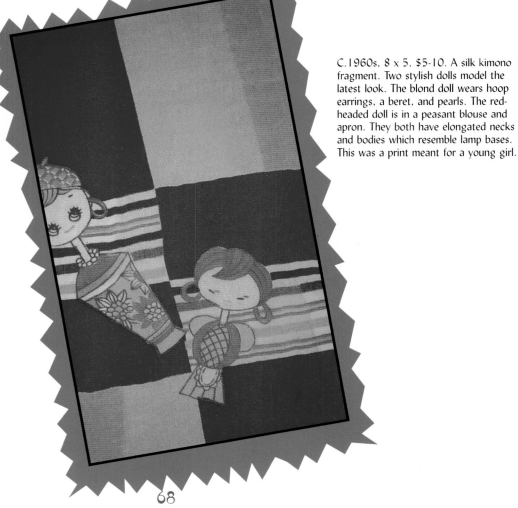

C.1960s, 8 x 5, $5-10. A silk kimono fragment. Two stylish dolls model the latest look. The blond doll wears hoop earrings, a beret, and pearls. The red-headed doll is in a peasant blouse and apron. They both have elongated necks and bodies which resemble lamp bases. This was a print meant for a young girl.

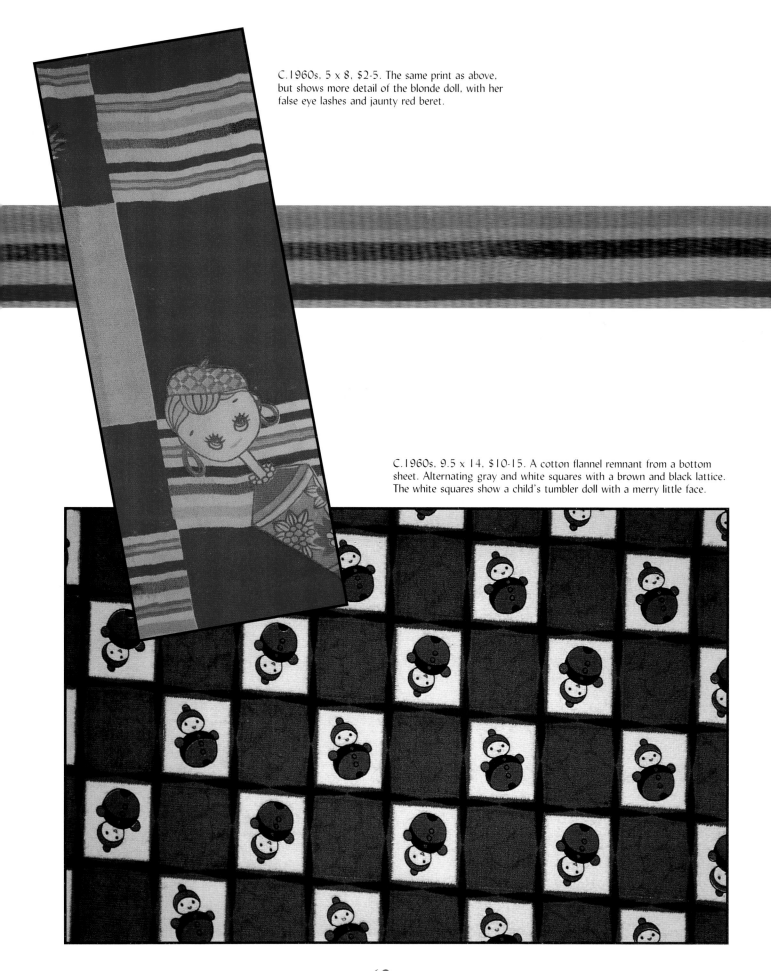

C.1960s, 5 x 8, $2-5. The same print as above, but shows more detail of the blonde doll, with her false eye lashes and jaunty red beret.

C.1960s, 9.5 x 14, $10-15. A cotton flannel remnant from a bottom sheet. Alternating gray and white squares with a brown and black lattice. The white squares show a child's tumbler doll with a merry little face.

Once Upon A Time...

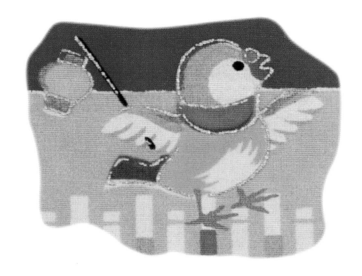

C.1950s, 11 x 9.5, $10-15. A synthetic silk kimono fragment. A fabric showing the famous characters from Japanese fairy tales, *Saru Kani Kassen* (*The Crab and the Monkey*) and *Shitakiri Suzume* (*Tongue Cut Sparrow*).

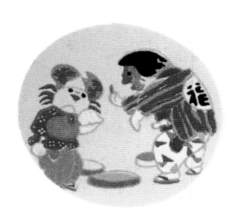

C.1950s, 19.5 x 14, $25-30. A silk kimono fragment. A wonderful piece based on the Japanese folktale *The Crab and The Monkey*. The top left circle shows the beginning of the tale, where the devious monkey tricks the crab out of her rice ball in exchange for a persimmon seed. The center image is of the crab diligently watering the seed and encouraging it to grow into a tree. The top right shows the greedy monkey eating all the persimmons.

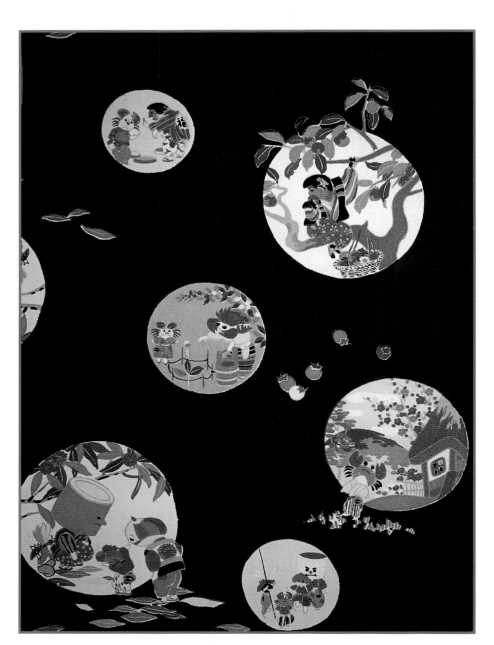

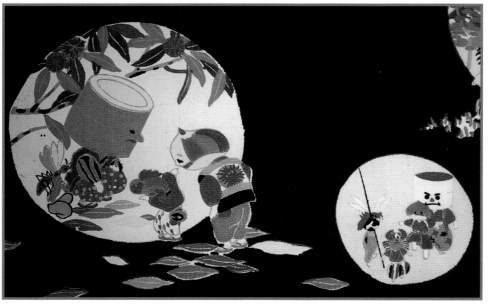

A detail of the previous print with the baby crab, bee, chestnut, and mortar plotting their revenge against the wicked monkey.

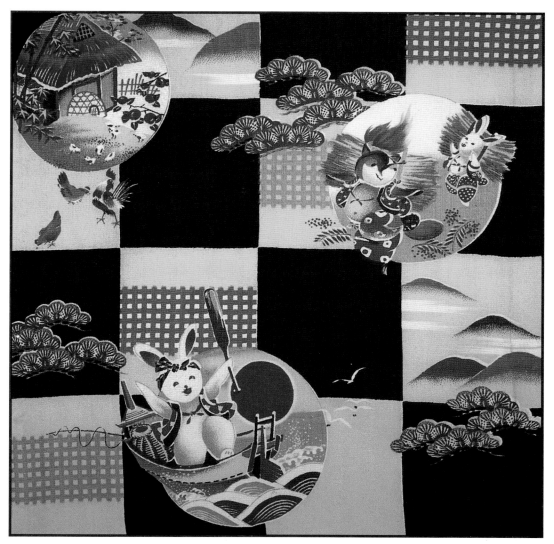

C.1950s, 14.5 x 13, $25-30. A muslin garment remnant. Two pivotal scenes from the story *KachiKachi Yama* are shown. The story is about a kind farmer, his wife, a rabbit, and a vicious raccoon. After the raccoon kills the farmer's wife, the rabbit sets out to get revenge for her death. In the upper right corner, the rabbit has set fire to the raccoon's kindling.

A detail of the previous print. The victorious rabbit raises his oars high above his head as the evil raccoon drowns in his boat made of mud.

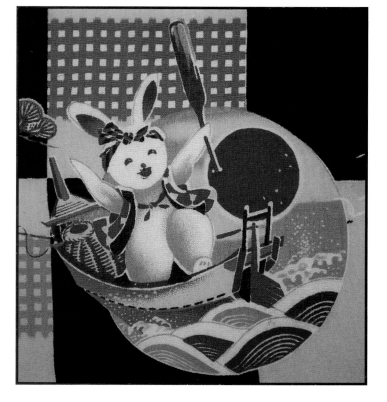

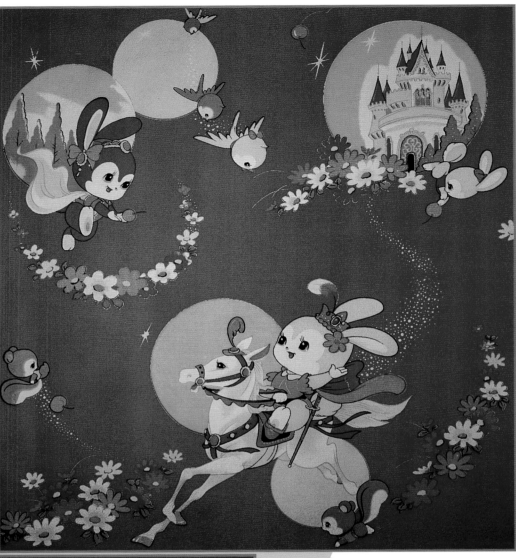

Mid-1960s, 20 x 18, $25-30. A pink poly cotton futon remnant. A fantastical fabric based on Disney's *Snow White and the Seven Dwarfs*. A beautiful white castle with elaborate blue door and red turrets shimmers in the distance. The print cleverly combines two pivotal scenes from *Snow White and The Seven Dwarfs* and even provides a glimpse of the happy ending through the image of the castle. In another scene, Snow White holds out the poisoned apple.

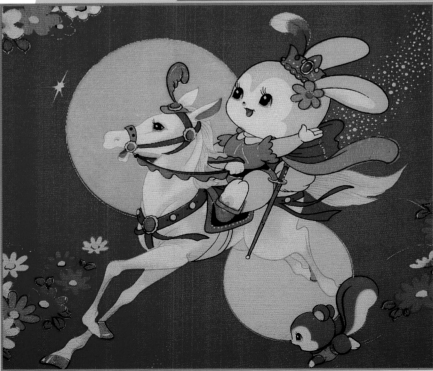

A detail of the previous print. The bunny prince gallops away on a white steed. A trail of gold dust is left behind in his wake.

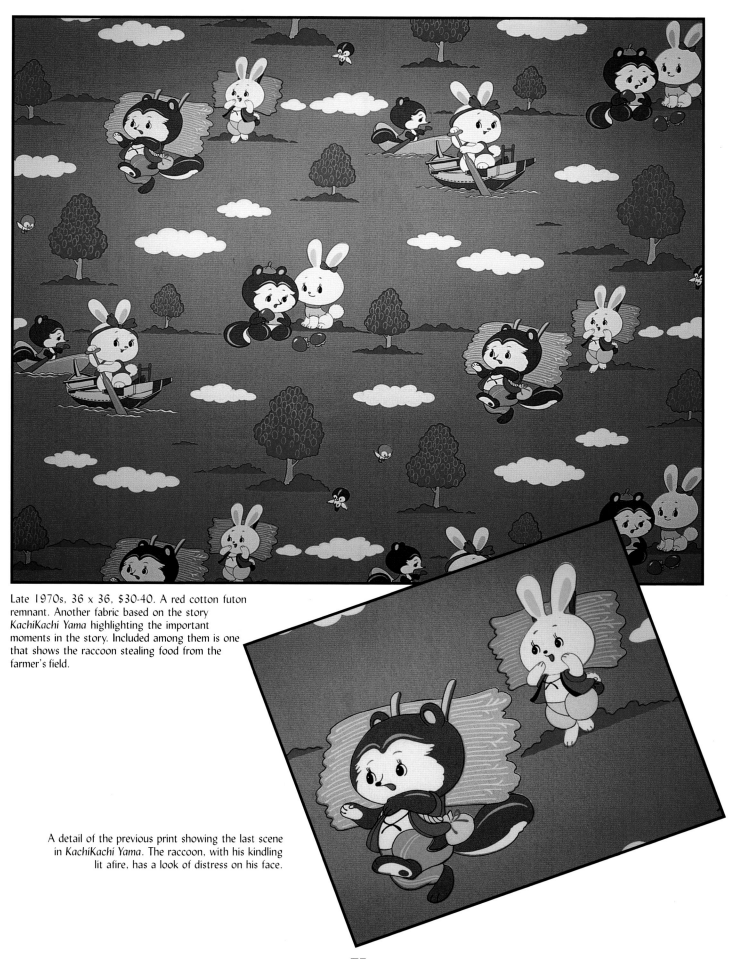

Late 1970s, 36 x 36, $30-40. A red cotton futon remnant. Another fabric based on the story *KachiKachi Yama* highlighting the important moments in the story. Included among them is one that shows the raccoon stealing food from the farmer's field.

A detail of the previous print showing the last scene in *KachiKachi Yama*. The raccoon, with his kindling lit afire, has a look of distress on his face.

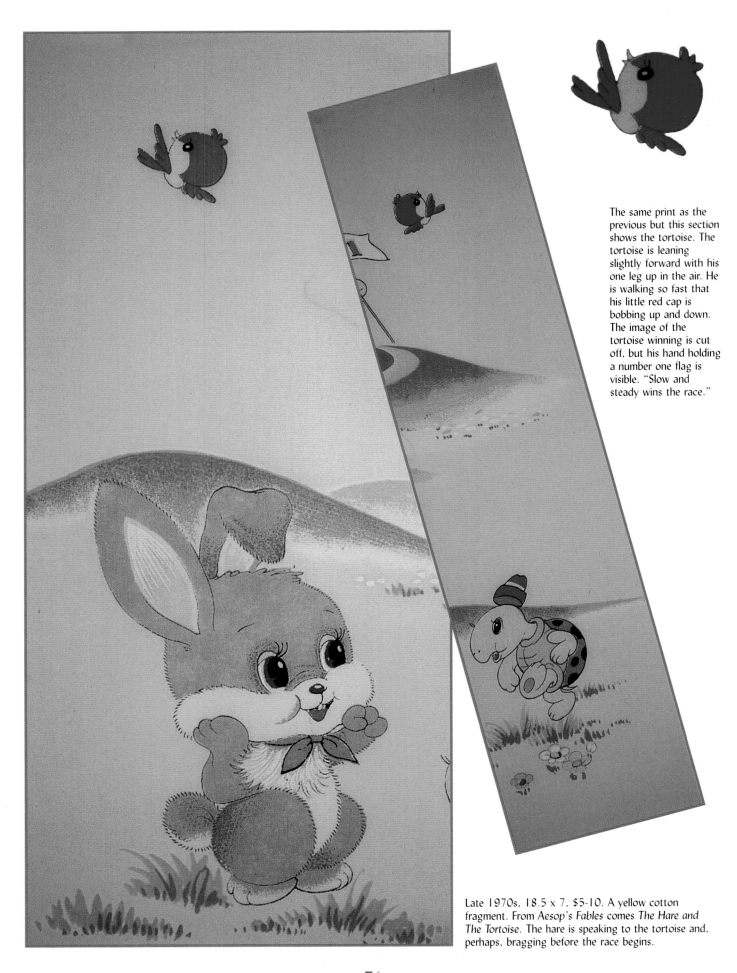

The same print as the previous but this section shows the tortoise. The tortoise is leaning slightly forward with his one leg up in the air. He is walking so fast that his little red cap is bobbing up and down. The image of the tortoise winning is cut off, but his hand holding a number one flag is visible. "Slow and steady wins the race."

Late 1970s, 18.5 x 7, $5-10. A yellow cotton fragment. From Aesop's Fables comes The Hare and The Tortoise. The hare is speaking to the tortoise and, perhaps, bragging before the race begins.

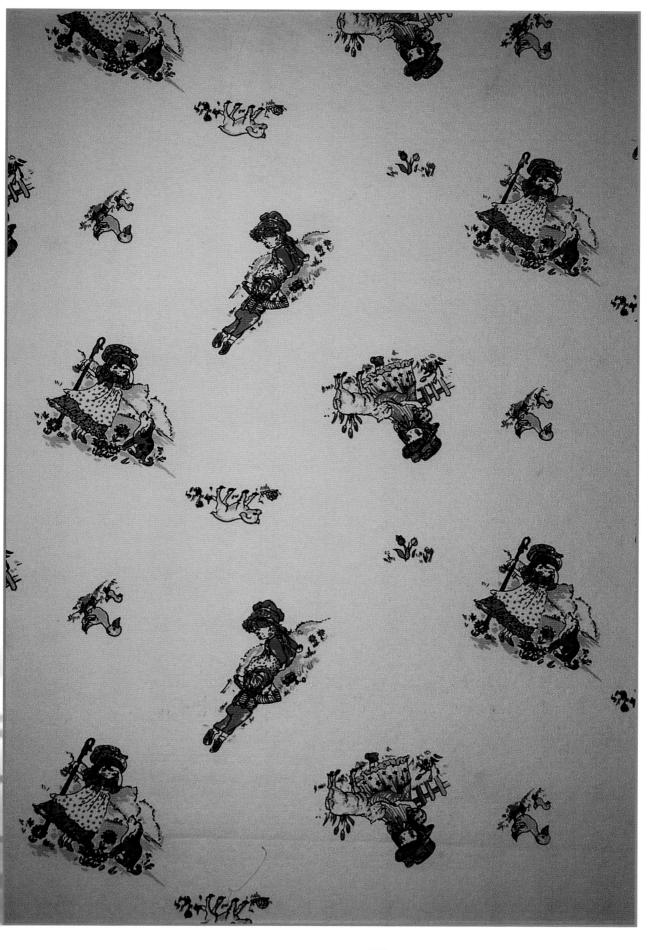

C.1970s, 36 x 17, $15-20. A white cotton curtain panel. This fabric features the children's classic nursery rhyme, *Mary Had a Little Lamb*. Mary is shown in various attitudes, including looking for her lambs, crying, and feeding a lamb.

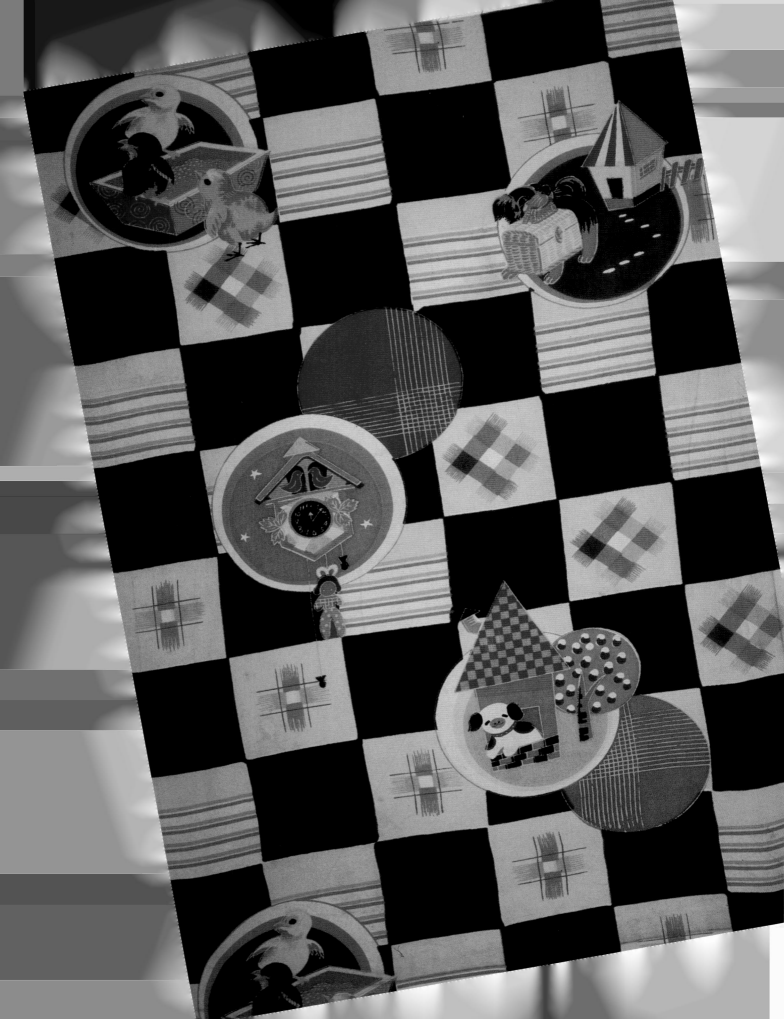

Wet Noses and Waggy Tails

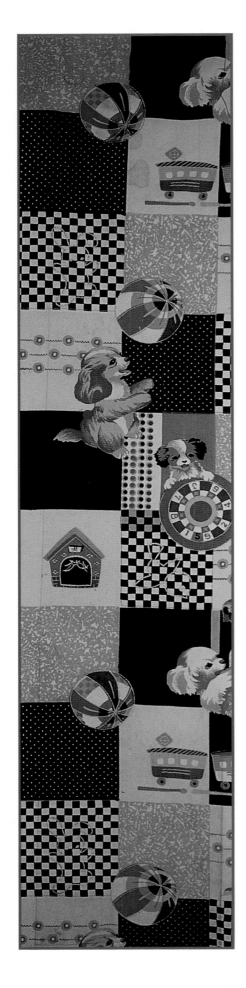

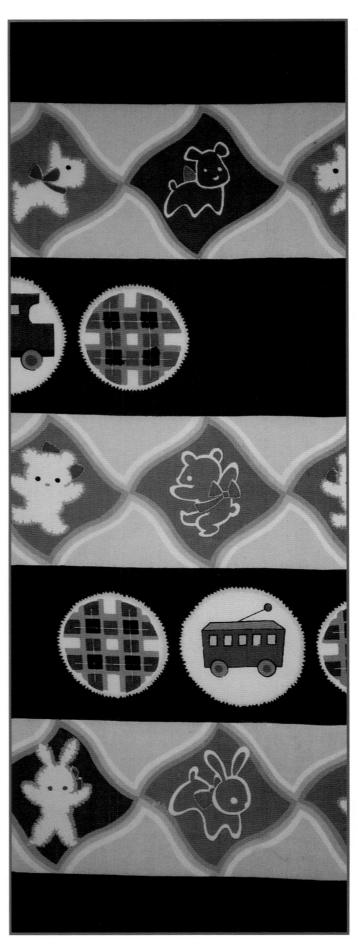

C.1950s, 30 x 7, $20-25. A synthetic silk kimono fragment executed in the signature colors of the early 1950s. A pup in muted shades of brown and gray plays with its ball. A doghouse, a dartboard, and a tram are also featured.

C.1950s, 26.5 x 7, $10-15. Bands of forest green and cream on a muslin kimono fragment. Wavy diamonds are filled with images of Scotty dogs, bunnies, teddies, and a tram.

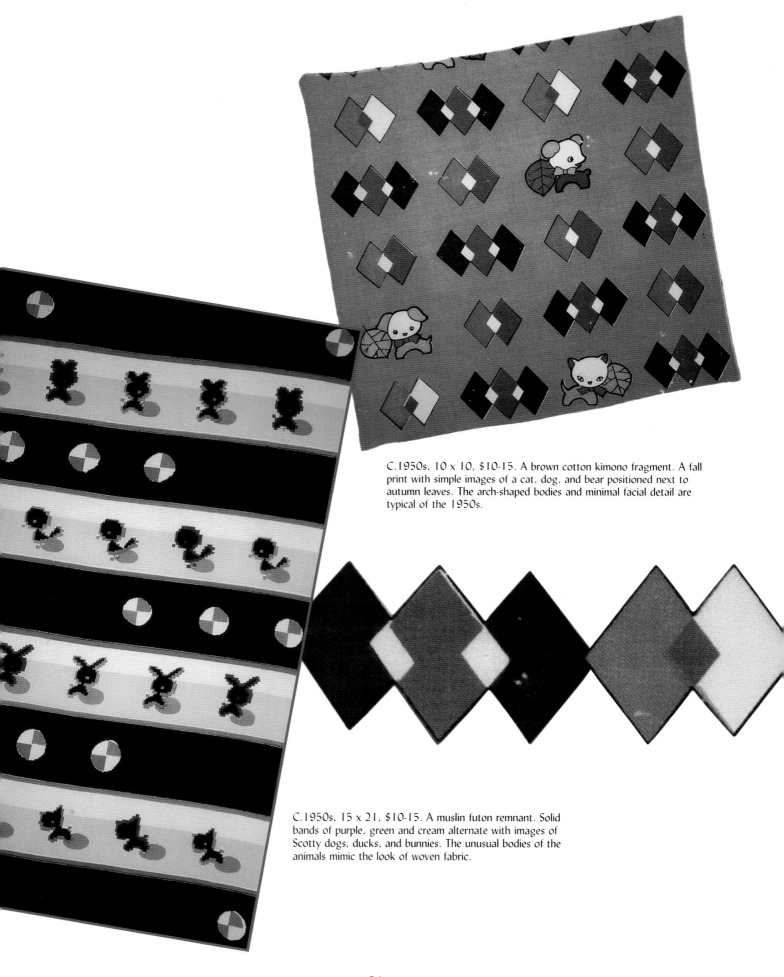

C.1950s, 10 x 10, $10-15. A brown cotton kimono fragment. A fall print with simple images of a cat, dog, and bear positioned next to autumn leaves. The arch-shaped bodies and minimal facial detail are typical of the 1950s.

C.1950s, 15 x 21, $10-15. A muslin futon remnant. Solid bands of purple, green and cream alternate with images of Scotty dogs, ducks, and bunnies. The unusual bodies of the animals mimic the look of woven fabric.

C.1950s, 25 x 3.5, $10-15. A red muslin fragment with pink bands and multicolored zigzags. A child's xylophone and playful spitz pup pulling a ribbon out of a sewing box are shown. The spitz enjoyed quite a period of popularity in Japan, peaking around 1961.

Mid-1960s, 18 x 14, $10-15. A white cotton yukata remnant. A whimsical print with a frowning dog, a cat with its "hands on it's hips," and a cow in an apron. The long-haired dog resembles Curly, a white stuffed dog that was all the craze in 1966 Japan. Curly's hair could be brushed and he came with a radio and gold collar.

Early 1960s, 17 x 13.5, $10-15. A white and blue cotton child's hand towel. A large, bold *ikat* mark dominates the piece. The realistic dog pictured on this piece is quite different from the static images on earlier fabrics.

Mid-1960s, 23 x 11, $25-30. A deep orange muslin remnant. The animated puppy, with its large, expressive eyes and curved limbs, shows the influence of Osamu Tezuka. Subtle shades of gray and a gold hand-brushed outline create texture. Berets, baseball caps, bows, and wreaths of flowers all combine to create an enchanting design.

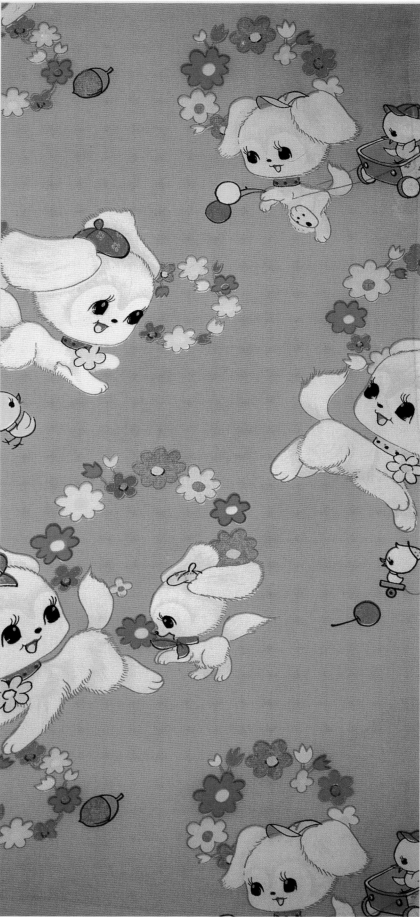

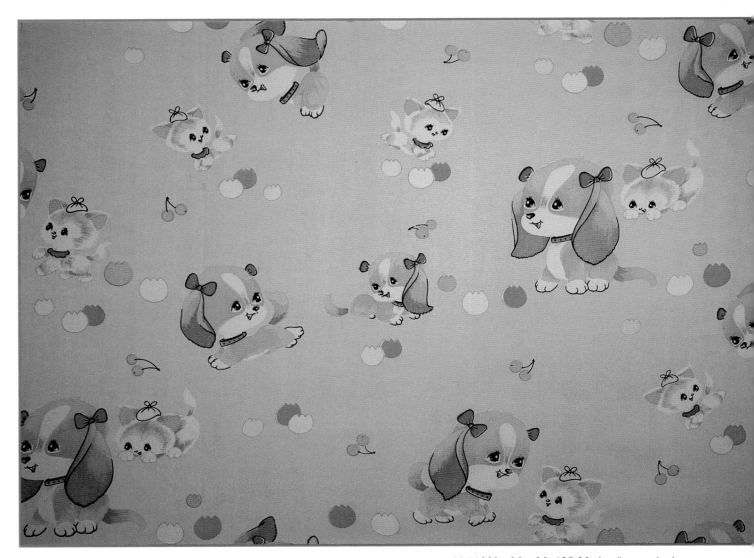

Mid-1960s, 28 x 29, $25-30. A yellow muslin futon remnant. A spaniel is shown playing, running, and sitting obediently. Neon pink cherries and tulips in white and blue are scattered across the fabric. This delicate print was probably intended for an infant.

Opposite page, Left: Mid-1960s, 45 x 9, $15-20. A pink muslin futon remnant. A fluorescent orange dog with an oversized head dominates the piece. His polka dot bow tie, striped hat, and tiny knob-like tail are comical elements. A female version of the same dog is partially cut off, but the exotic flower tucked into her ear and striped bow tie are visible.

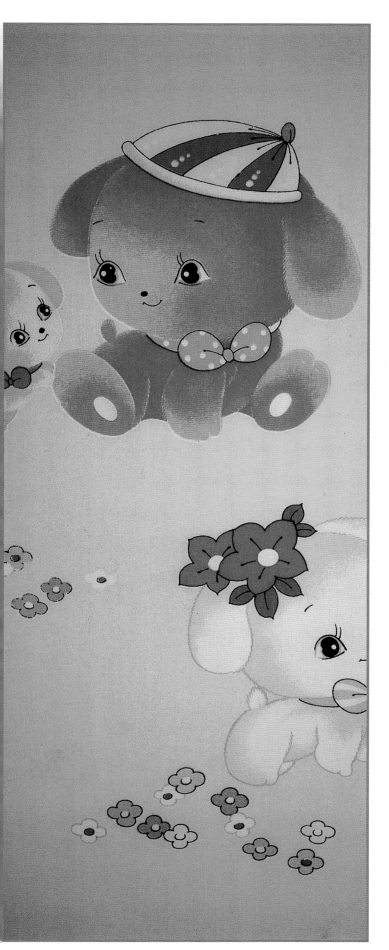

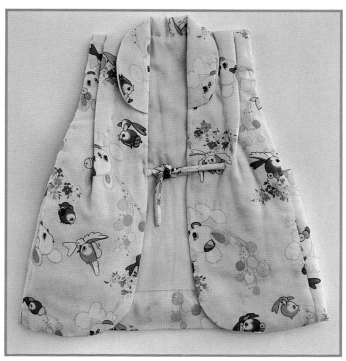

Mid-1960s, 2- to 3-year-old size, $20-30. A quilted cotton *chanchanko* (vest) with a pink muslin lining. A white puppy romps through a garden filled with pastel balloons and flowers.

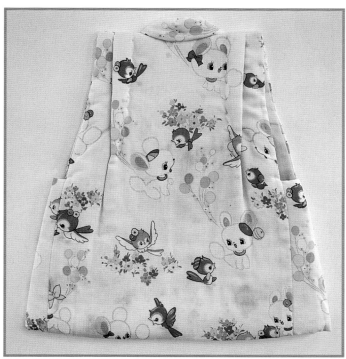

A detail of the previous print showing the reverse side of the vest with two pleats at the shoulder blades. The hand-painted silver threads around the dog and balloons add a little sparkle to the design.

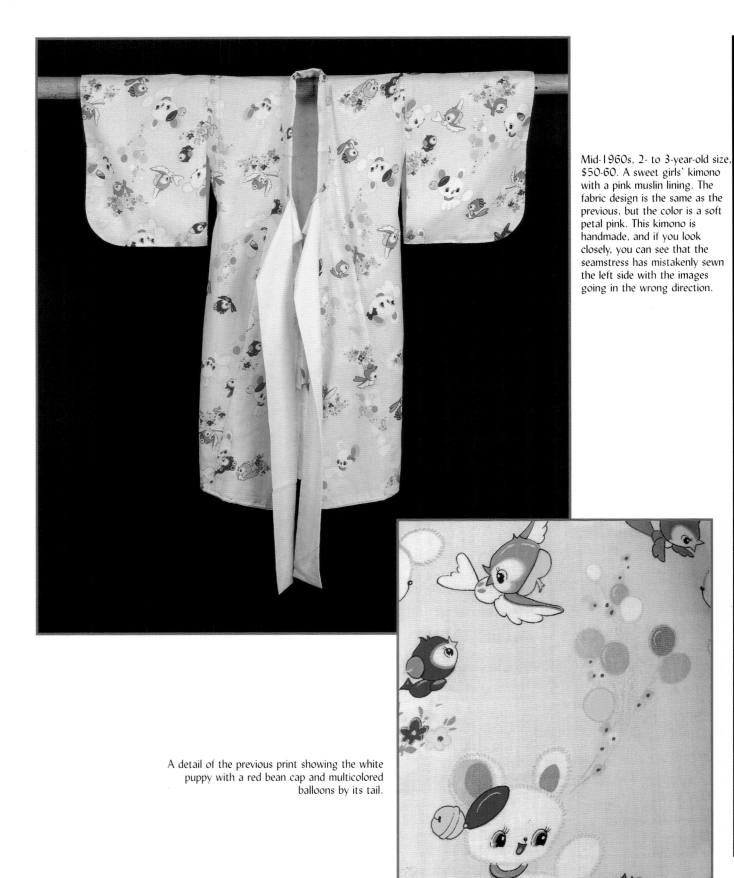

Mid-1960s, 2- to 3-year-old size, $50-60. A sweet girls' kimono with a pink muslin lining. The fabric design is the same as the previous, but the color is a soft petal pink. This kimono is handmade, and if you look closely, you can see that the seamstress has mistakenly sewn the left side with the images going in the wrong direction.

A detail of the previous print showing the white puppy with a red bean cap and multicolored balloons by its tail.

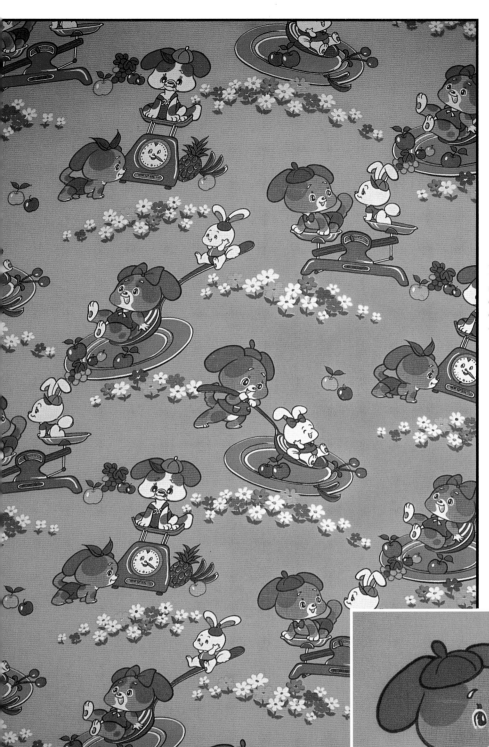

Mid-1960s, 36 x 36, $40-50. A mustard muslin futon remnant. A baking theme print with a mischievous bunny sliding down a spoon onto a dinner plate. From "Let's cook!" to "Let's eat!" in one easy bound! Cherries, strawberries, and flowers are scattered about the plates.

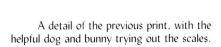

A detail of the previous print, with the helpful dog and bunny trying out the scales.

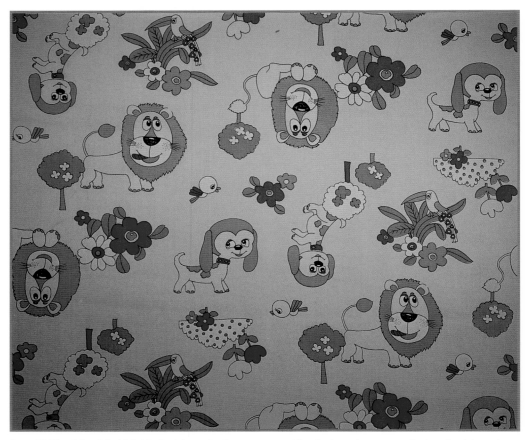

Late 1960s, 36 x 36, $30-40. A pink muslin futon remnant. The dog's oval eyes, eye shadow, lipstick, and body shape are indicative of a Rune Naito-influenced design.

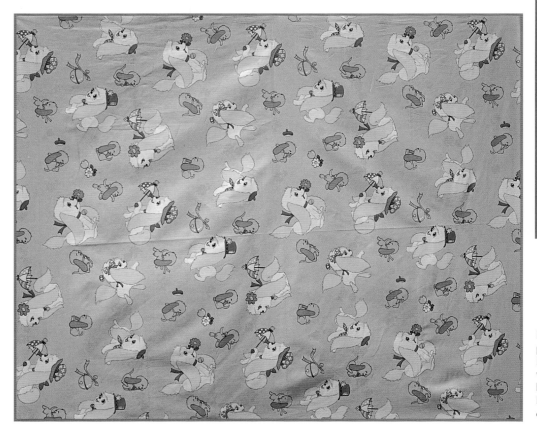

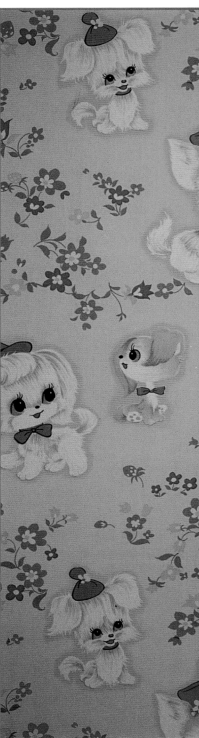

Late 1960s, 36 x 36, $40-50. A pink cotton futon remnant from Kurokawa Ltd. Two cheerful spaniels with berets, top hats, parasols, and heart collars prance across this print. Deep pink silhouettes of flowers add depth.

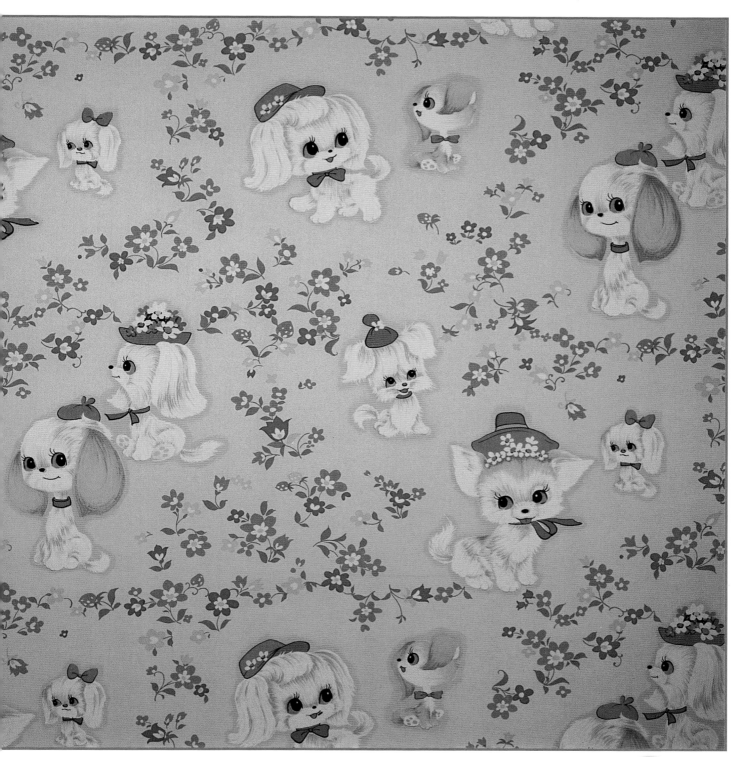

Late 1960s, 36 x 36, $40-50. A pink cotton futon remnant from Kurokawa Ltd. Trailing strawberry vines are intertwined around the images, which are outlined in fluorescent pink creating a halo effect. Great attention has been paid through shading to show movement in the dog's fur.

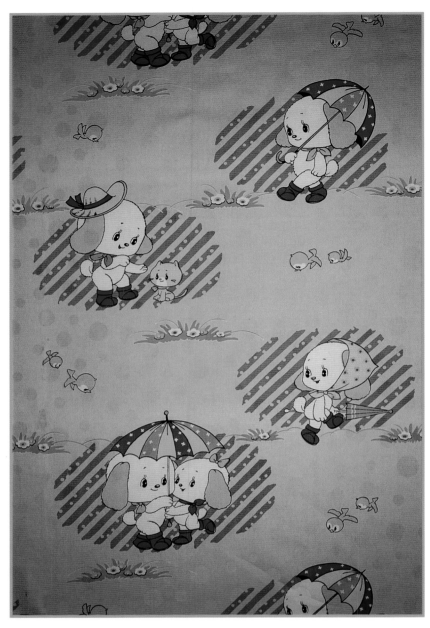

Early 1970s, 36 x 36, $30-40. A pink cotton futon remnant from Kurokawa Ltd. Literally, a "puppy love" theme print. The combination of embossed polka dots and diagonal stripes indicating sheets of rain gives this print texture and dimension.

A detail of the previous print with the two pups sharing a star-covered multicolored umbrella. When an umbrella is shared in Japan, it is called a love umbrella.

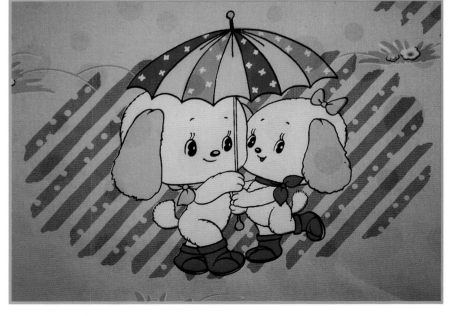

Late 1970s, 23.5 x 17.5, $15-20. A pink cotton futon remnant from Kurokawa Ltd. Two smiling poodles sit, patiently waiting for their small master or mistress to come to bed. A large fluffy cloud effectively highlights the pair.

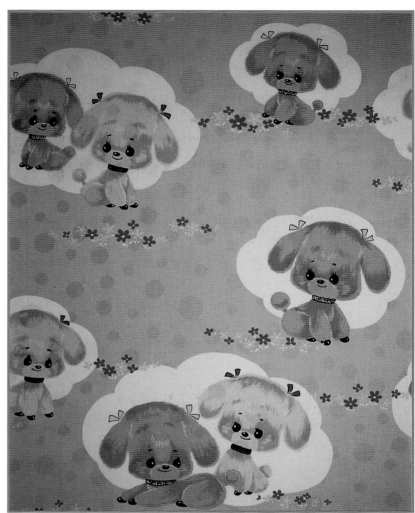

Early 1970s, 36 x 36, $30-40. An orange cotton futon remnant. A white puppy scampers from one pot of sunflowers to another. The large eyes, curved contours, continual motion of the limbs, and thick black outline show design influences from Osamu Tezuka.

C.1970s, 36 x 36, $40-50. A yellow cotton futon remnant from Kurokawa Ltd. A delightful fabric with a white poodle on a rich background of yellow and orange checks.

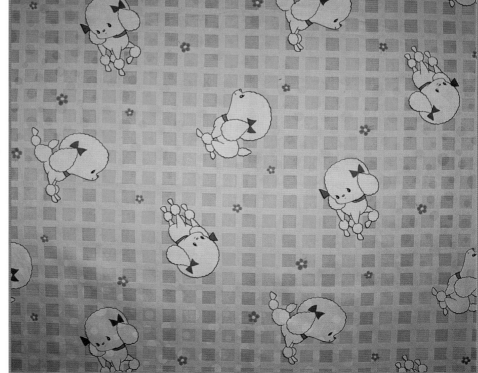

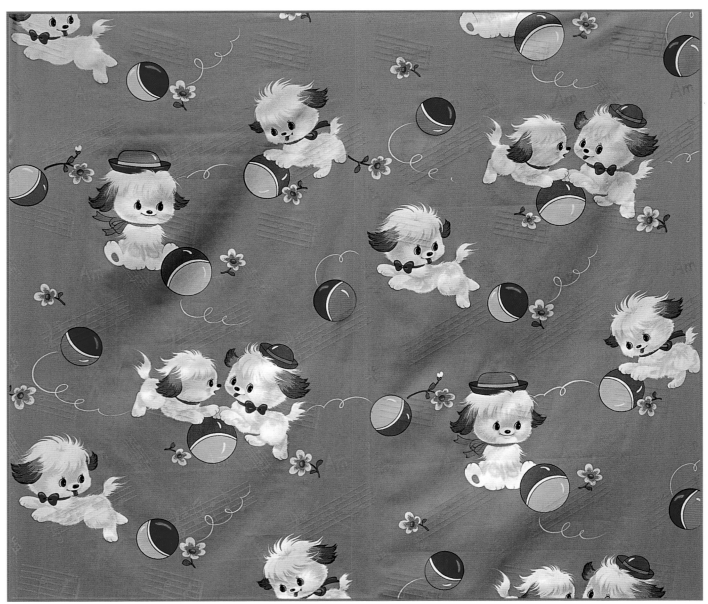

C.1970s, 36 x 36, $40-50. A blue futon remnant from Kurokawa Ltd. Notes on a scale are embossed on the sky-blue background. Two puppies play with multicolored balls. A white, curling line indicates the balls' movements.

A detail of the previous print, with two dogs playing with a colored ball. The soft white fur of the dogs contrasts nicely with the deep blue background.

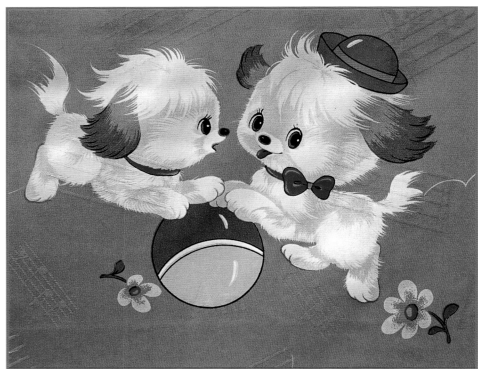

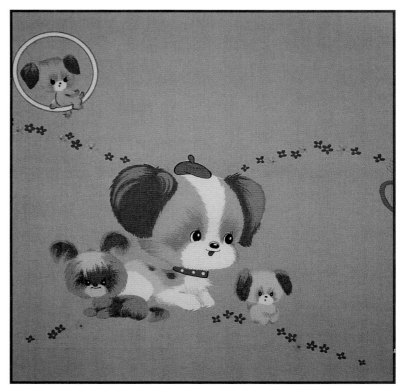

C.1970s, 9.5 x 10, $5-10. A blue cotton remnant from Kurokawa, Ltd. A pink daisy chain winds above and below the central trio. A little dog is left adrift in a large circle above the central motif.

C.1970s, 40 x 10, $5-10. A white cotton yukata remnant. The bull dog waits patiently for his master to return. The image is dominated by the dog's large head, complete with beret.

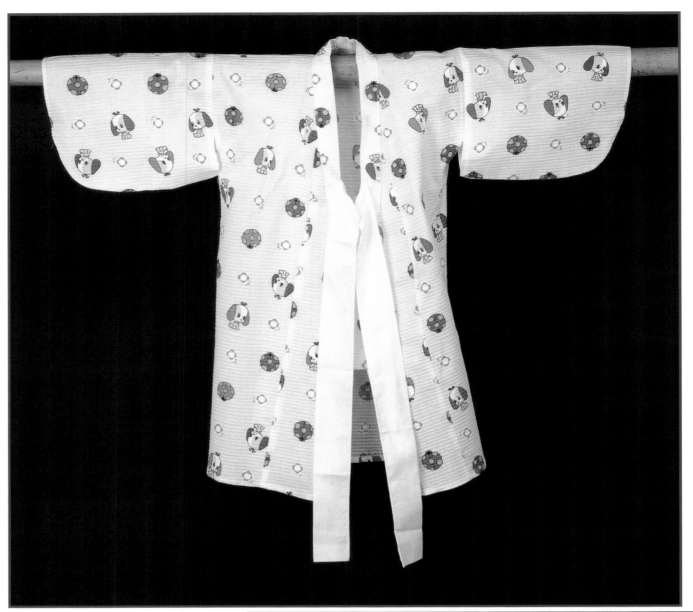

C.1970s, 3-to 4-year-old size, $40-50. A white seersucker girl's yukata. In mint condition, this cheerful yukata with it's original tags is a gem. Alternating images of pink and blue dogs are interspersed with ladybugs.

A detail of the previous print.

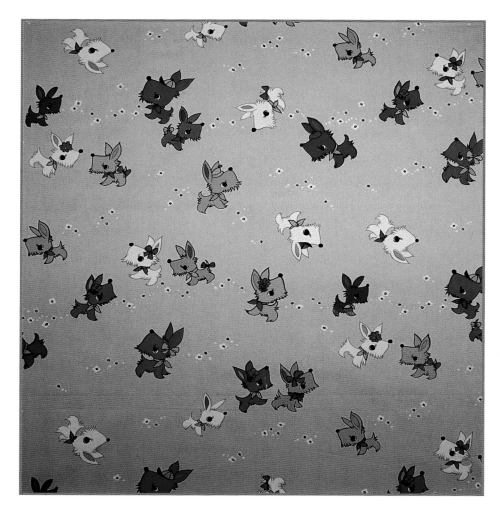

Late 1970s, 23 x 15, $5-10. A pink cotton garment remnant. Multicolored Scotty dogs and tiny flowers decorate this print.

C.1970s, 36 x 36, $30-40. A yellow cotton futon remnant. Large beige polka dots and pink balloons provide the backdrop for the Scotty dogs. Their enormous eyes and long lashes dominate the image. The tiny, avocado green Scotties add some essential 1970s color.

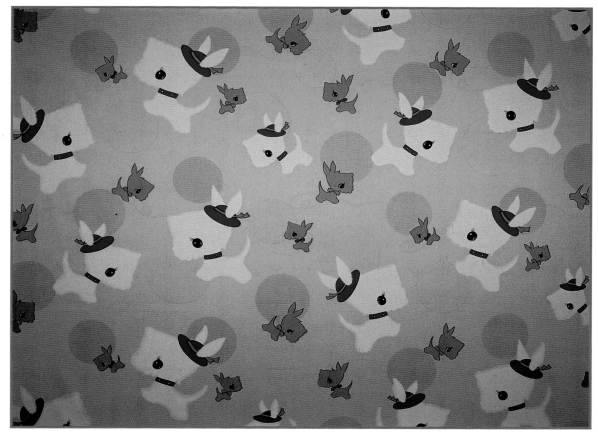

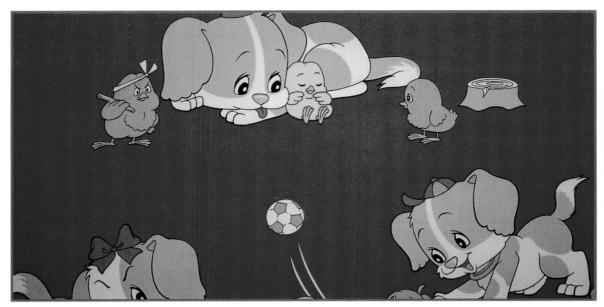

Late 1970s, 18 x 10, $5-10. A red cotton futon remnant from Kurokawa, Ltd. A dog takes a rest from playing soccer. This print was also made in pale blue.

Late 1970s, 18 x 18, $5-10. A blue cotton canvas cushion cover. The overly excited dog runs after a dragonfly as his unfortunate friend is hit in the head by a falling apple.

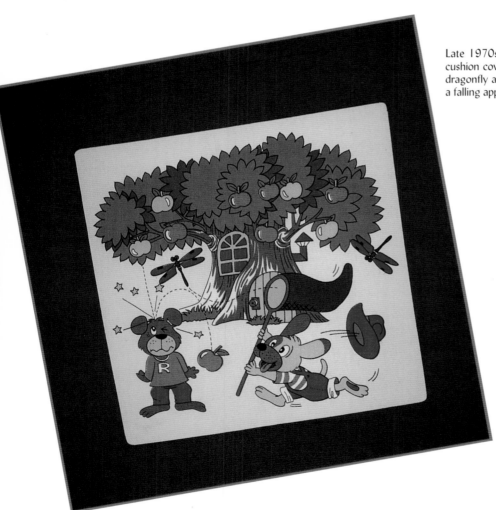

C.1970s, 39 x 39, $15-20. A poly cotton curtain panel with avocado green and mustard Scotties. The large scale of the dogs lends itself to a window covering.

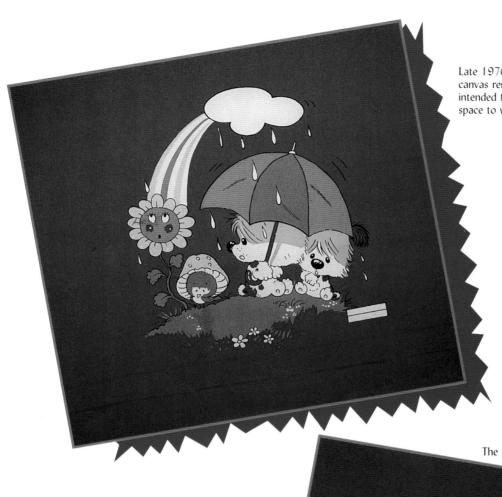

Late 1970s, 18 x 18, $5-10. A green cotton canvas remnant. This fabric was probably intended for a child's school bag, as there is a space to write a name below the image.

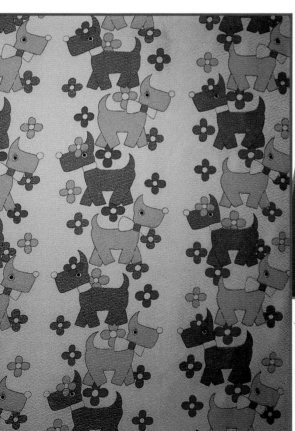

The same as the previous print, in blue.

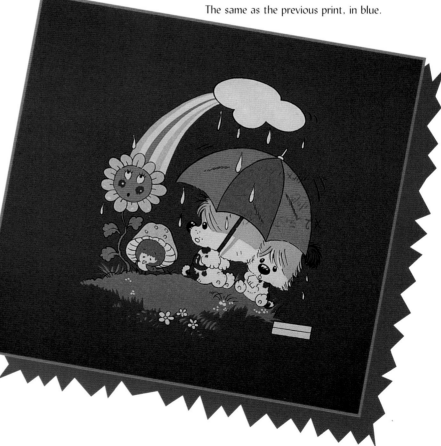

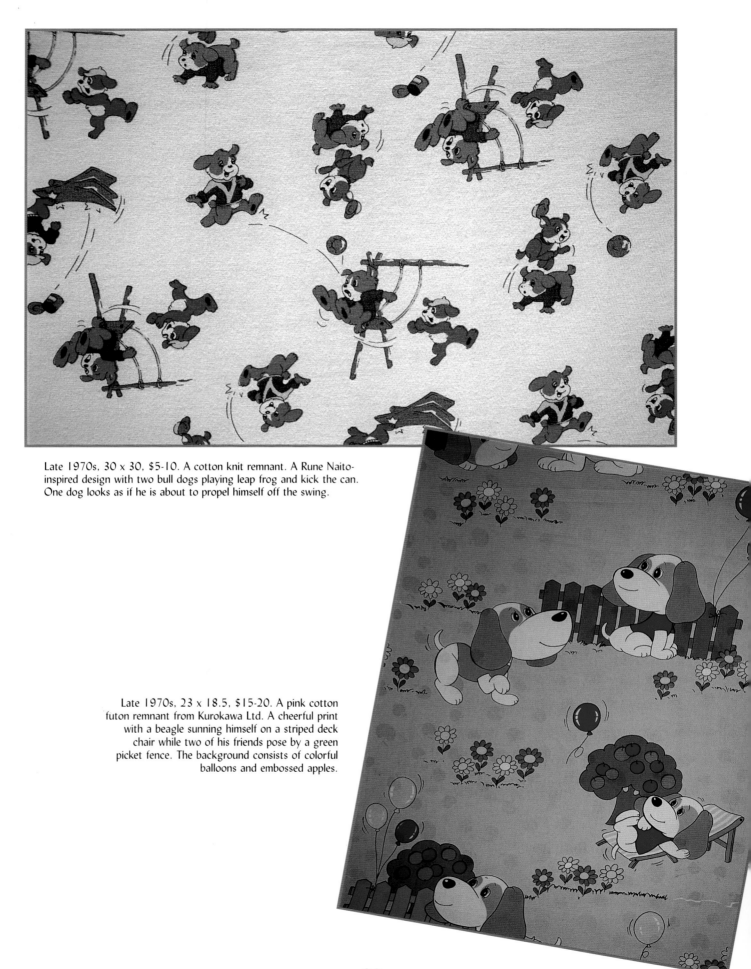

Late 1970s, 30 x 30, $5-10. A cotton knit remnant. A Rune Naito-inspired design with two bull dogs playing leap frog and kick the can. One dog looks as if he is about to propel himself off the swing.

Late 1970s, 23 x 18.5, $15-20. A pink cotton futon remnant from Kurokawa Ltd. A cheerful print with a beagle sunning himself on a striped deck chair while two of his friends pose by a green picket fence. The background consists of colorful balloons and embossed apples.

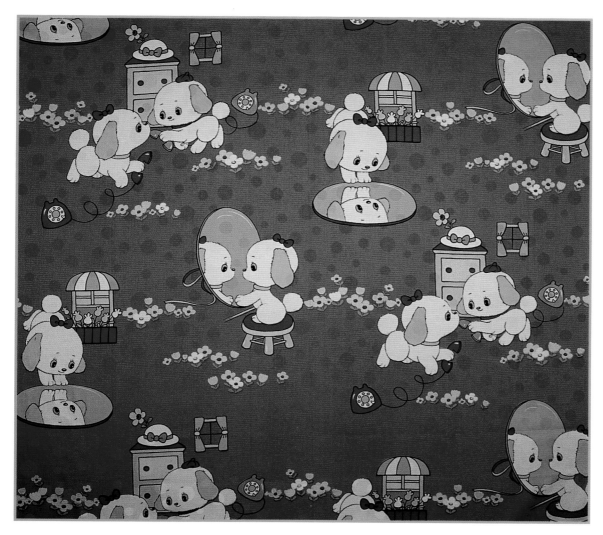

Late 1970s, 51 x 7.5, $25-30. A pink cotton futon remnant from Kurokawa Ltd. One white puppy primps in front of a large vanity mirror while two others chat on rotary dial phones.

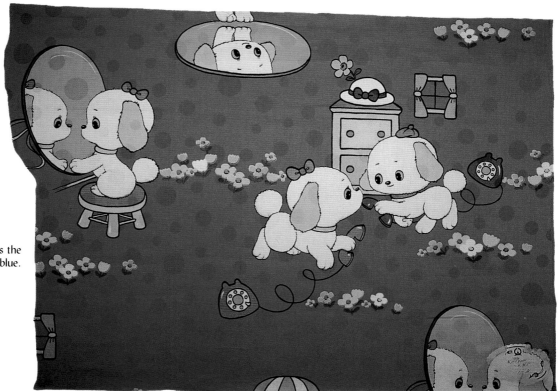

The same as the previous print, in blue.

99

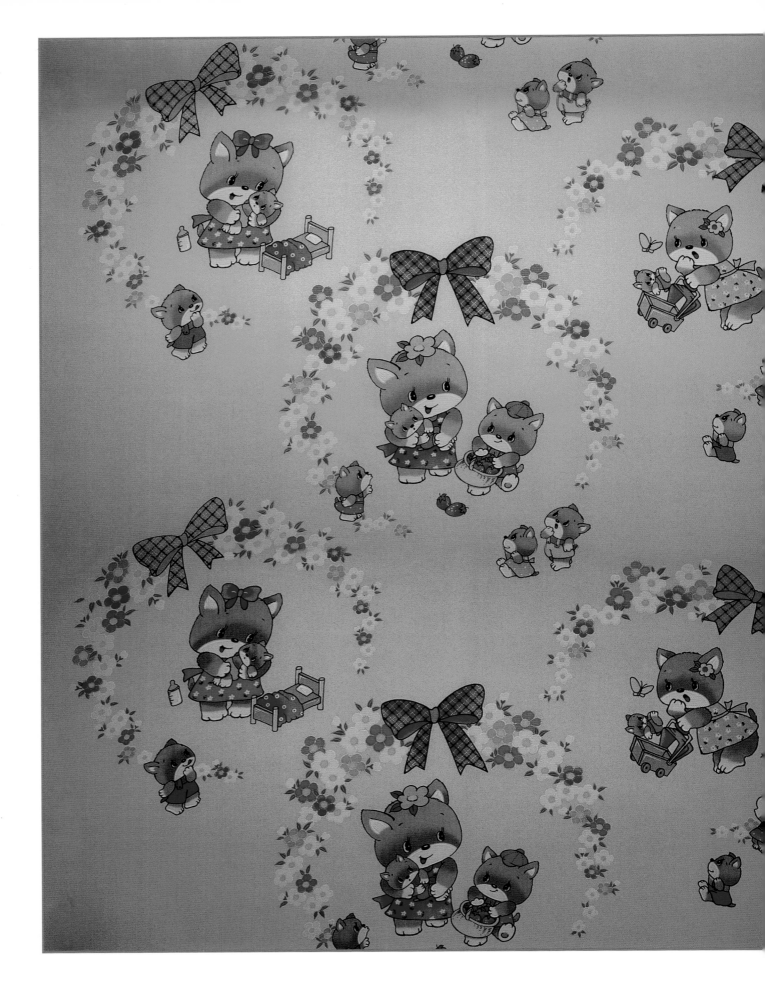

Smitten With Kittens

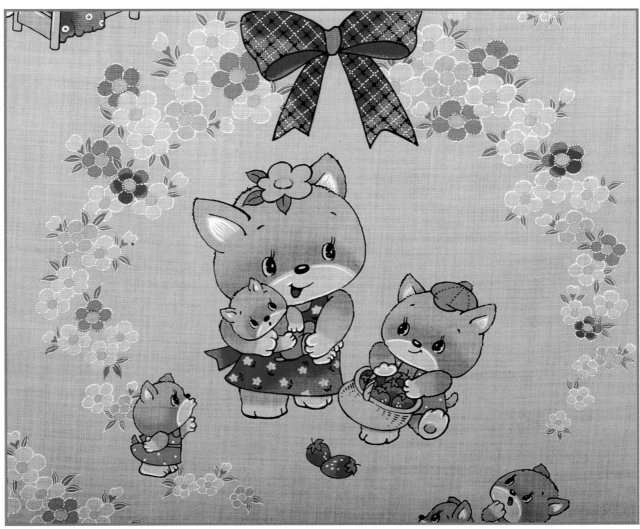

Mid-1960s, 36 x 36, $40-50. A pink muslin futon remnant. Wreaths of daisies and a tartan bow encircle the many adventures of baby. The images are confined to the center of the fabric, as it would have been used in conjunction with a protective white cover. Only a large oval opening would then have been visible, showing the central scene.

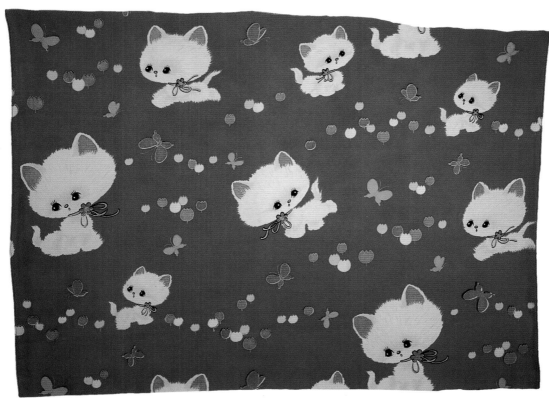

Mid-1960s, 20 x 14, $15-20. An emerald green muslin futon remnant. The fluffy white kittens are poised, ready to pounce on the butterflies.

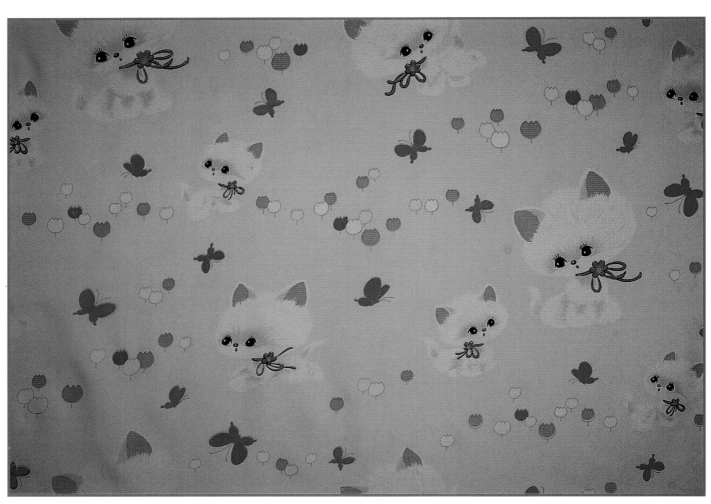

The same design as the previous print, in pale lemon yellow.

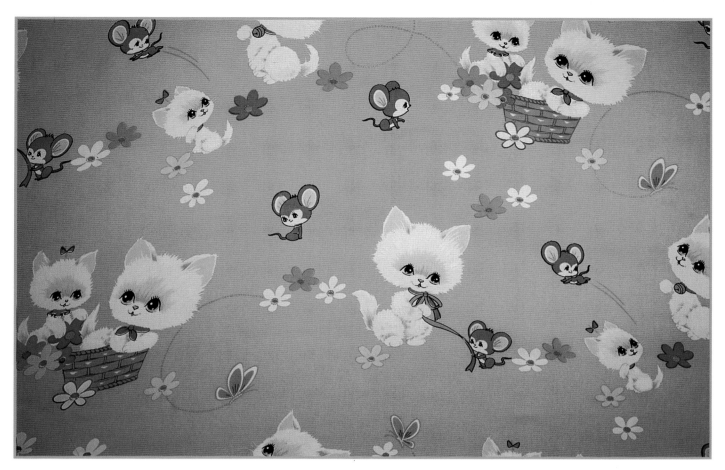

Mid-1960s, 20 x 14, $15-20. A peach muslin futon remnant. The fabric is part of the same series as the previous print. The kitten is lifelike, down to its tiny paws and luminous eyes.

A detail of the previous print. In this scene, a little blue mouse plays with a kitten's bow. In another scene, a kitten clambers out of a green wicker basket. This print was also made in pink.

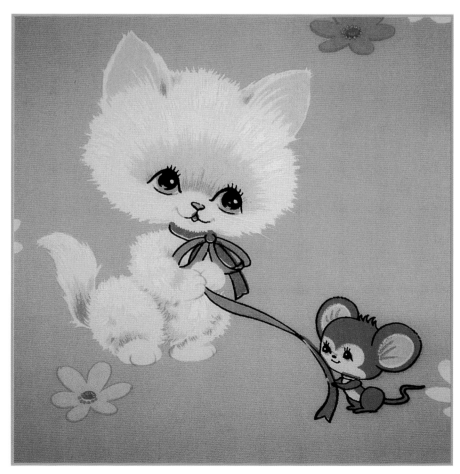

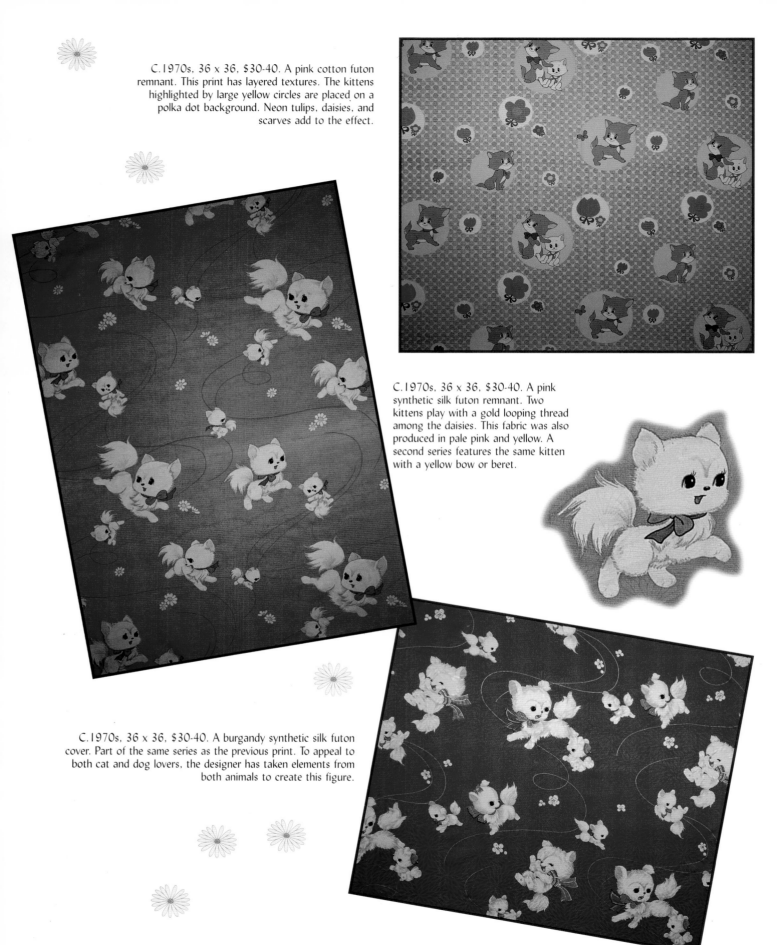

C.1970s, 36 x 36, $30-40. A pink cotton futon remnant. This print has layered textures. The kittens highlighted by large yellow circles are placed on a polka dot background. Neon tulips, daisies, and scarves add to the effect.

C.1970s, 36 x 36, $30-40. A pink synthetic silk futon remnant. Two kittens play with a gold looping thread among the daisies. This fabric was also produced in pale pink and yellow. A second series features the same kitten with a yellow bow or beret.

C.1970s, 36 x 36, $30-40. A burgandy synthetic silk futon cover. Part of the same series as the previous print. To appeal to both cat and dog lovers, the designer has taken elements from both animals to create this figure.

C.1970s, 36 x 36, $40-50. A pink cotton futon remnant from Kurokawa Ltd. A sweetheart theme print features two lovebirds sitting on a gold wire while a kitten and puppy gaze fondly at each other. Daisy chains, lemon hearts, and ribbons complete the design.

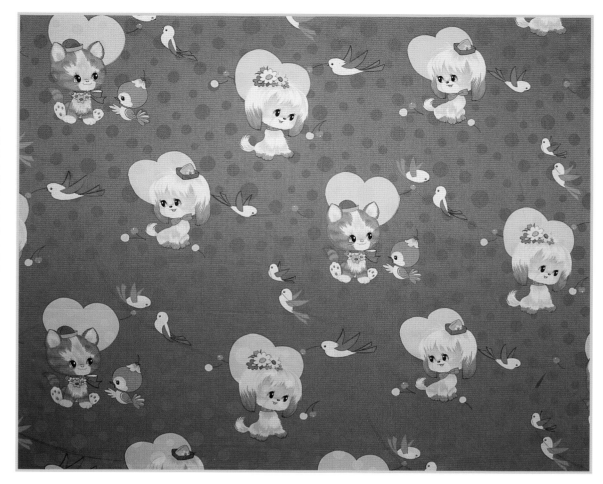

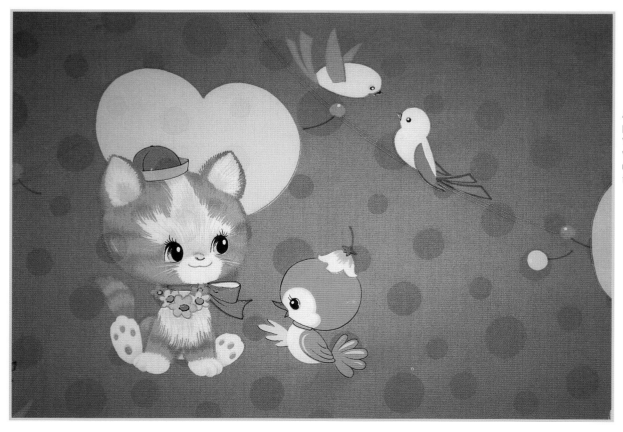

A detail of the previous print, with a pink bird wearing a darling upside-down flower hat.

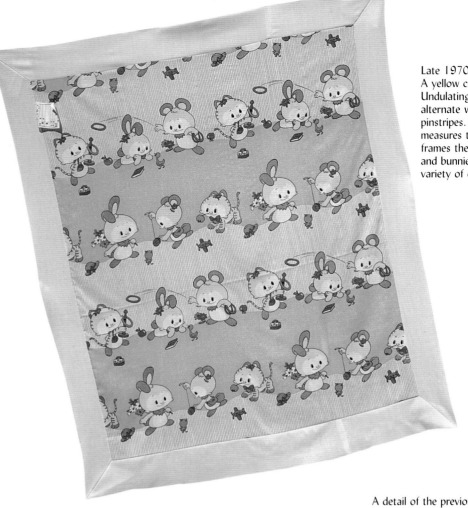

Late 1970s, 44 x 52, $40-50. A yellow cotton futon cover. Undulating bands of mustard alternate with sections of pinstripes. The solid yellow band measures three inches across and frames the central panel. Kittens and bunnies are engaged in a variety of childhood games.

A detail of the previous print with one of the kittens playing with a yo-yo. This fabric was also produced in orange.

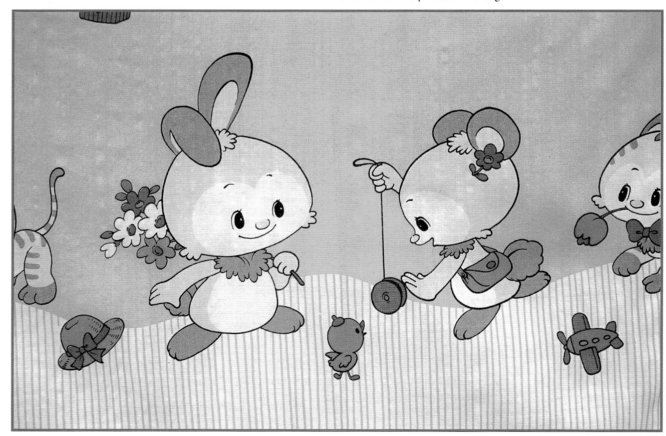

Late 1970s, 36 x 36, $30-40. A pink cotton futon remnant from Kurokawa, Ltd. The background has the company's trademark pink, embossed polka dots. White kittens grouped in twos and threes climb out of a wicker basket. Dimension is achieved through the use of a brushed outline stroke around the kittens, and shading on the basket.

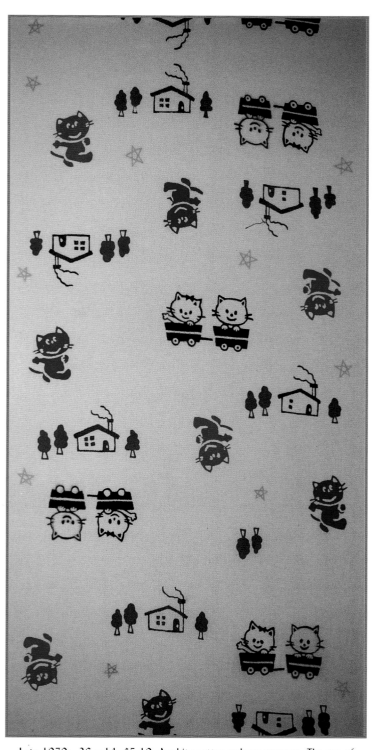

Late 1970s, 36 x 14, $5-10. A white cotton yukata remnant. The use of red, blue, and purple on the dancing cat and kittens in the wagon creates a fresh print.

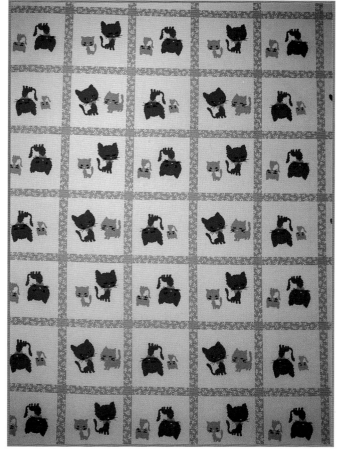

Late 1970s, 21 x 28, $5-10. A cream cotton futon remnant. Another quilt-inspired design with orange sashing. Two alternating images of cats with open and closed eyes adorn each square.

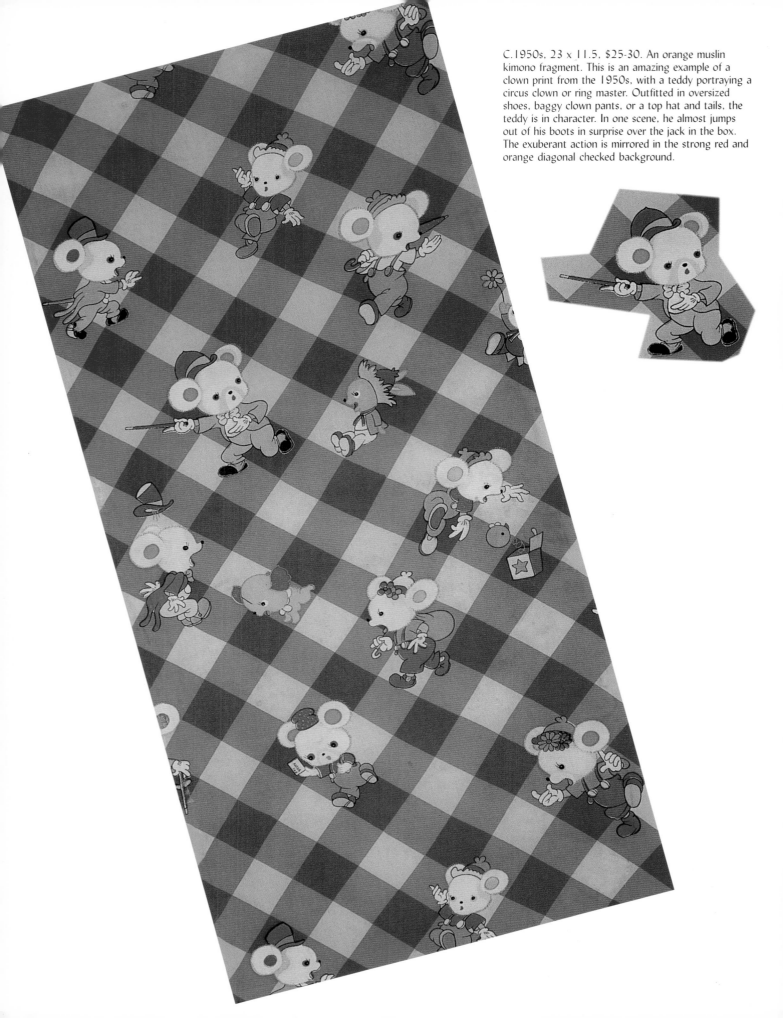

C.1950s, 23 x 11.5, $25-30. An orange muslin kimono fragment. This is an amazing example of a clown print from the 1950s, with a teddy portraying a circus clown or ring master. Outfitted in oversized shoes, baggy clown pants, or a top hat and tails, the teddy is in character. In one scene, he almost jumps out of his boots in surprise over the jack in the box. The exuberant action is mirrored in the strong red and orange diagonal checked background.

Chapter Ten

Bear Hugs

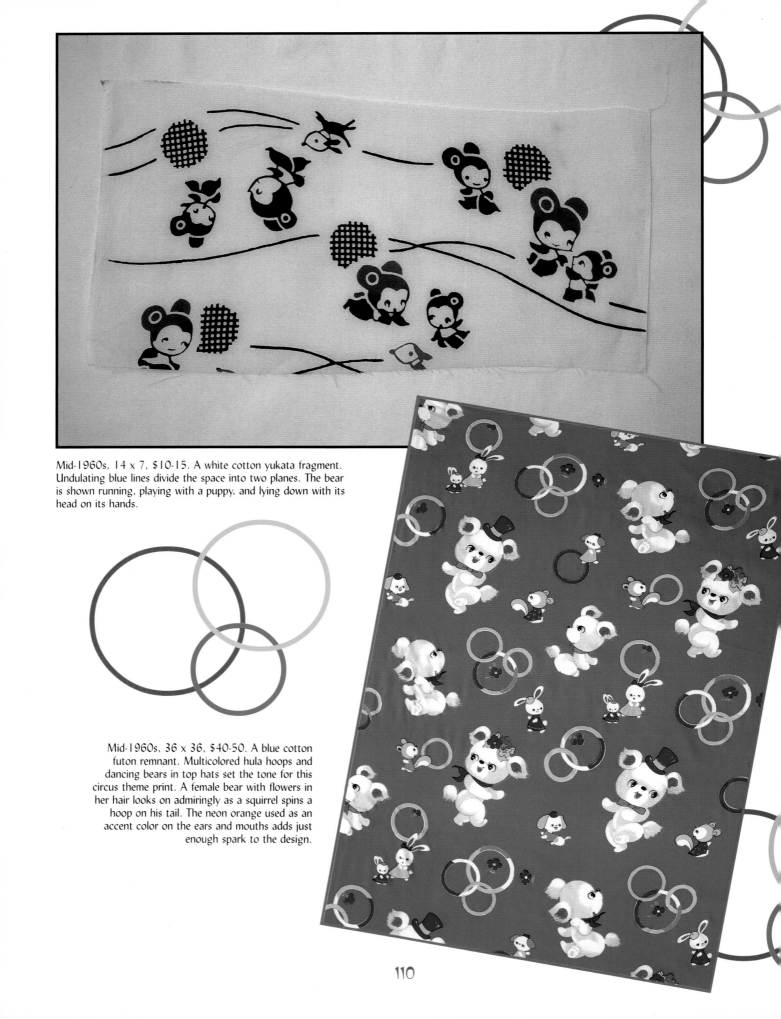

Mid-1960s, 14 x 7, $10-15. A white cotton yukata fragment. Undulating blue lines divide the space into two planes. The bear is shown running, playing with a puppy, and lying down with its head on its hands.

Mid-1960s, 36 x 36, $40-50. A blue cotton futon remnant. Multicolored hula hoops and dancing bears in top hats set the tone for this circus theme print. A female bear with flowers in her hair looks on admiringly as a squirrel spins a hoop on his tail. The neon orange used as an accent color on the ears and mouths adds just enough spark to the design.

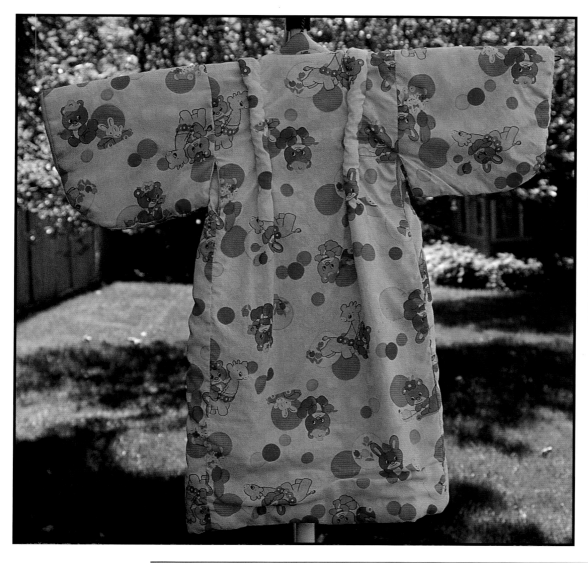

Mid-1960s, 1- to 2-year-old size, $15-20 (due to damage). A quilted baby bunting with large pastel and fluorescent polka dots. This bunting was sewn by hand and filled with cotton batting, and obviously saw a lot of wear. A garment such as this would have been used primarily during the cold winter months.

A detail of the previous print, showing an orange bear holding a large blue daisy. A pot of flowers highlighted by a large yellow circle is placed beside him.

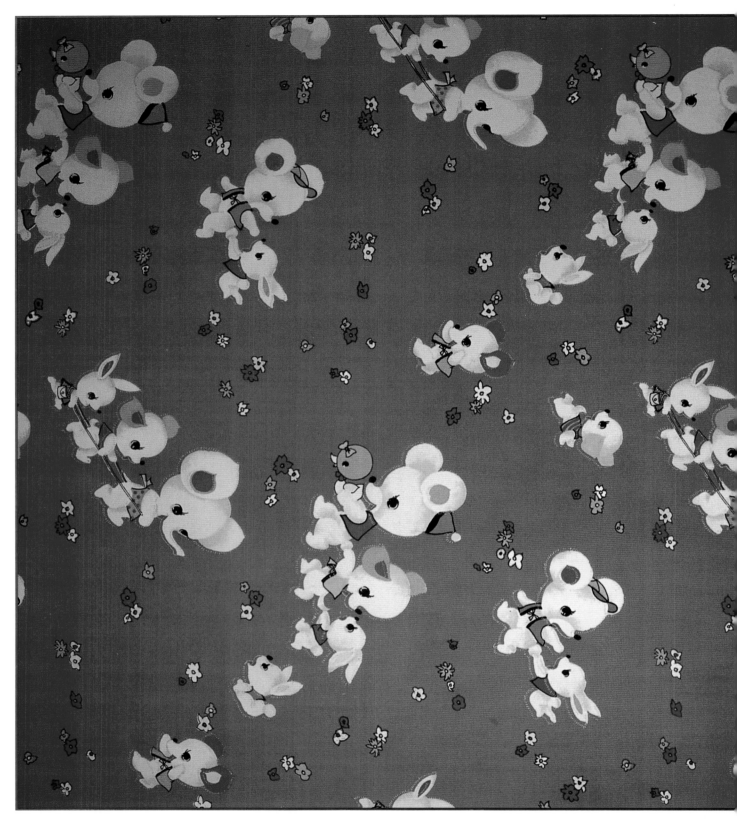

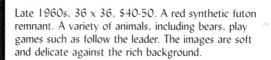

Late 1960s, 36 x 36, $40-50. A red synthetic futon remnant. A variety of animals, including bears, play games such as follow the leader. The images are soft and delicate against the rich background.

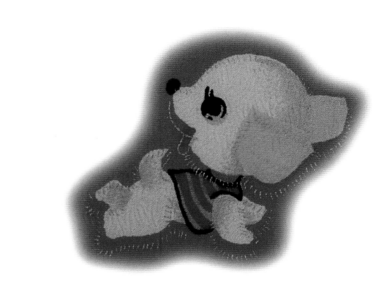

A detail of the previous print. A little group, led by an elephant, are holding onto a rope and pretending to be a train.

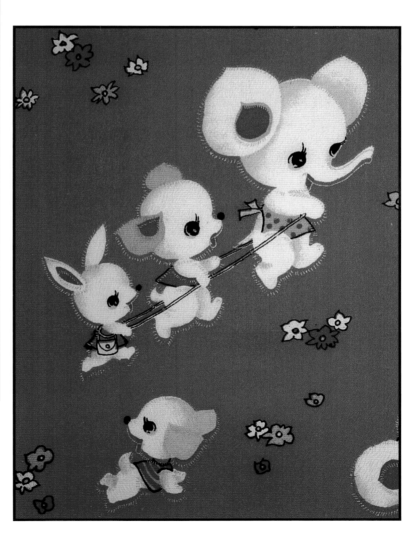

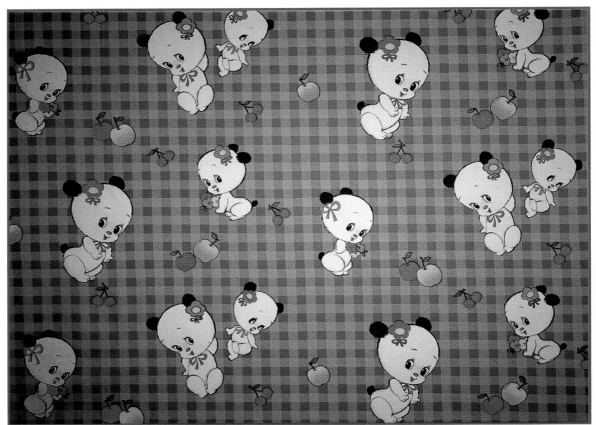

Early 1970s, 36 x 36, $30-40. A green cotton futon remnant. The bashful panda adorned with neon pink or blue flowers is full of charm. Alternating solid green and herring bone squares create a dense backdrop.

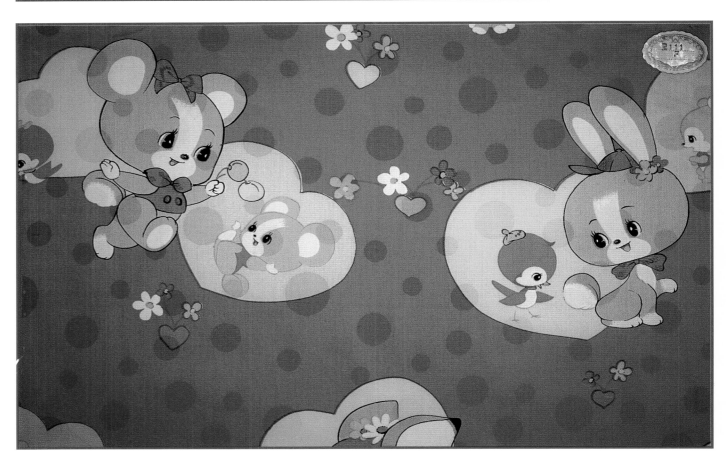

Early 1970s, 10.5 x 16, $10-15. A green futon remnant from Kurokawa Ltd. The teddy extends a gift of cherries to a friend. Embossed polka dots and silhouettes of hearts and cherry blossoms create a rich background.

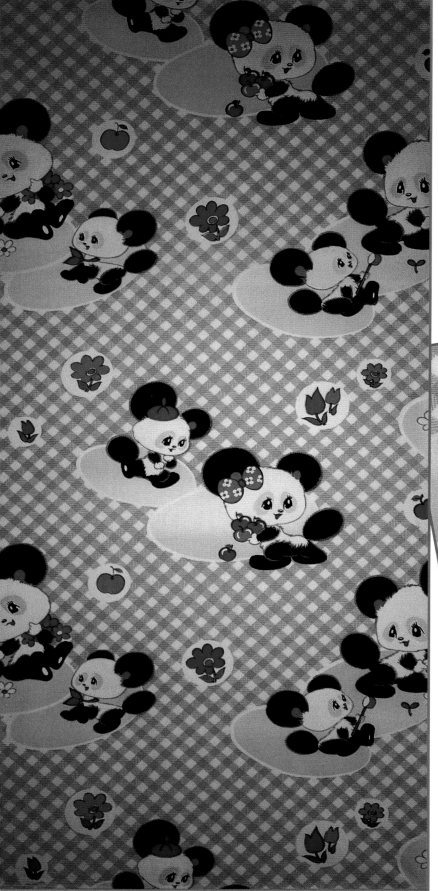

Mid-1970s, 36 x 36, $40-50. A pink polished cotton futon remnant. The two pandas are busy collecting apples and flowers instead of bamboo. With the arrival of the pandas LanLan and KanKan from China in 1972, panda goods became very popular in Japan. A pink and white diagonal checked background and large blue ovals provide a charming backdrop for the famous duo.

A detail of the previous print with the baby panda holding a bamboo water scoop.

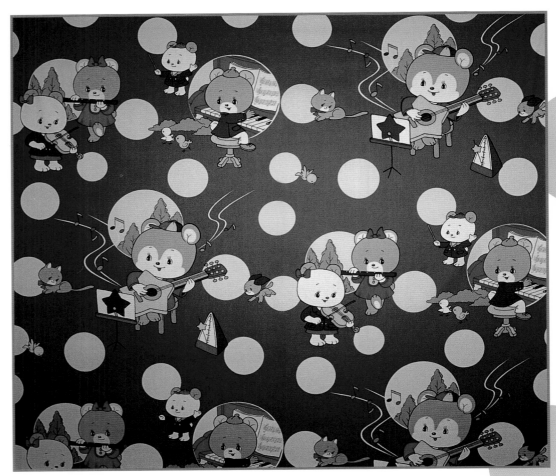

Late 1970s, 36 x 36, $30-40. A green cotton futon remnant by Kurokawa, Ltd. The large yellow polka dots and primary colors used for the musician's clothing create a vibrant print. A tiny bear conducts this outdoor concert. There are images of a violin, flute, piano, and guitar player.

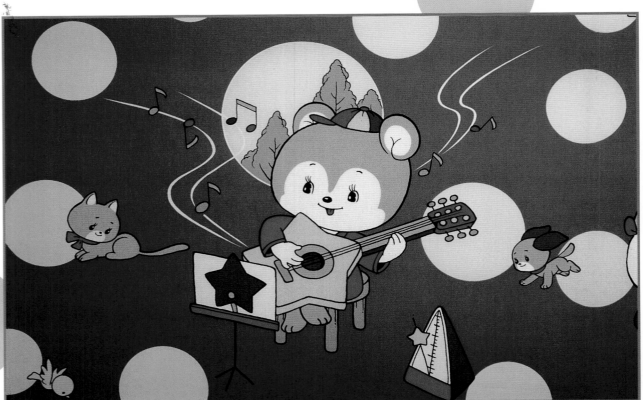

A detail of the previous print with a brown bear playing a star guitar. A metronome ticks while notes float away on a musical breeze. This fabric was also made in yellow.

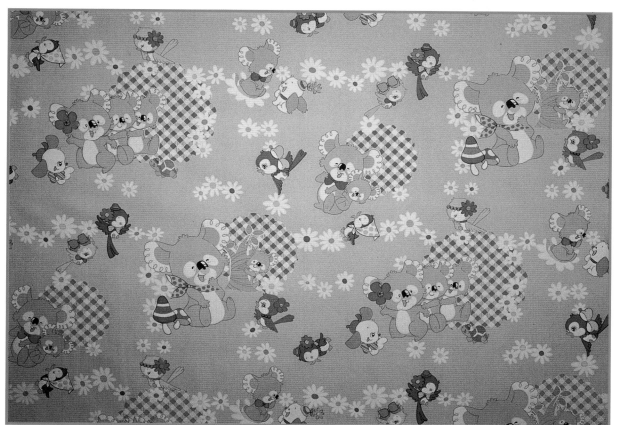

Late 1970s, 36 x 36, $30-40. A pink cotton futon remnant from Toyobo Ltd. A sweet fabric with koalas in a conga line, playing peek-a-boo or laughing. The red polka dot necktie and candy mushrooms are similar to designs by Rune Naito. Though koalas are marsupials and not bears, they are included in this section.

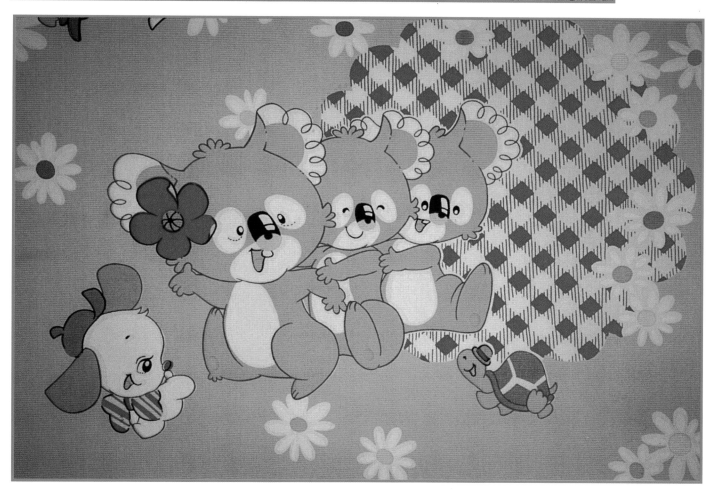

A detail of the previous print. The three koalas laugh and smile as they dance along.

Late 1970s, 10.5 x 10.5, $5-10. A yellow cotton futon remnant. A bear in red dungarees plays with a spinning top. The bear's large bubble-head is reminiscent of earlier designs, but the strong primary colors and thick black outline identifies this fabric as a much later piece.

C.1970s, 18 x 10, $5-10. A blue cotton futon fragment. A dream-like print in soft pastels, with tiny white birds on the background. Each vignette is set within the silhouette of a teddy's head. In the left corner, a baby teddy plays giddy-up on her Papa while holding onto a pink balloon. The center shows an unfortunate bear who has taken a spill on his roller skates. The upper right corner shows two friends skipping along and holding hands.

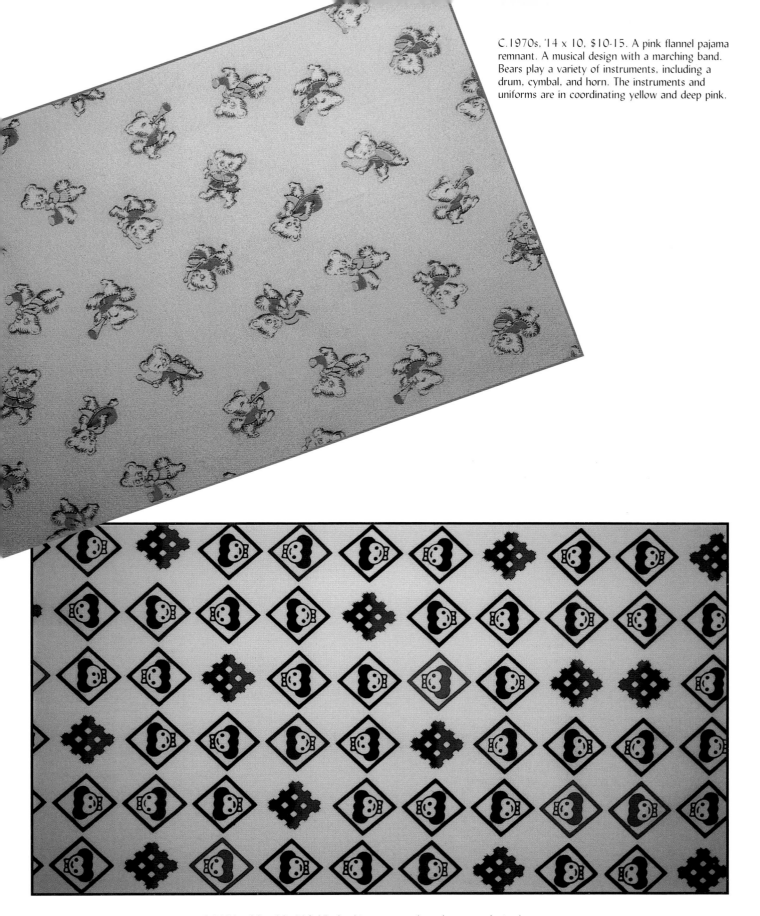

C.1970s, '14 x 10, $10-15. A pink flannel pajama remnant. A musical design with a marching band. Bears play a variety of instruments, including a drum, cymbal, and horn. The instruments and uniforms are in coordinating yellow and deep pink.

C.1970s, 36 x 18, $10-15. A white cotton yukata fragment. A simple diamond design with the silhouette of a bear's head decorates this fragment.

119

C.1970s, 36 x 14, $15-20. A blue cotton futon remnant. The central scene shows thoughtful bears posed with fingers to their mouths and their heads cocked slightly to the side. On the lower left side, a girl gives a bunny a ride on a toy train.

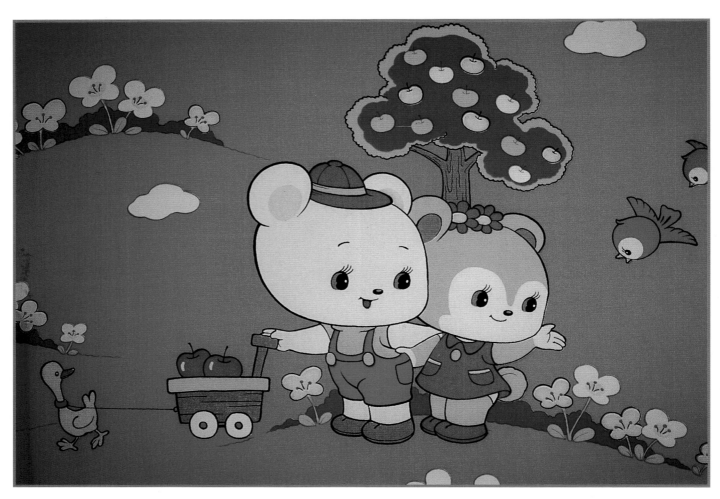

A detail of the previous print. Two cheerful bears walk home after apple picking. A helpful duck pulls the wagon laden with apples.

C.1970s, 36 x 36, $30-40. A pink synthetic futon remnant. A little bear navigates his way through a jungle. Another bear, complete with pith helmet, rides upon a white elephant and a donkey. He then proceeds to sleep off his adventures under a flowering tree.

Late 1970s, 36 x 36, $20-30. A yellow cotton futon remnant. The teddies are engaged in a variety of children's activities, including pushing a pram, looking at a picture book, and playing with a train set. Pastel polka dots or squares behind the bears contain notes, trumps, or toys. On the bottle are the letters "MIL" with the "K" obscured by the teddy's paw. The use of English words and roman letters was a popular design element during the late 1970s and still continues today.

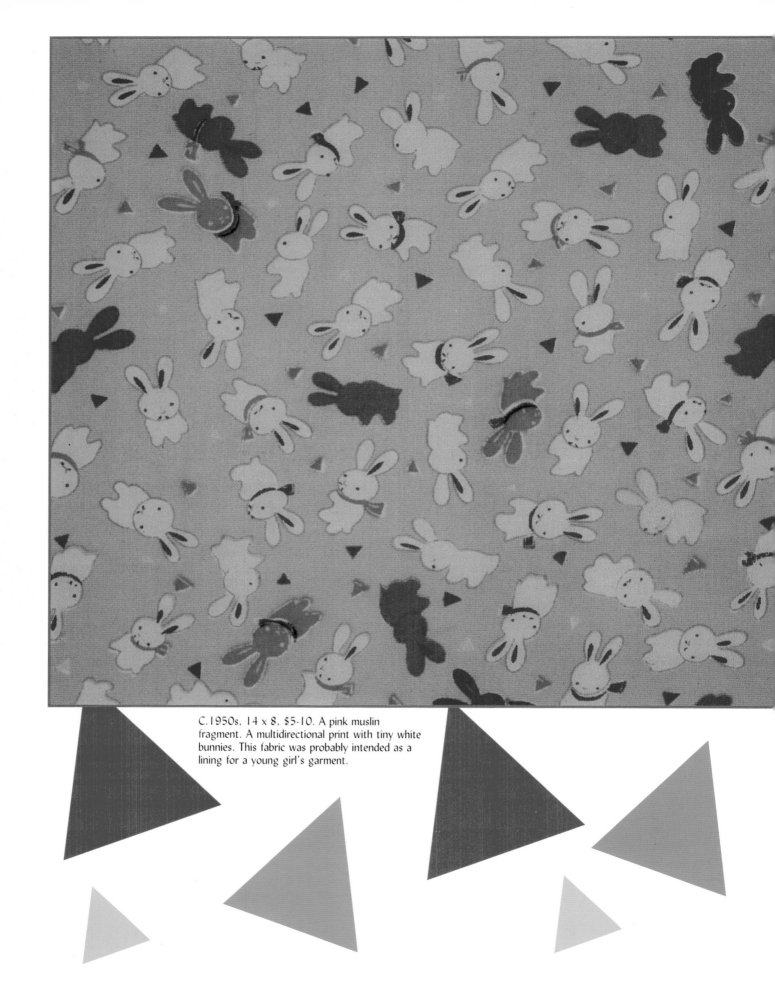

C.1950s, 14 x 8, $5-10. A pink muslin fragment. A multidirectional print with tiny white bunnies. This fabric was probably intended as a lining for a young girl's garment.

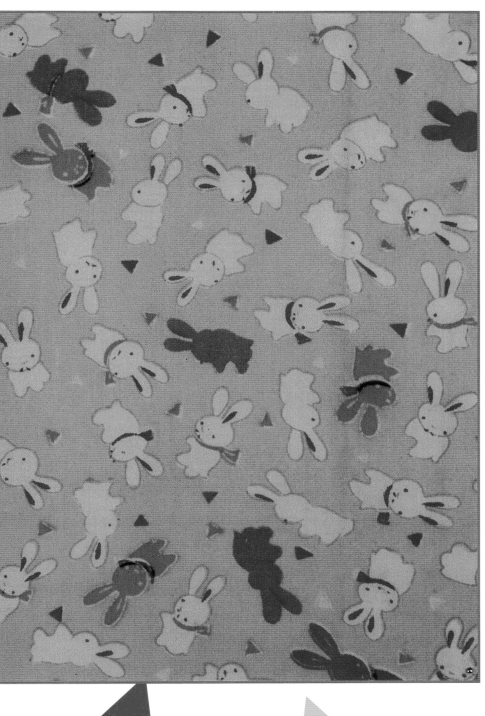

Honey Bunny

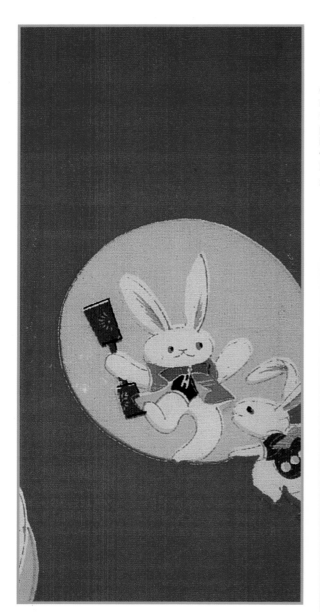

C.1950s, 37 x 7, $5-10. A red muslin fragment. The images are based on a Japanese folktale, which tells of two rabbits pounding rice cakes on the moon. The pink polka dot represents the moon, and one of the bunnies is holding a wooden pestle needed to pound rice. Moon-viewing is held on the night of the full moon in September. People set a table with rice cakes, fruits, and vegetables to give thanks for the harvest of the year.

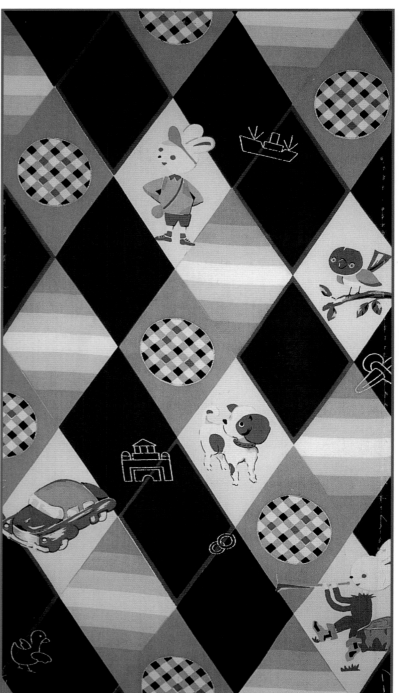

C.1950s, 17.5 x 11, $10-15. A synthetic silk fragment. A travel theme with a bunny dressed for a day trip with his visor and water canteen. The places he plans to visit are outlined in silver. The boat represents a port, the duck a park, the bird hiking and the jester a carnival.

C.1950s, 7.5 x 6, $10-15. A synthetic silk fragment. A bunny dressed as a child waves the Japanese flag.

C.1950s, 16.5 x 14, $10-15. A synthetic silk fragment. This print reflects the interest in travel and foreign destinations during the post-war years. The elephant is used to represent the exotic theme.

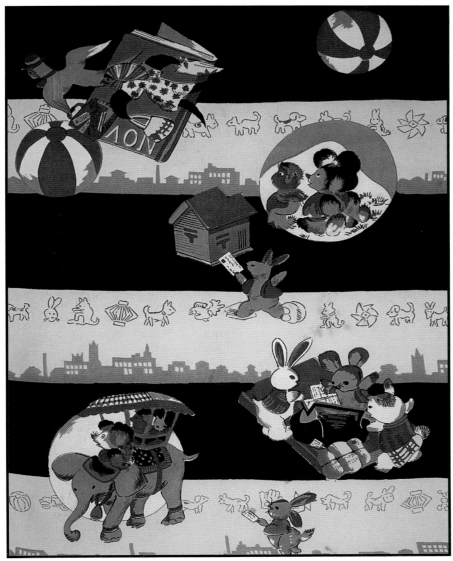

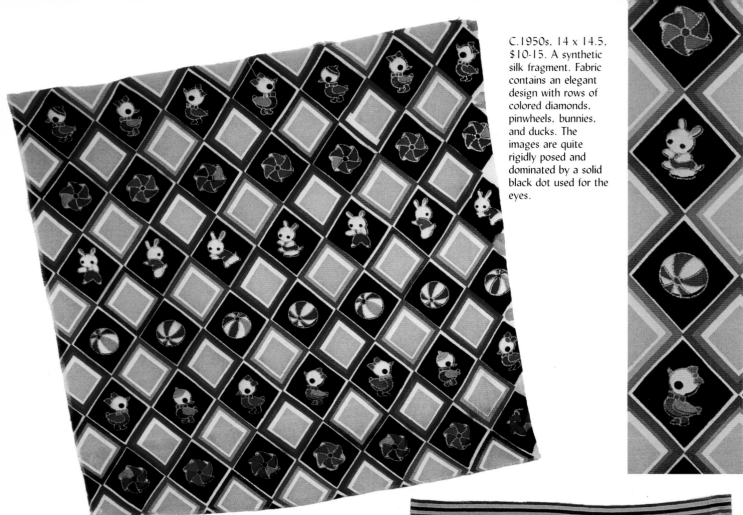

C.1950s, 14 x 14.5, $10-15. A synthetic silk fragment. Fabric contains an elegant design with rows of colored diamonds, pinwheels, bunnies, and ducks. The images are quite rigidly posed and dominated by a solid black dot used for the eyes.

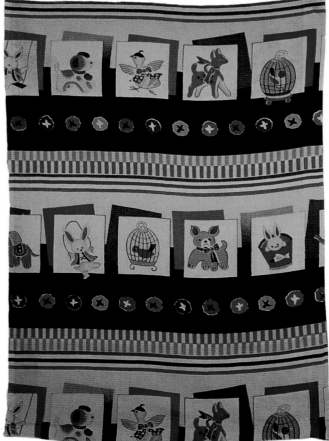

C.1950s, 18.5 x 13, $15-20. A synthetic silk futon remnant. This print depicts a child's summer journal. Elementary school children in Japan are encouraged to keep a journal, complete with pictures, during their summer holiday. Here, the bunny represents the child. The story reads from left to right: He skipped, fed his pet bird, played with his dog, etc.

126

C.1950s, 3 x 11, $2-5. A red muslin futon fragment. Only three images remain on this piece, including a duck, bunny, and candle holder, all within yellow or pink polka dots.

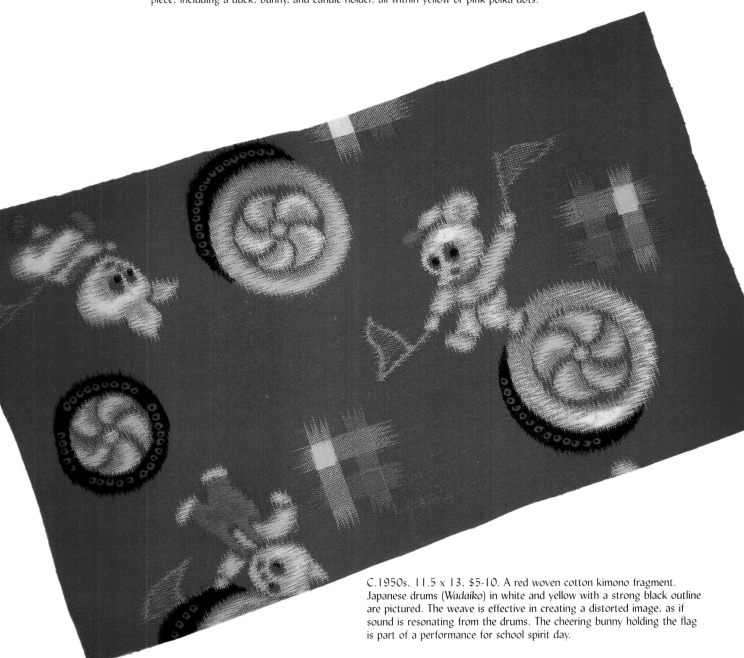

C.1950s, 11.5 x 13, $5-10. A red woven cotton kimono fragment. Japanese drums (*Wadaiko*) in white and yellow with a strong black outline are pictured. The weave is effective in creating a distorted image, as if sound is resonating from the drums. The cheering bunny holding the flag is part of a performance for school spirit day.

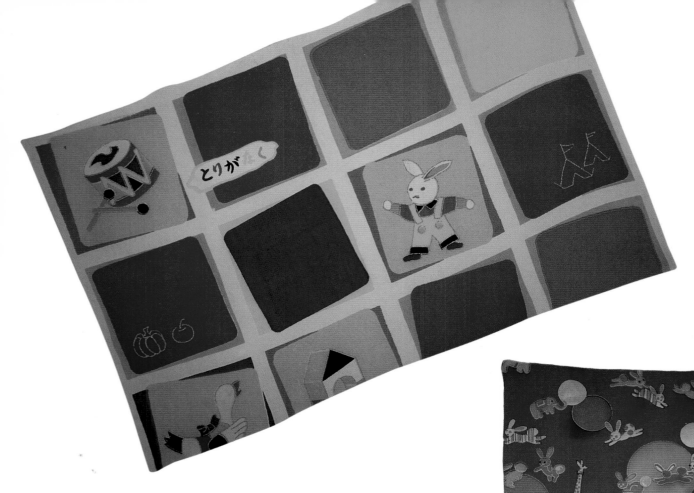

C.1950s, 13 x 8.5, $10-15. A synthetic silk kimono remnant. A fabric with a spring theme indicated by the words "*tori ga naku*" or, "a bird sings," written in *Hiragana* letters. In *Haiku* poetry, this phrase indicates spring time. Off-centered squares in orange, brilliant blue, and yellow contain images of a drum and a bunny dressed as a small child.

C.1950s, 20 x 8.5, $10-15. A red silk kimono fragment. Images of rabbits leaping across the moon adorn this print. Other nursery animals add to the design. The candy stripe and polka dot bodies are a wonderful touch.

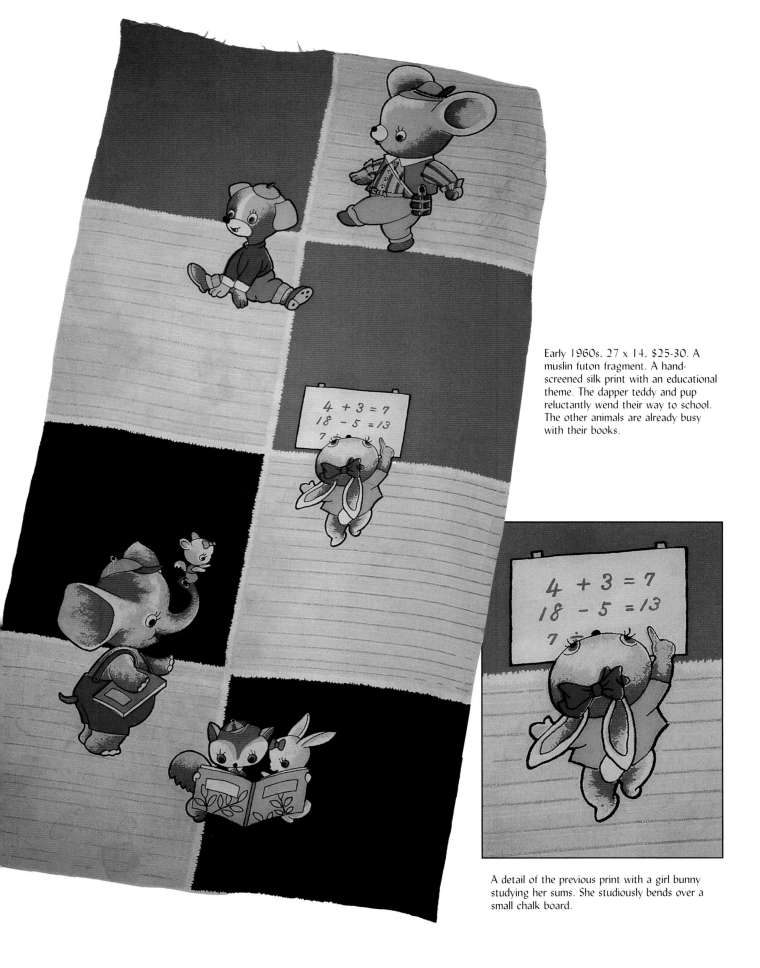

Early 1960s, 27 x 14, $25-30. A muslin futon fragment. A hand-screened silk print with an educational theme. The dapper teddy and pup reluctantly wend their way to school. The other animals are already busy with their books.

A detail of the previous print with a girl bunny studying her sums. She studiously bends over a small chalk board.

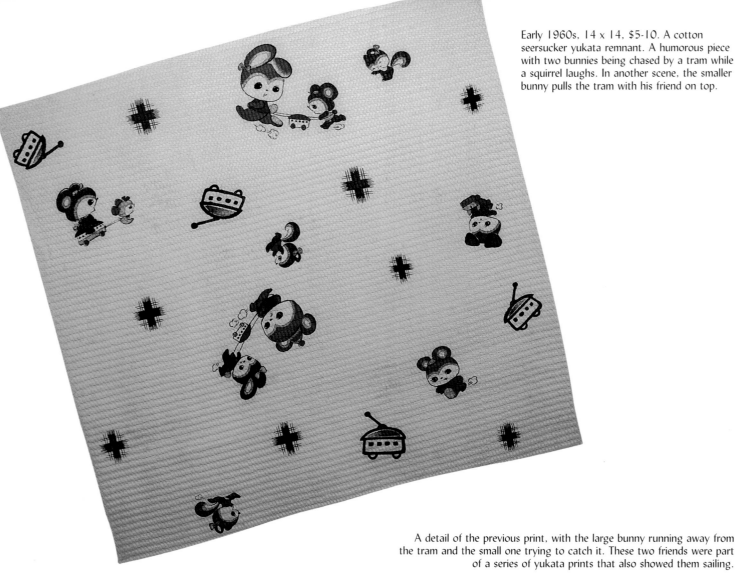

Early 1960s, 14 x 14, $5-10. A cotton seersucker yukata remnant. A humorous piece with two bunnies being chased by a tram while a squirrel laughs. In another scene, the smaller bunny pulls the tram with his friend on top.

A detail of the previous print, with the large bunny running away from the tram and the small one trying to catch it. These two friends were part of a series of yukata prints that also showed them sailing.

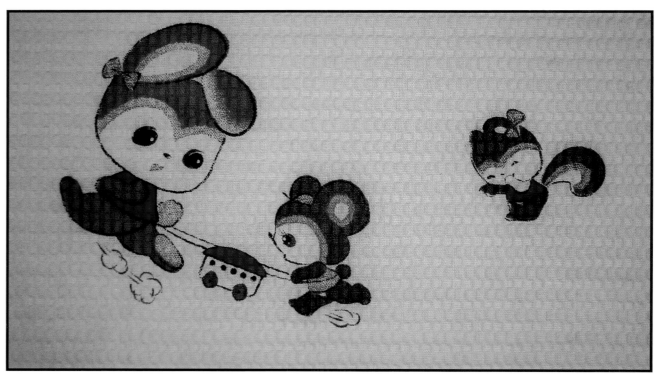

130

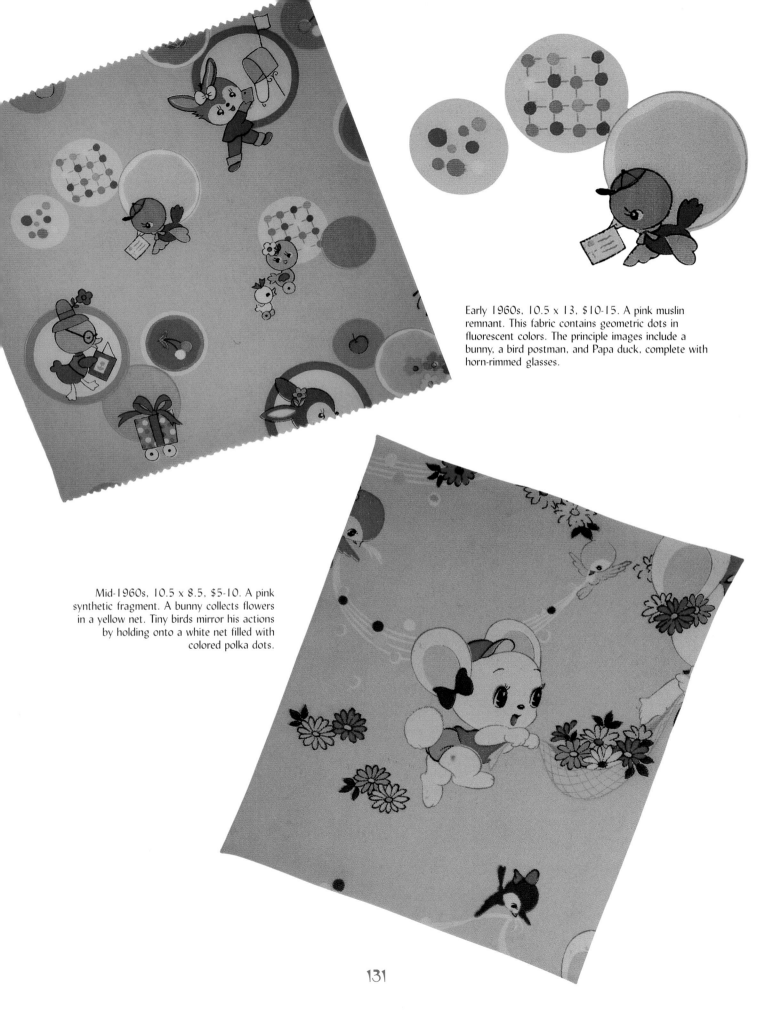

Early 1960s, 10.5 x 13, $10-15. A pink muslin remnant. This fabric contains geometric dots in fluorescent colors. The principle images include a bunny, a bird postman, and Papa duck, complete with horn-rimmed glasses.

Mid-1960s, 10.5 x 8.5, $5-10. A pink synthetic fragment. A bunny collects flowers in a yellow net. Tiny birds mirror his actions by holding onto a white net filled with colored polka dots.

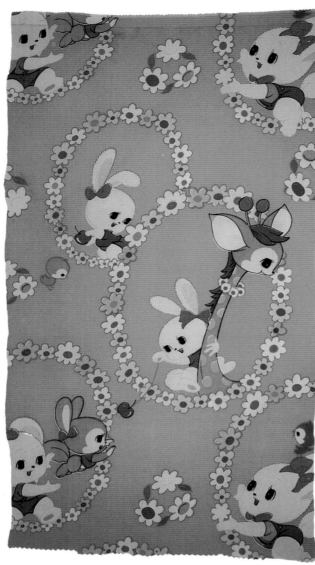

Mid-1960s, 23 x 12, $20-25. An orange muslin futon remnant. Perched high on a giraffe, a bunny dangles an apple for a leaping blue squirrel. Ornamental floral garlands twist around the images. This fabric was also produced in pale and deep pink.

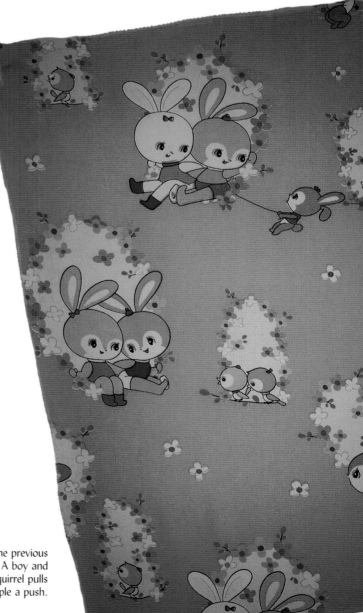

Mid-1960s, 23 x 12, $20-25. The same series as the previous print. A romantic fabric depicting two bunnies in love. A boy and a girl sit together on a delightful floral swing. A little squirrel pulls on the rope to give the happy couple a push.

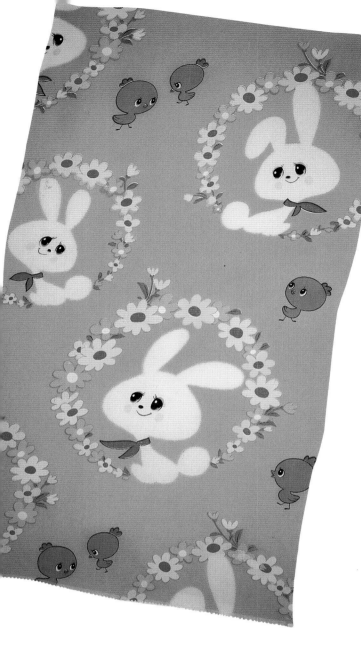

Mid-1960s, 23 x 12, $20-25. Same series as the previous print. An angelic white bunny gazes upwards. He is framed in a garland of daisies.

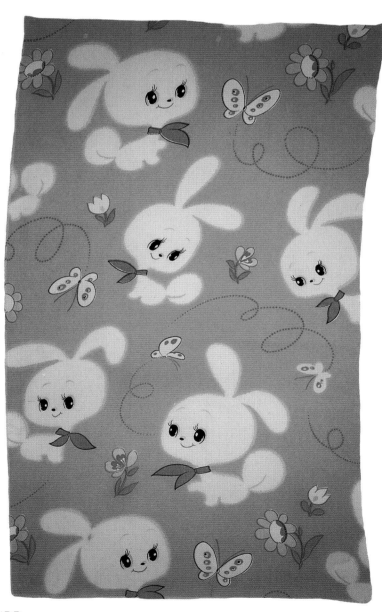

Mid-1960s, 23 x 12, $20-25. Same series as the previous print. The bunny watches a butterfly moving through the flowers. Gold dots trace the butterfly's movements.

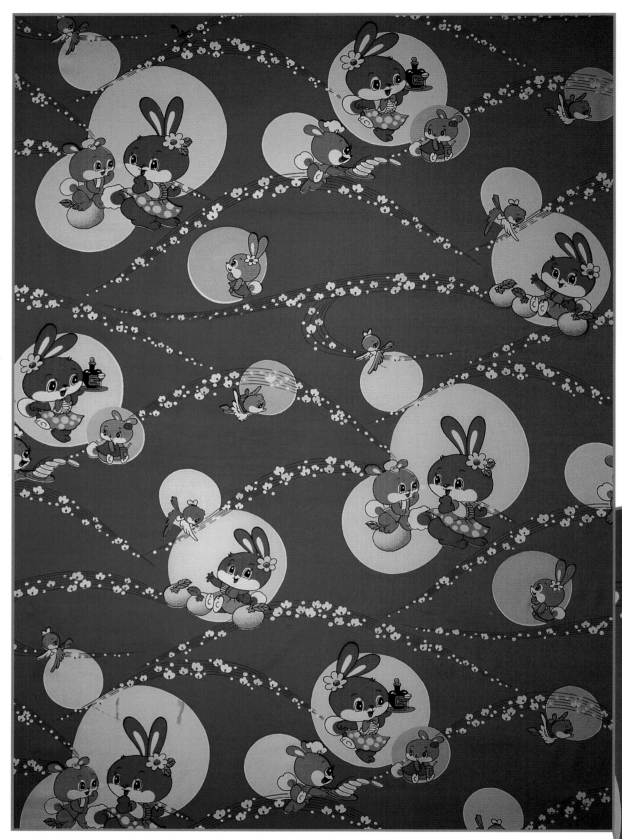

Mid-1960s, 36 x 28, $25-30. A blue muslin futon remnant. A summer fabric with two bunnies enjoying oranges, the fruit of the season. A waitress offers prune juice to a little bunny in a red dress.

A detail of the previous print with an energetic chef bounding into the picture with so much enthusiasm that he spills his pancakes.

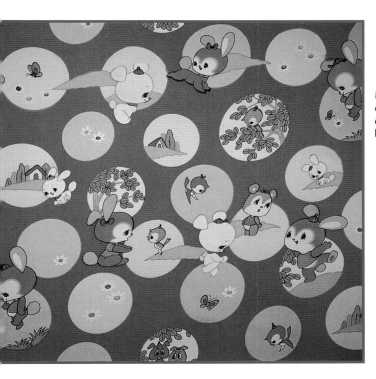

Mid-1960s, 20 x 13, $25-30. An orange muslin futon remnant. Idyllic days of summer are pictured in bright colors.

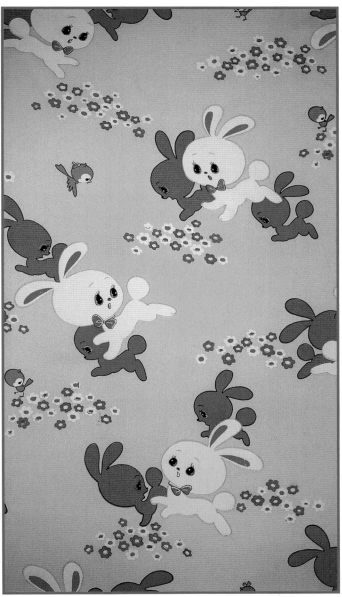

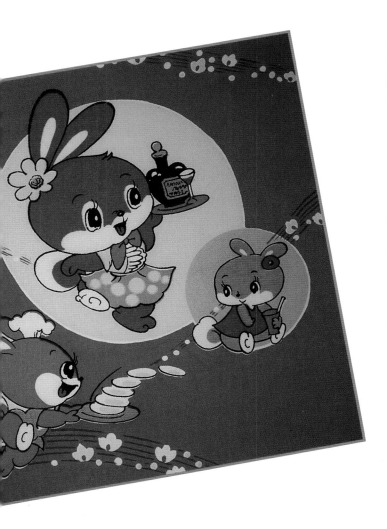

Mid-1960s, 32 x 28, $15-20. A yellow muslin futon remnant. Three bunnies scamper across a meadow of bright flowers.

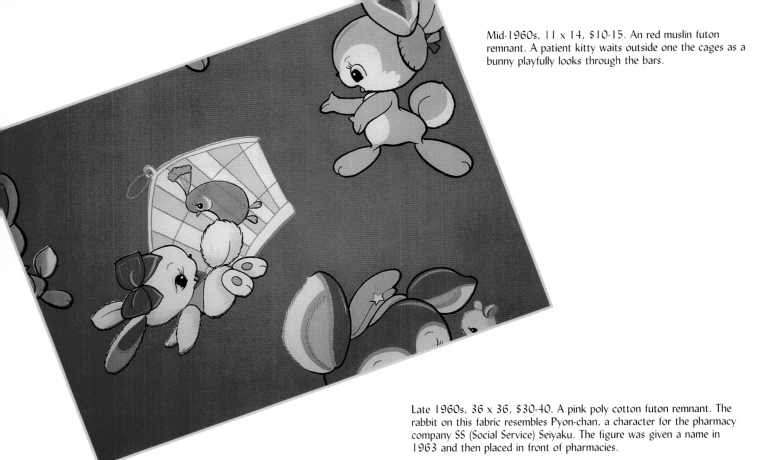

Mid-1960s, 11 x 14, $10-15. An red muslin futon remnant. A patient kitty waits outside one the cages as a bunny playfully looks through the bars.

Late 1960s, 36 x 36, $30-40. A pink poly cotton futon remnant. The rabbit on this fabric resembles Pyon-chan, a character for the pharmacy company SS (Social Service) Seiyaku. The figure was given a name in 1963 and then placed in front of pharmacies.

Early 1960s, 36 x 15, $15-20. A gray muslin kimono fragment. A birthday print shows the special bunny with his birthday hat on. The striped pram, colorful balloons, and happy friends echo the theme.

Mid-1960s, 38 x 7, $10-15. A purple synthetic silk kimono fragment. A white rabbit with an expressive face and just a rough impression for his body decorates this fabric.

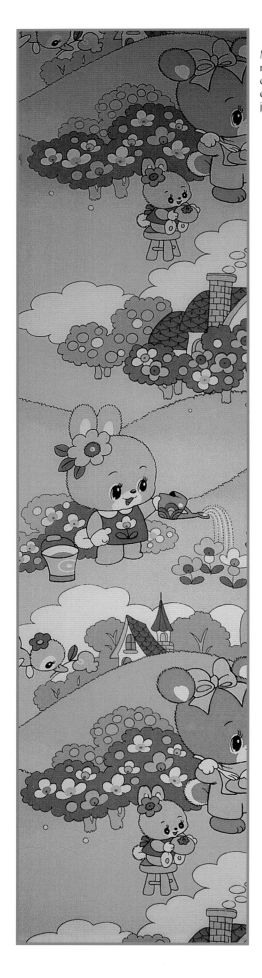

Mid-1960s, 36 x 7, $10-15. A peach muslin futon remnant. Rolling hills serve to divide the tranquil design into two repeating scenes. A Mama bunny eats a piece of cake while her baby bites into a juicy persimmon.

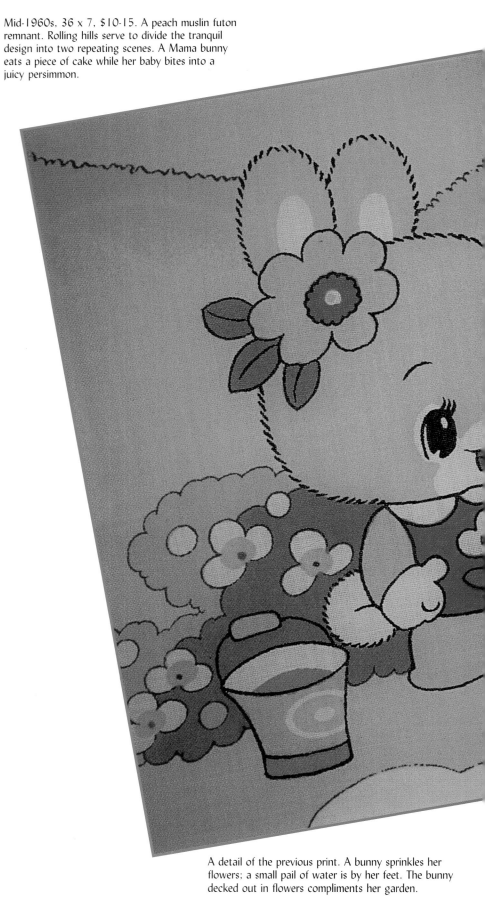

A detail of the previous print. A bunny sprinkles her flowers; a small pail of water is by her feet. The bunny decked out in flowers compliments her garden.

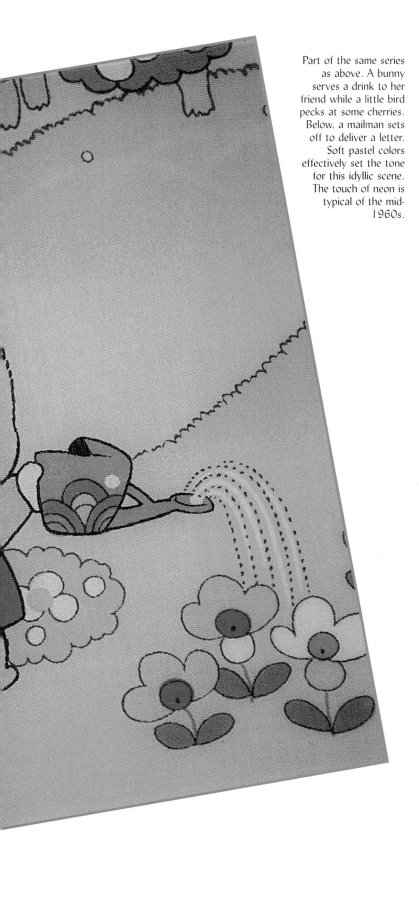

Part of the same series as above. A bunny serves a drink to her friend while a little bird pecks at some cherries. Below, a mailman sets off to deliver a letter. Soft pastel colors effectively set the tone for this idyllic scene. The touch of neon is typical of the mid-1960s.

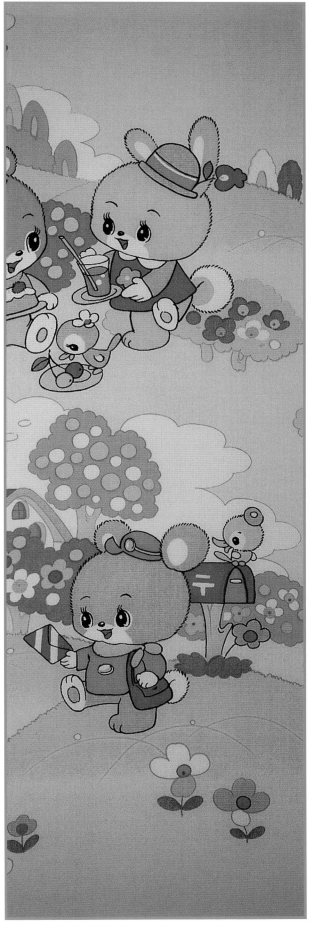

C.1970s, 29 x 20, $15-20. A pink muslin futon remnant. Friends collect apples amongst the daisies. In a quiet moment, rabbit and bear read a story.

The same print as the previous, in turquoise.

The same print as the previous, in yellow.

C.1970s, 39 x 14.5, $20-25. A cream muslin futon remnant. A quiet print with images of tulips, daisies, birds, and rabbits.

Mid-1960s, 39 x 7, $10-15. A pale orange muslin futon remnant. A musical theme fabric with a marching band, a bunny majorette, a raccoon on flute and horn, and tiny bears cheering. The orange blocks resemble stepping stones and effectively serve to break the design into different scenes.

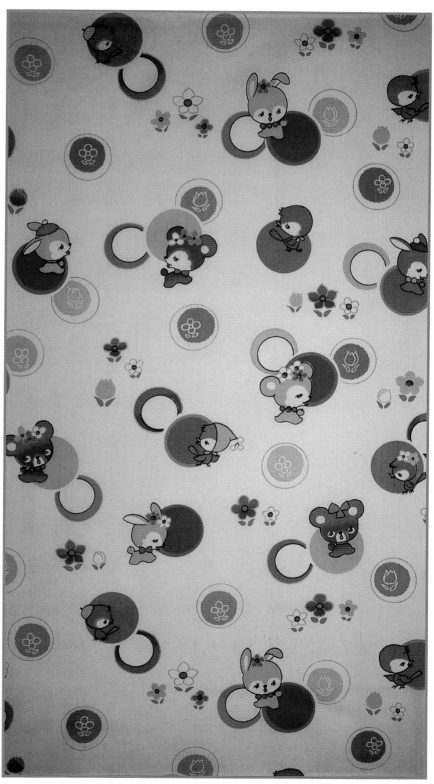

141

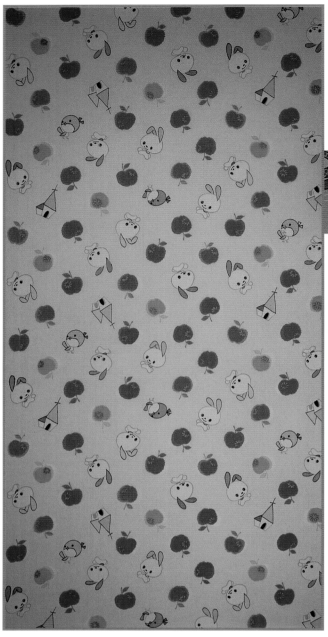

C.1970s, 36 x 15, $15-20. A yellow muslin fragment. With no theme apparent, the designer has used apples, bunnies, and even churches to decorate. This is the only piece in this collection with Christian iconography.

C.1970s, 36 x 14, $10-15. A white seersucker yukata remnant. A circus theme piece, with a bunny holding a flower flag and skillfully balancing on a rainbow ball. The little bird follows suit.

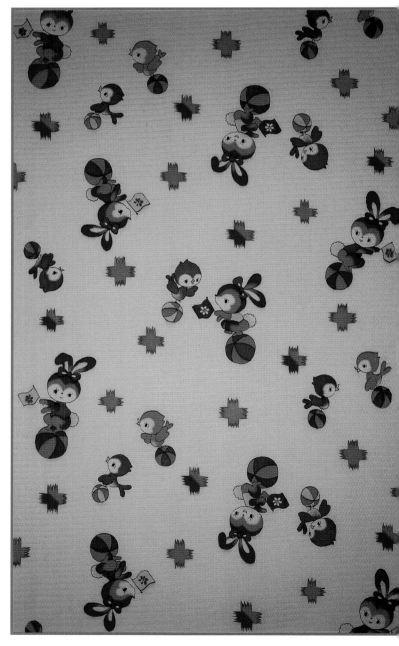

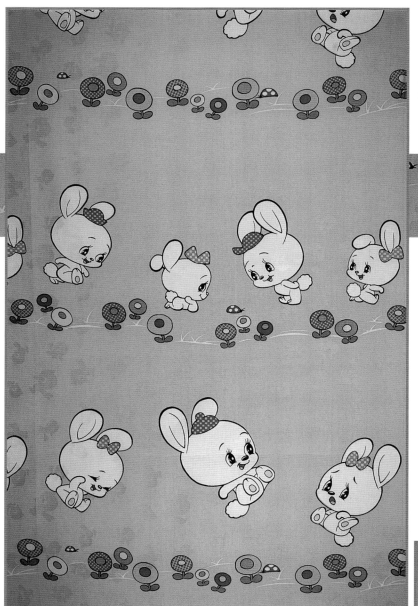

Late 1970s, 36 x 36, $30-40. A yellow cotton futon remnant from Kurokawa Ltd. Instead of the trademark polka dots, there are baby chicks embossed on the background. The print features a trio of hopping bunnies in a meadow of button flowers and lady bugs.

A detail of the previous print. One bunny has a look of alarm on her face as if she is about to take a tumble.

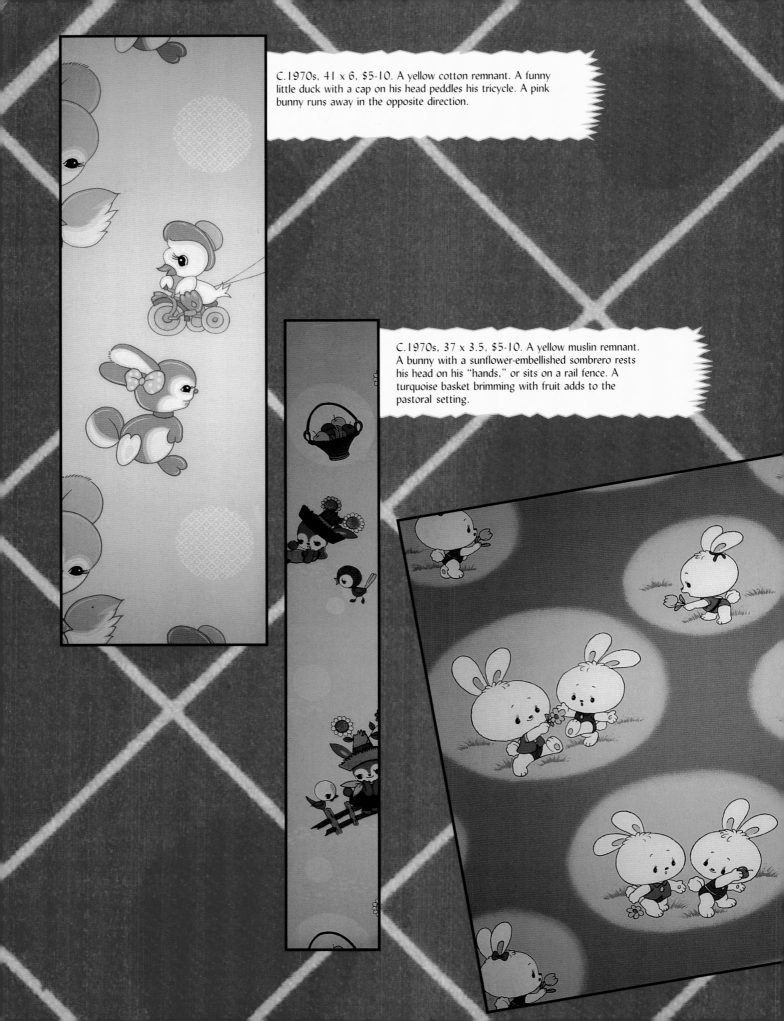

C.1970s, 41 x 6, $5-10. A yellow cotton remnant. A funny little duck with a cap on his head peddles his tricycle. A pink bunny runs away in the opposite direction.

C.1970s, 37 x 3.5, $5-10. A yellow muslin remnant. A bunny with a sunflower-embellished sombrero rests his head on his "hands," or sits on a rail fence. A turquoise basket brimming with fruit adds to the pastoral setting.

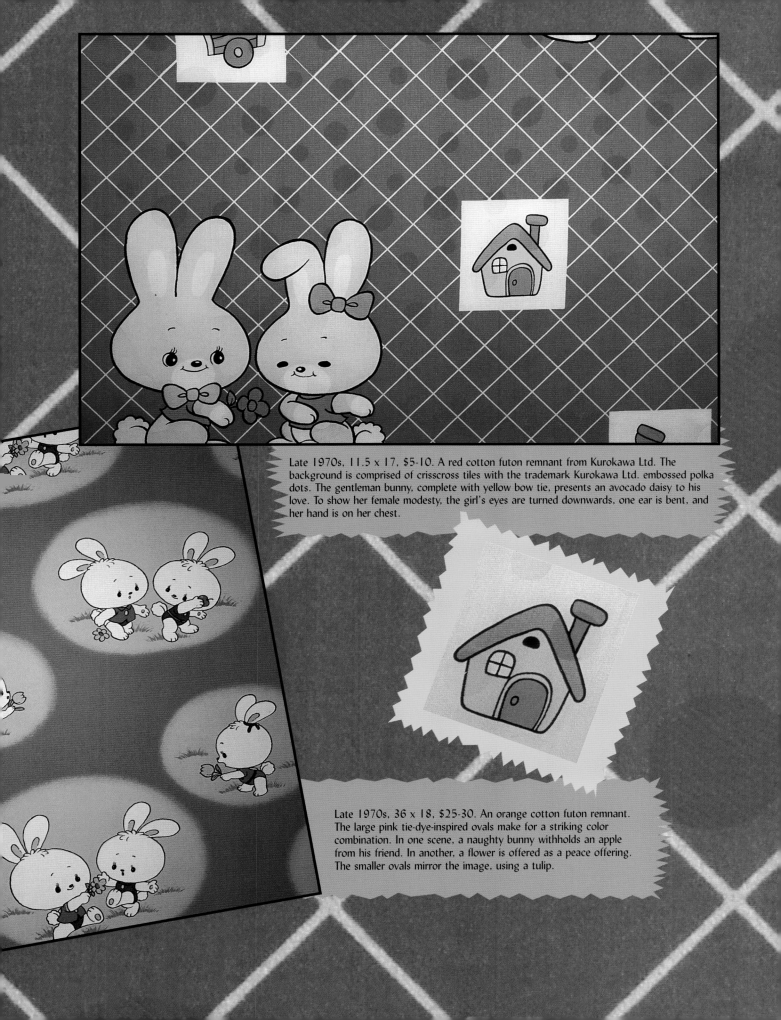

Late 1970s, 11.5 x 17, $5-10. A red cotton futon remnant from Kurokawa Ltd. The background is comprised of crisscross tiles with the trademark Kurokawa Ltd. embossed polka dots. The gentleman bunny, complete with yellow bow tie, presents an avocado daisy to his love. To show her female modesty, the girl's eyes are turned downwards, one ear is bent, and her hand is on her chest.

Late 1970s, 36 x 18, $25-30. An orange cotton futon remnant. The large pink tie-dye-inspired ovals make for a striking color combination. In one scene, a naughty bunny withholds an apple from his friend. In another, a flower is offered as a peace offering. The smaller ovals mirror the image, using a tulip.

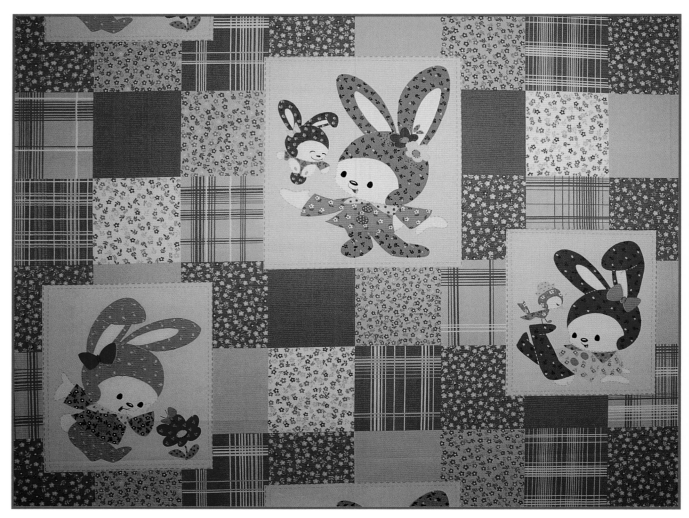

C.1970s, 36 x 36, $25-30. A cotton futon remnant from Kanebo Ltd. A quilt-inspired design with nine patch blocks and appliqué-like bunnies. There are three repeating images of a fashion conscious bunny wearing an angel-sleeved blouse and bell bottoms.

C.1970s, 12 x 14, $5-10. A white seersucker yukata remnant. The design consists of random images of stenciled letters, flowers, apples, and rabbits.

146

Late 1970s, 36 x 14, $10-15. An orange cotton remnant. The simple image of a bunny posing in various attitudes alternates with orange and pink squares.

Late 1970s, 36 x 36, $25-30. A yellow cotton futon remnant. A friendship theme fabric with a bunny offering his friend a pair of balloons or cherries.

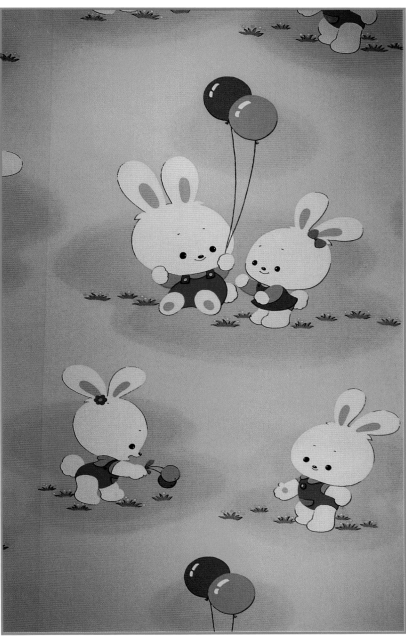

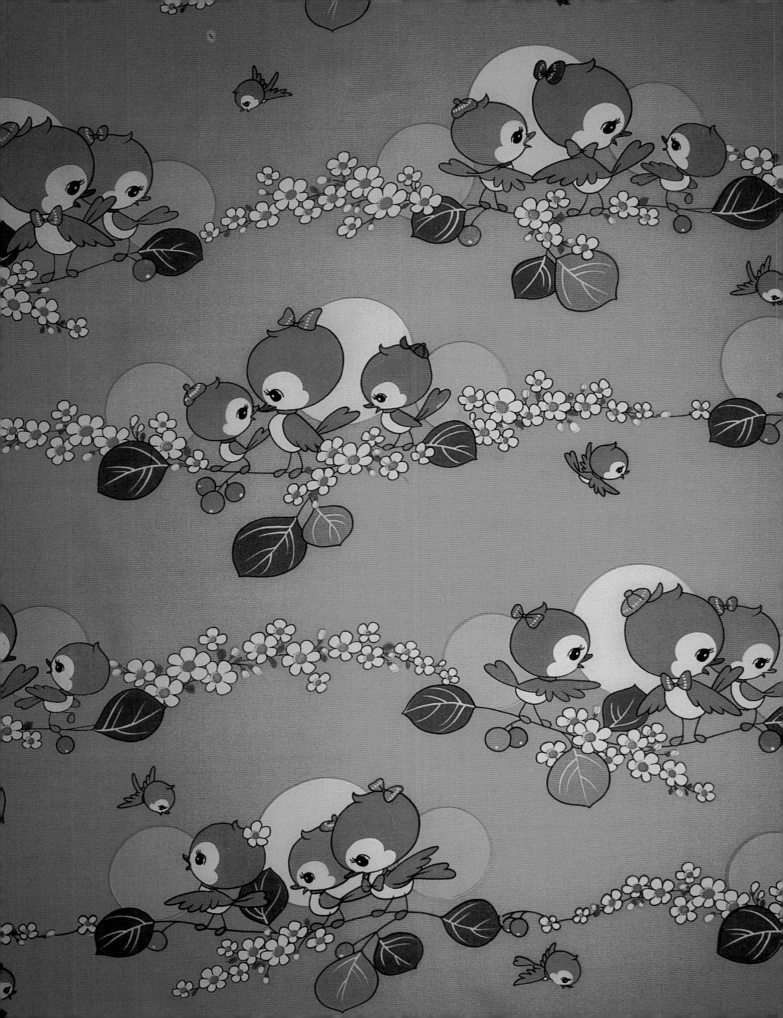

Fine Feathered Friends

Mid-1960s, 36 x 28, $30-40. An orange muslin futon remnant. Fabrics which solely
feature birds are rare and sought after by collectors. Delicate blossoms provide the
backdrop for a trio of singing birds. The deep orange and the pastel polka dots are
indicative of the 1960s. Though the orange provides a dramatic punch of color, the
delicate flowers and simple trio of birds provides balance to the design. The same design
was also produced in blue, and a third series featured rabbits instead of birds.

C.1950s, 14 x 8, $10-15. A pink muslin remnant. A fabric decorated with fluffy chicks in yellow, turquoise, green, and red. This fabric was probably used to line a girl's garment.

Mid-1960s, 10 x 17, $5-10. A blue muslin futon remnant. Pictured are tiny birds wearing a bow, beret, or kerchief.

A detail of the opposite print. A pink bird, complete with handbag, goes shopping. The hand-painted gold outline around the cherries, tulips, and figures adds a touch of sparkle.

Mid-1960s, 36 x 36, $30-40. A green muslin garment remnant from Kasugano Honzome Ltd. A dream-like print decorated with bunnies floating down from pink clouds on flower umbrellas or being carried away on hot air balloons.

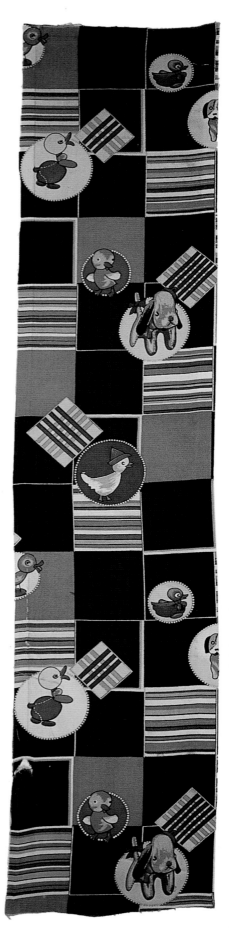

C.1950s, 32 x 7, $10-15. A green muslin remnant. Images of lifelike ducks, toy ducks, and stuffed dogs are intermingled with solid green, brown, and striped patches.

Late 1960s, 13.5 x 13, $10-15. A white cotton yukata fragment. A red bird with a hat or a bow sits among feathered branches.

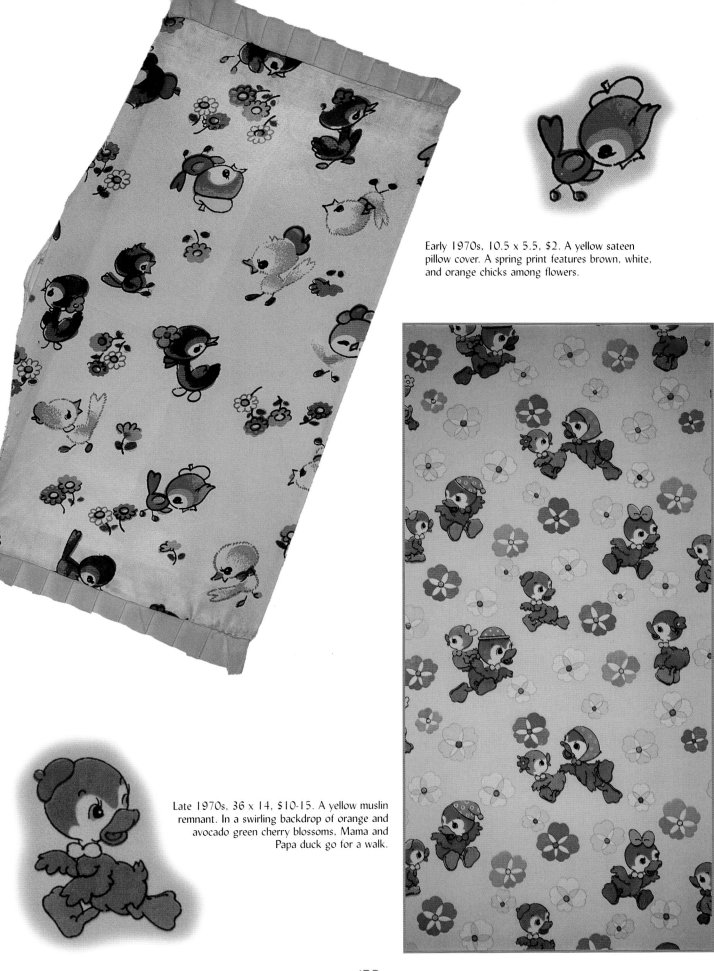

Early 1970s, 10.5 x 5.5, $2. A yellow sateen pillow cover. A spring print features brown, white, and orange chicks among flowers.

Late 1970s, 36 x 14, $10-15. A yellow muslin remnant. In a swirling backdrop of orange and avocado green cherry blossoms, Mama and Papa duck go for a walk.

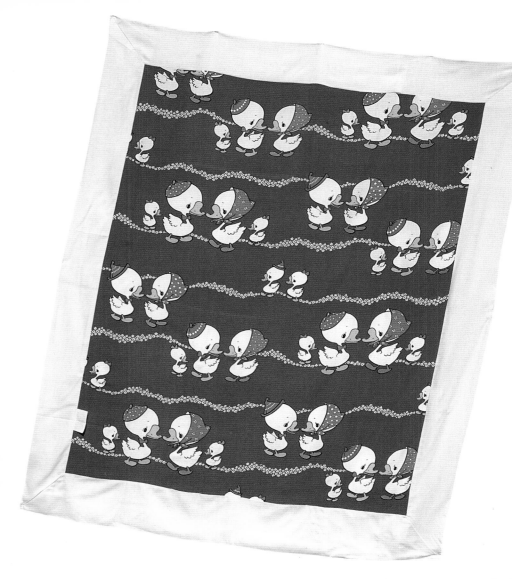

Late 1970s, 44 x 52, $40-50. A red 100% rayon futon cover. This is a cheerful fabric, with a family of ducklings enjoying a swim. The patterned fabric is framed by a three inch solid border. The same yellow fabric is used on the back, where there is a long slit through which the duvet would have been inserted.

A detail of the previous print, with Mama duck in her kerchief and Papa in his cap floating down a stream of daisies, bill to bill. The ducklings are in coordinating colors of pink and green. Typical of this time, the images are quite large and spaced out as a cost-saving device.

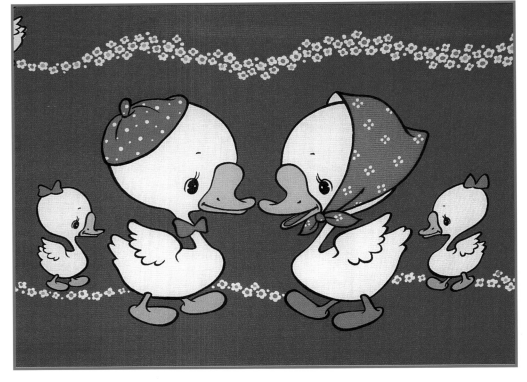

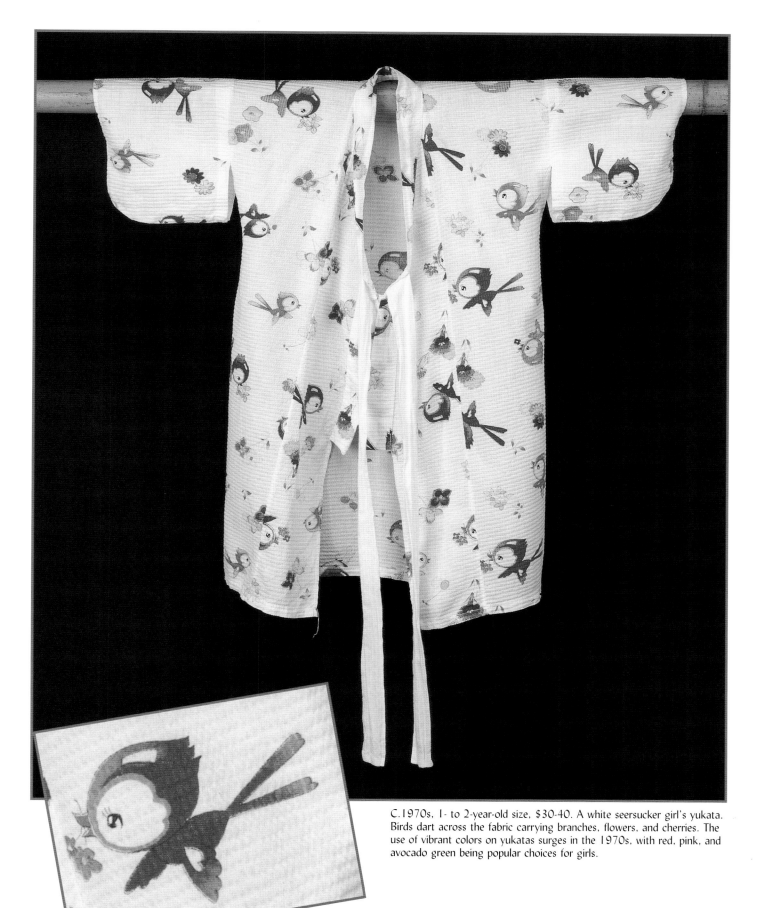

C.1970s, 1- to 2-year-old size, $30-40. A white seersucker girl's yukata. Birds dart across the fabric carrying branches, flowers, and cherries. The use of vibrant colors on yukatas surges in the 1970s, with red, pink, and avocado green being popular choices for girls.

A detail of the previous print, showing a red bird holding flowers in its beak. The image of a bird with a bubble head, small body, and long tail feathers becomes standardized by the 1970s.

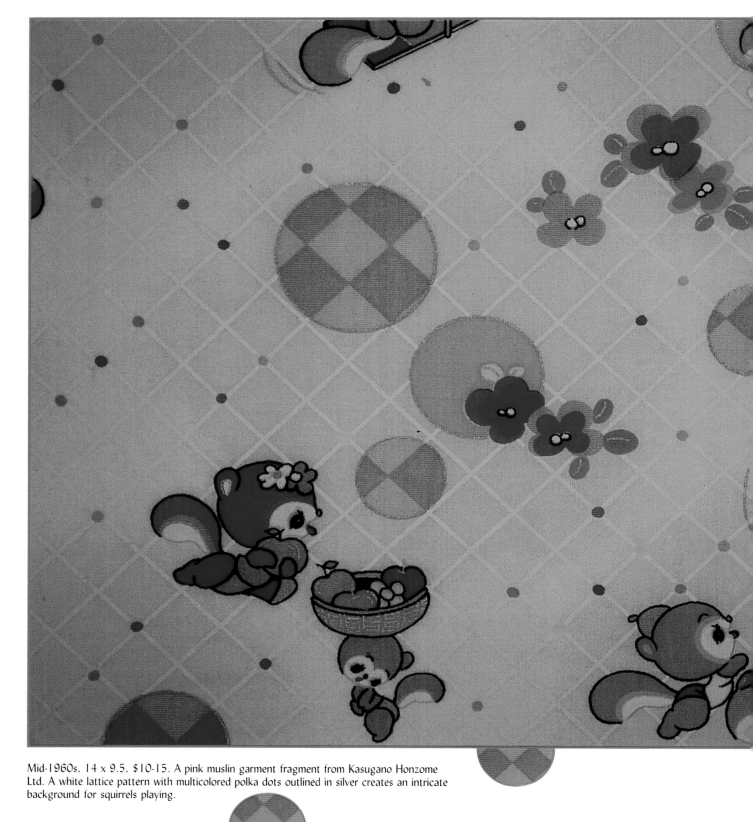

Mid-1960s, 14 x 9.5, $10-15. A pink muslin garment fragment from Kasugano Honzome Ltd. A white lattice pattern with multicolored polka dots outlined in silver creates an intricate background for squirrels playing.

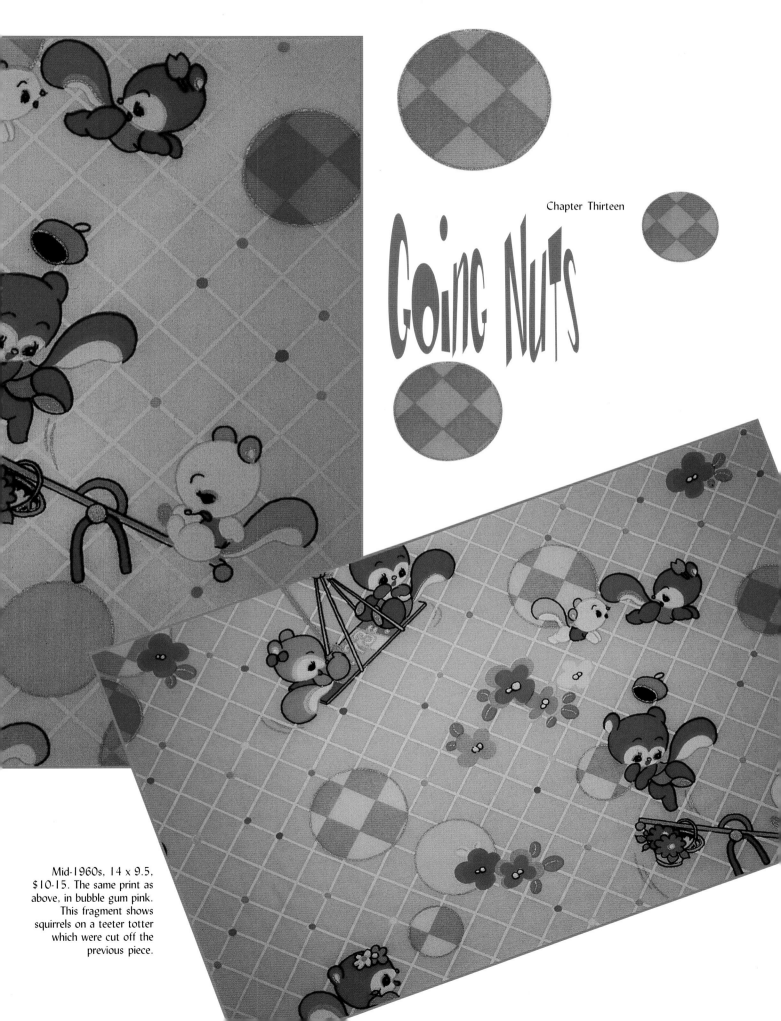

Going Nuts

Mid-1960s, 14 x 9.5, $10-15. The same print as above, in bubble gum pink. This fragment shows squirrels on a teeter totter which were cut off the previous piece.

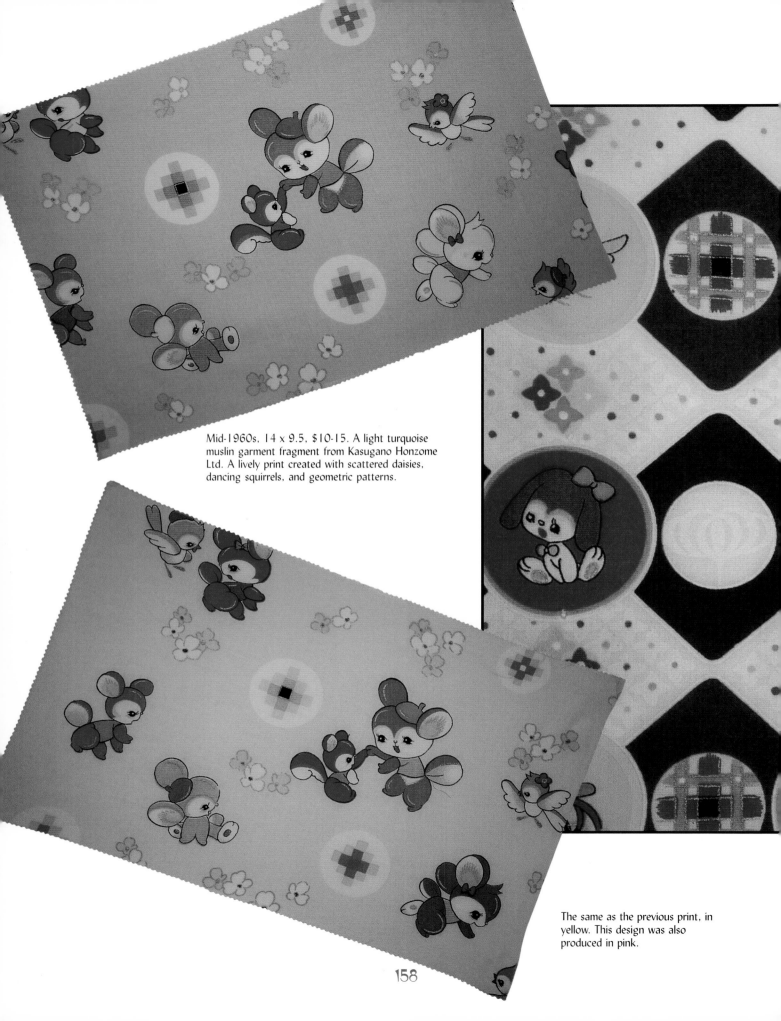

Mid-1960s, 14 x 9.5, $10-15. A light turquoise muslin garment fragment from Kasugano Honzome Ltd. A lively print created with scattered daisies, dancing squirrels, and geometric patterns.

The same as the previous print, in yellow. This design was also produced in pink.

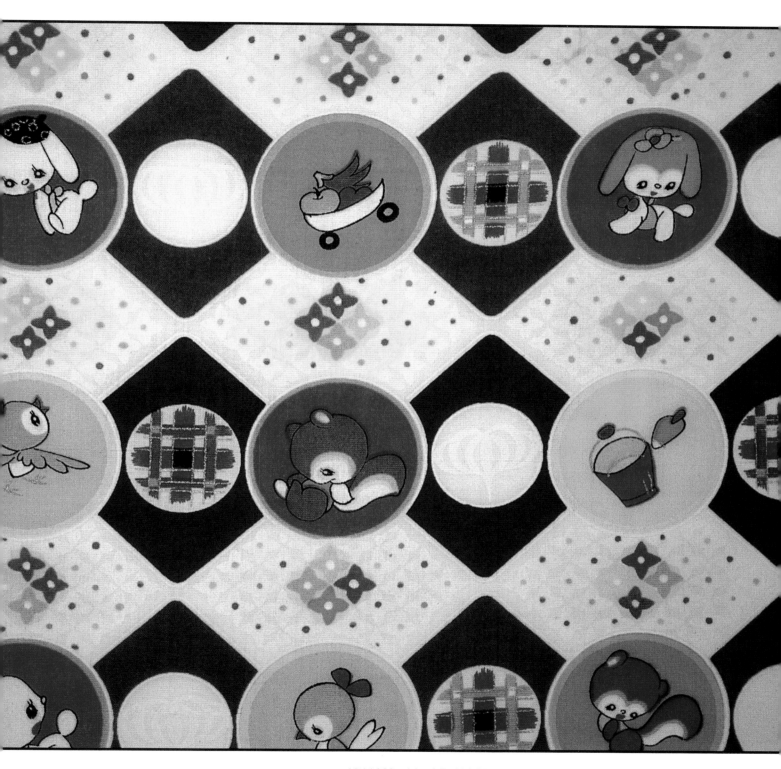

Mid-1960s, 14 x 9.5, $10-15. A muslin garment fragment from Kasugano Honzome Ltd. This fabric perfectly exhibits the design house's trademark layered style. The puppy, bird, and squirrel appear to be bounding out of their circles.

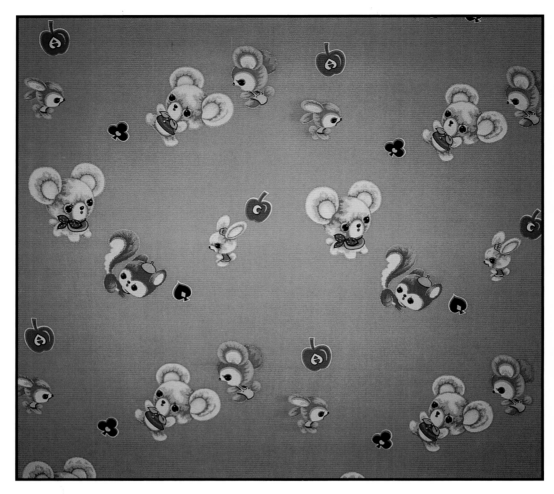

Mid-1960s, 35 x 39, $15-20. A synthetic silk garment fragment. An unusually colored fabric with random images from playing cards and apples. The figures have disproportionately large heads and deep black eyes.

Mid-1960s, 33 x 5.5, $10-15. A yellow muslin kimono fragment. A romantic print decorated with intertwining ribbons and cherry blossoms. A squirrel with long "arms" runs after a bird.

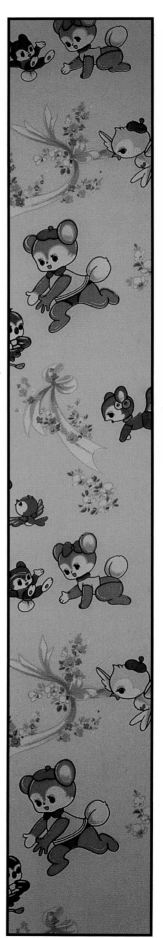

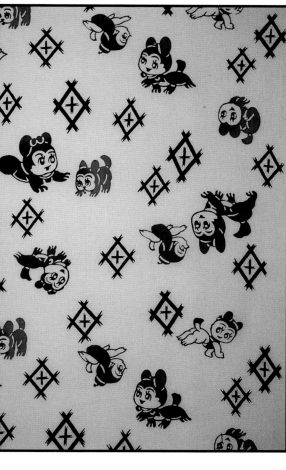

Late 1960s, 17 x 14, $10-15. A white cotton yukata fragment. This print features squirrels in shades of brown, blue, and green.

Late 1960s, 36 x 39, $25-30. A silver sateen futon remnant. A lush fabric with falling leaves, polka dots, curving lines, and large peonies in shades of green, gray and white. An animated squirrel marches busily about with an open mouth, large expressive eyes, and human-like gestures. This print was also produced in pink.

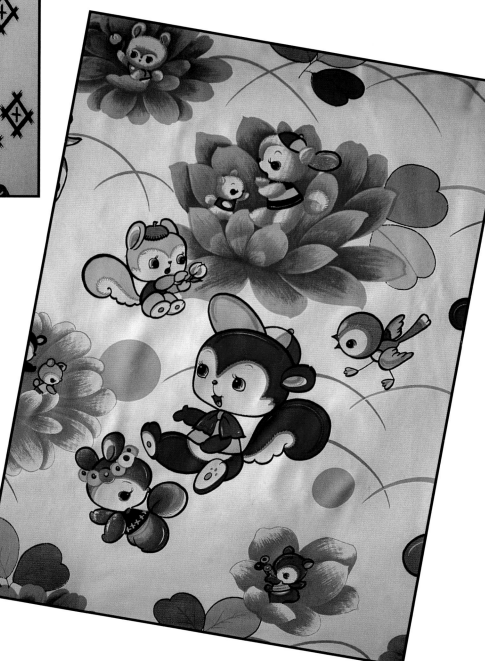

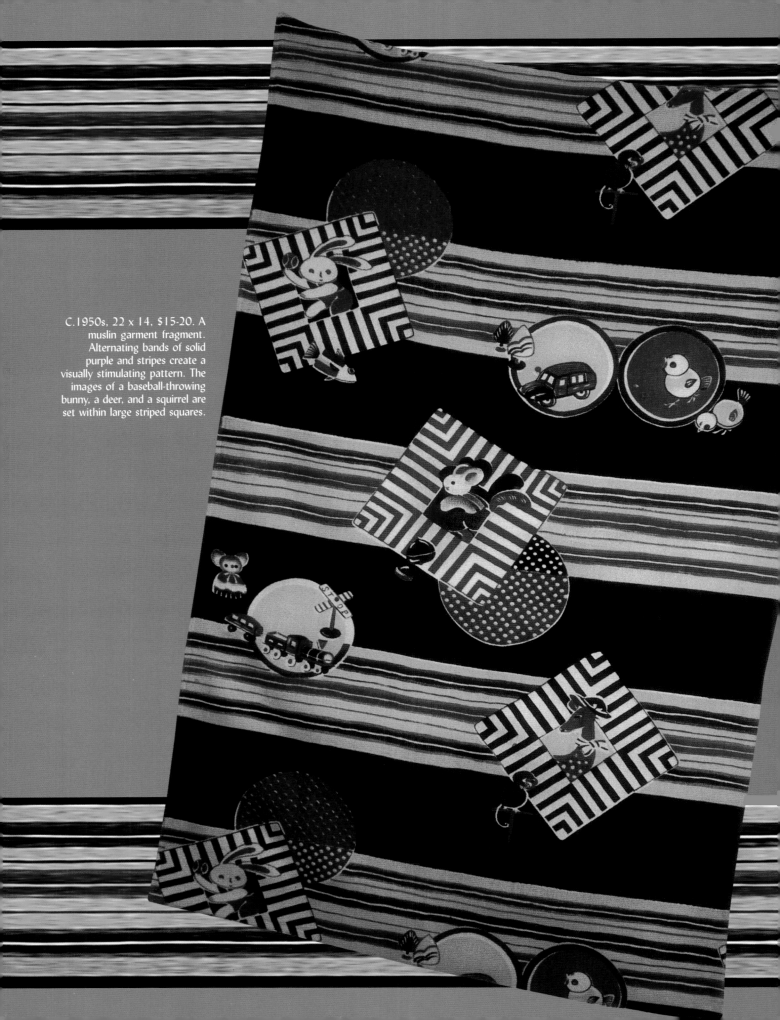

C.1950s, 22 x 14, $15-20. A muslin garment fragment. Alternating bands of solid purple and stripes create a visually stimulating pattern. The images of a baseball-throwing bunny, a deer, and a squirrel are set within large striped squares.

Chapter Fourteen

Bambi

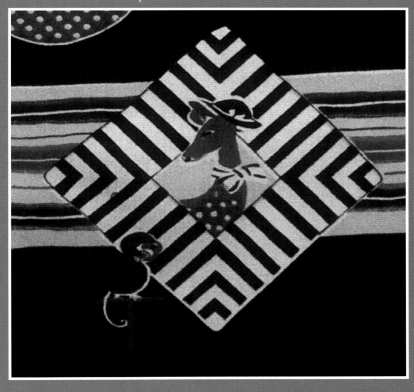

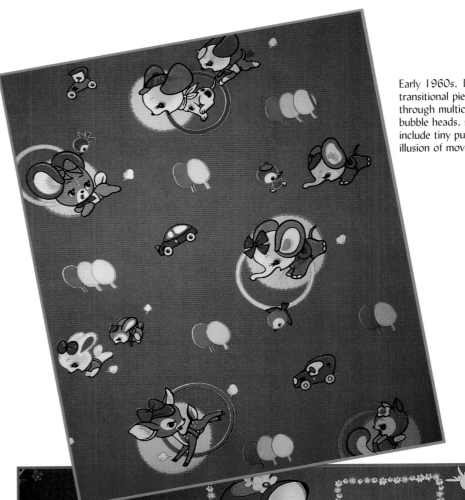

Early 1960s, 18 x 14, $20-25. An red muslin futon remnant. A transitional piece with a simply-rendered Bambi and friends leaping through multicolored hoops. They are typical of the 1960s, with bubble heads, stiff limbs, and open mouths. Details in this print include tiny puffs of smoke by the animal's paws to create the illusion of movement.

Early 1960s, 26 x 29, $20-25. An green muslin futon remnant. Bambi in tangerine with a pink cap and bow tie talks to Faline. The squares are ringed by daisies and laid out on the diagonal to resemble stepping stones.

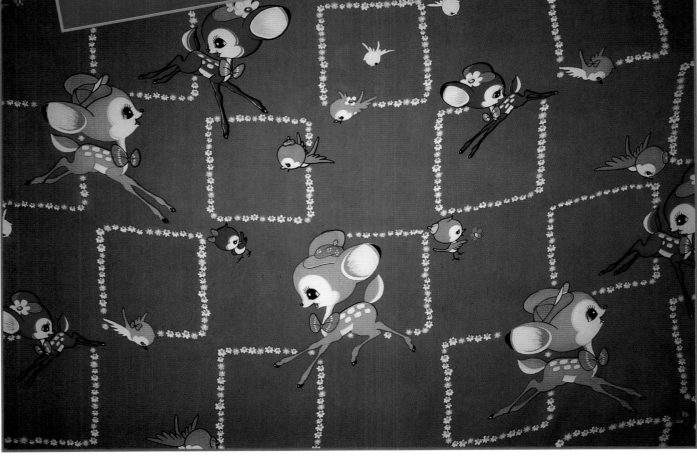

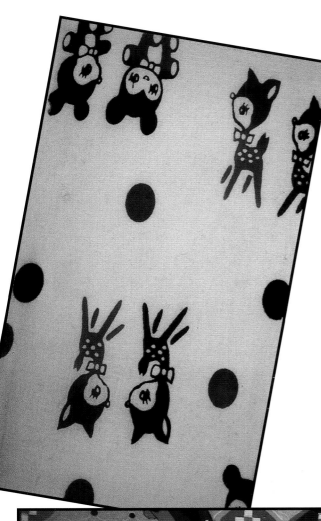

Mid-1960s, 6.5 x 9, $5-10. A white cotton yukata fragment with polka dots in muted shades of navy and green. Bambi is given a Japanese touch with an over-sized head, bow tie, and long, stylized, 1960s lashes. The image of Bambi more closely resembles a stuffed animal than the animated Disney version.

Mid-1960s, 9.5 x 13.5, $10-15. A muslin kimono fragment. Bambi appears on this fabric, either looking over his shoulder or mesmerized by a large television set. Undulating bands of blue with sunburst diamonds create a bold design.

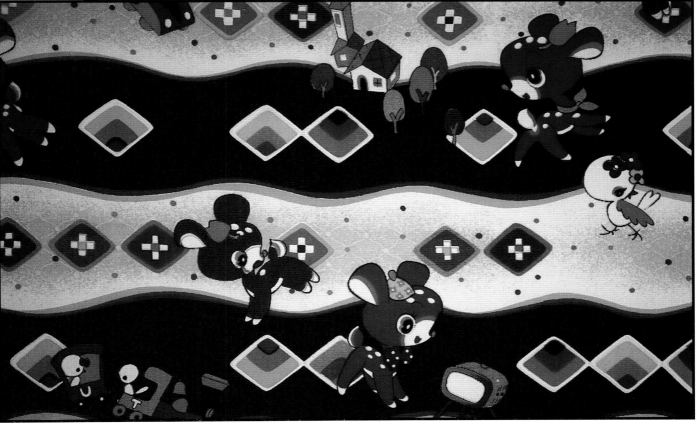

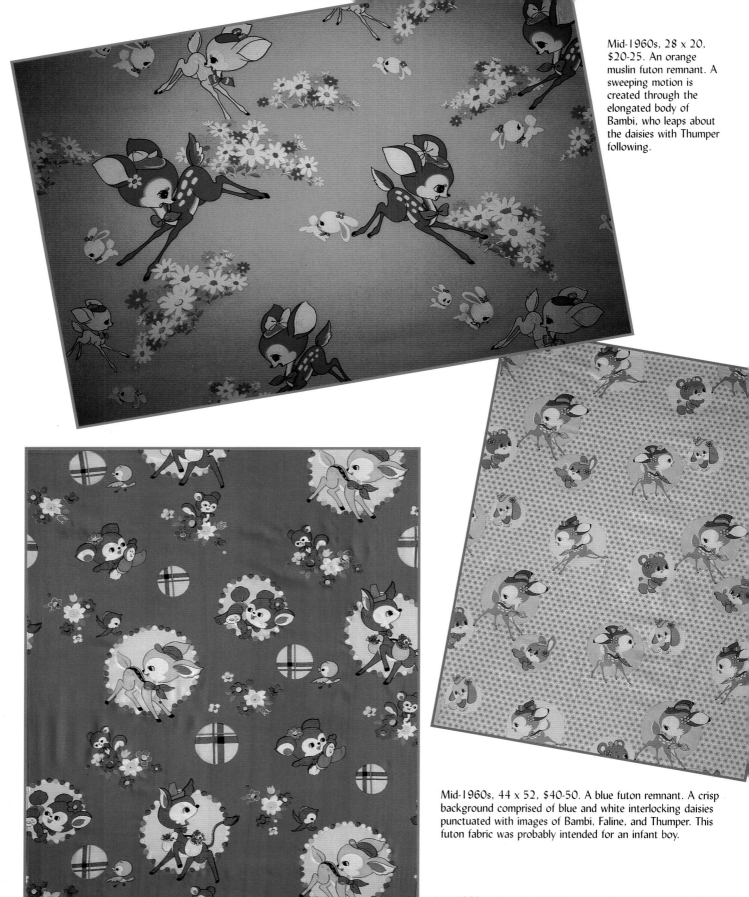

Mid-1960s, 28 x 20, $20-25. An orange muslin futon remnant. A sweeping motion is created through the elongated body of Bambi, who leaps about the daisies with Thumper following.

Mid-1960s, 44 x 52, $40-50. A blue futon remnant. A crisp background comprised of blue and white interlocking daisies punctuated with images of Bambi, Faline, and Thumper. This futon fabric was probably intended for an infant boy.

Mid-1960s, 44 x 52, $40-50. A blue futon remnant. Small candy-colored polka dots provide a frame for the main characters. Bambi is shown with two baskets brimming with flowers. His head is turned and mouth opened as if beckoning to his friends.

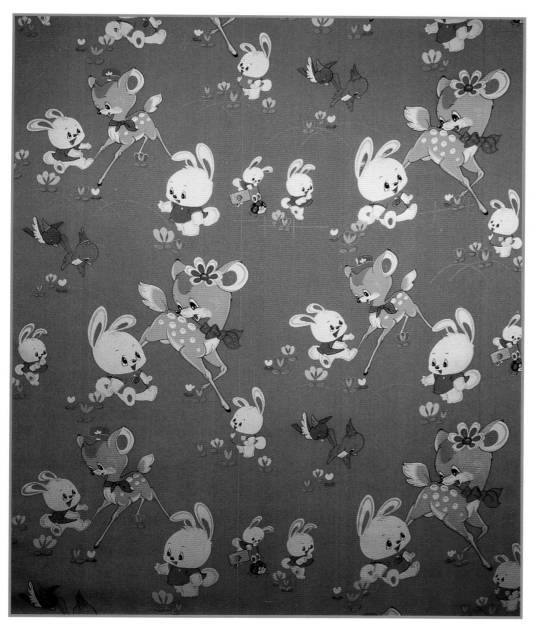

Mid-1960s, 36 x 36, $30-40. A red muslin futon remnant. Faline is happily engaged in conversation with Thumper, while in another scene, Thumper runs to greet Bambi with his "arms" outstretched.

A detail of the previous print. A touch of humor is provided by a naughty bunny who runs over an unfortunate ladybug.

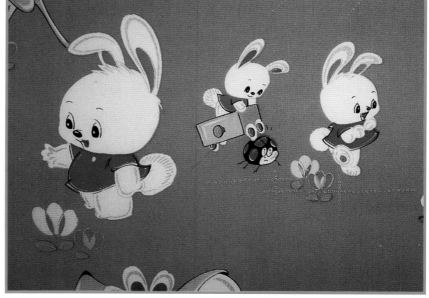

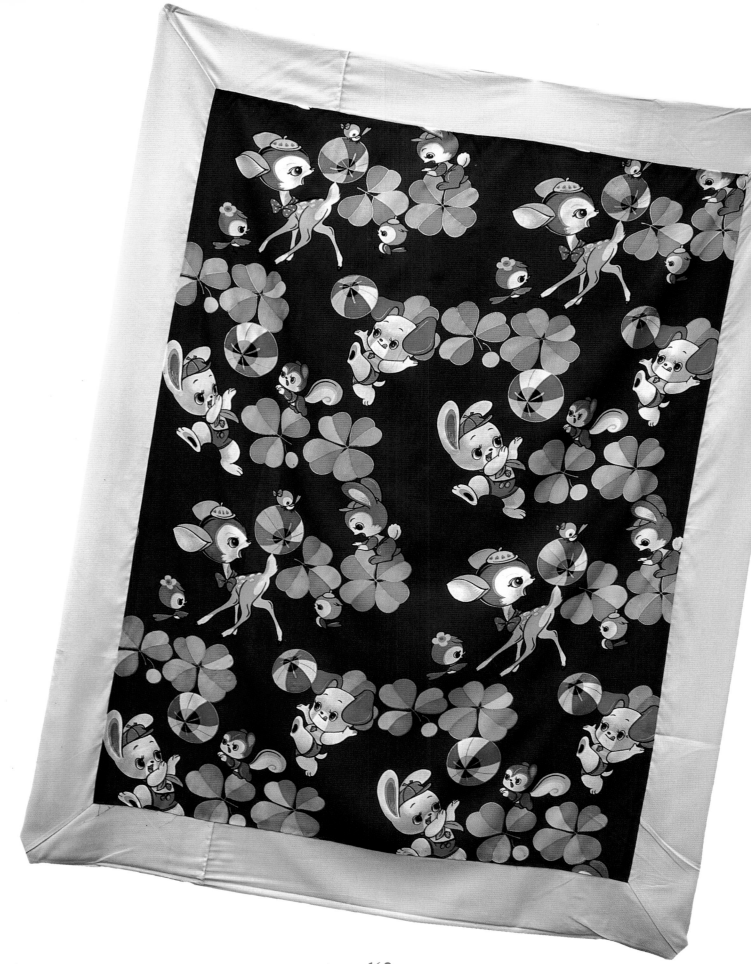

Mid-1960s, 44 x 52, $50-60. A purple futon cover. A stunning rich purple makes this piece truly unique. On the image of Bambi alone, over twelve different colors were used. Bambi plays a game of soccer with Thumper and friends.

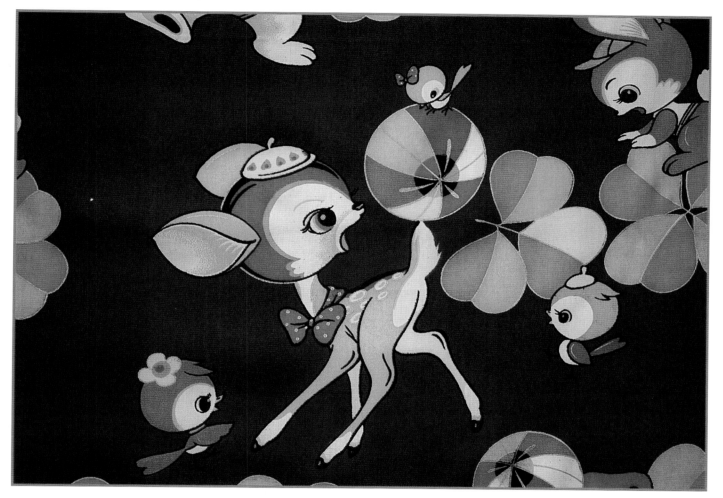

A detail of the previous print, with Bambi skillfully using his tail to pass the ball. Lucky clovers in two shades of orange seem to spin in the background.

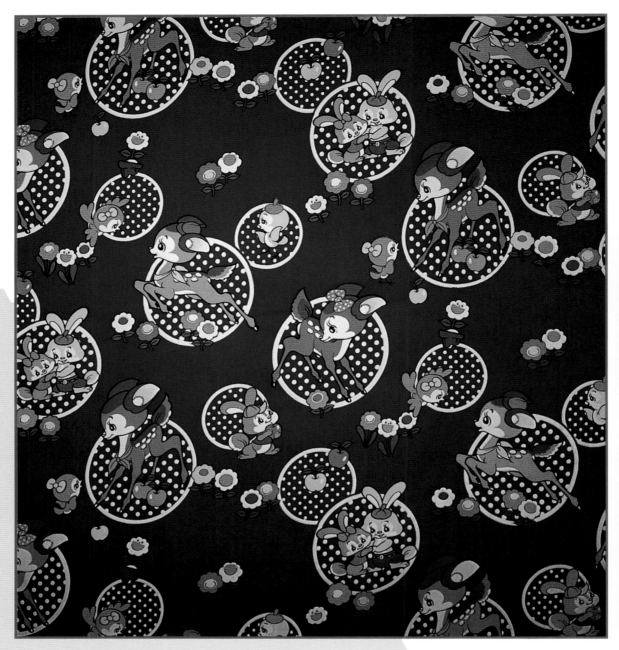

Mid-1960s, 36 x 36, $30-40. A blue muslin futon remnant. Bambi and Faline are shown talking to a friendly bird, or poised on the edge of a circle ready to bound away. The white circles and polka dots add a crispness to the fabric.

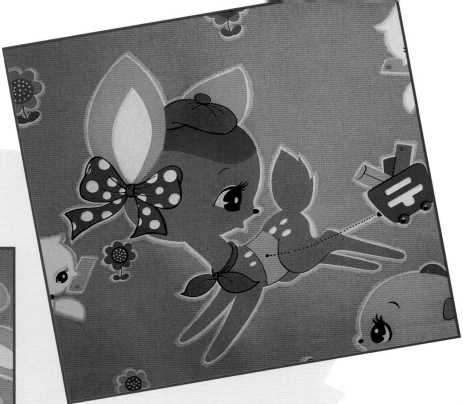

A detail of the previous print. Delivering the mail by foot, scooter, or by enlisting Bambi's help to pull a wagon, the mail always get through. Daisies, bounding squirrels, and other assorted creatures in neon colors combine to make this an eye-catching print.

Mid-1960s, 36 x 36, $50-60. A pink cotton futon remnant. A special fabric with Bambi and Thumper delivering the mail in Japan. The symbol which looks like the letter "T" with a line across the top is the mark of the Japanese Postal System. This is a great example of giving a classic Disney image a very Japanese twist.

Late 1960s, 30 x 16, $20-25. A blue muslin futon remnant. The fluorescent images of Bambi and Faline with primitive-looking daisies and pink and yellow polka dots create a garish combination. This print was also produced in green.

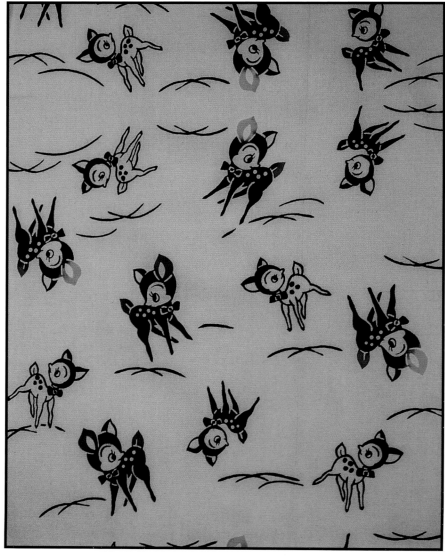

Early 1970s, 18 x 14, $10-15. A white cotton yukata fragment. A traditional yukata color of indigo blue is used on the first image of Bambi and the second uses two tones of mustard to create a batik effect. The head on this image is dominated by an exaggerated brow and long eye lashes.

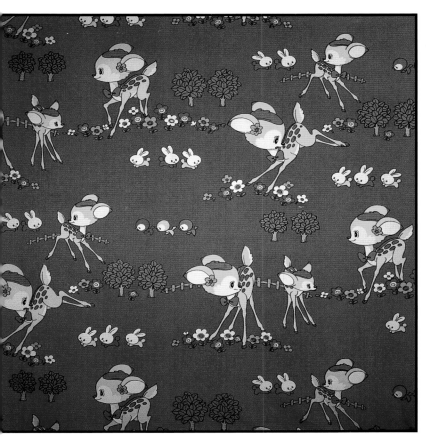

Early 1970s, 36 x 17, $20-30. A red cotton futon remnant. A wonderfully expressive Bambi with his face registering surprise as he kicks his hooves up into the air. In another scene he is happily walking through a field of daisies.

Same as the previous print, in turquoise.

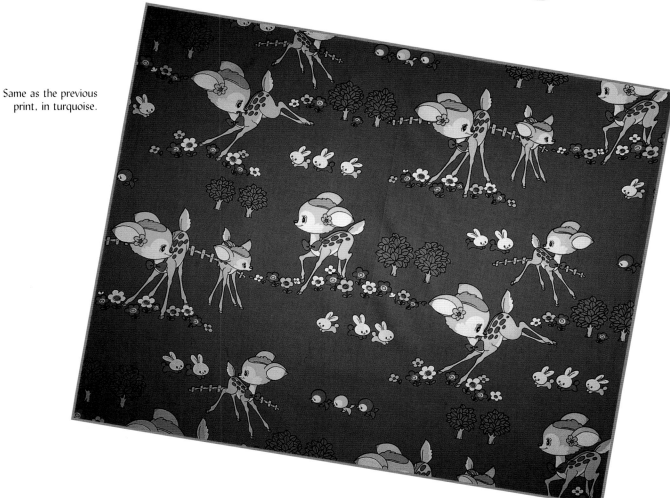

173

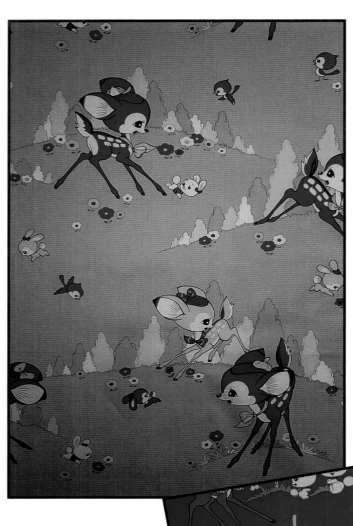

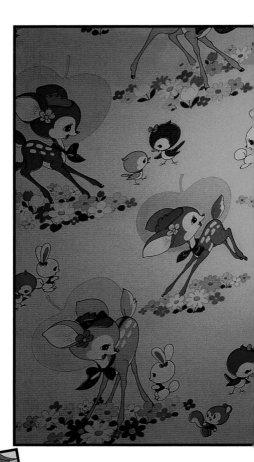

Early 1970s, 36 x 36, $30-40. A pink cotton futon remnant. Bambi and Faline are pictured on a ridge. They are outlined in black, with coordinating blue beret and bow. The bushes, in sherbert tones of green and yellow, create a dream-like world. This is mirrored in the gentle expressions of Bambi and Faline.

C. 1970s, 36 x 36, $30-40. A pink cotton futon remnant from Kurokawa Ltd. The silhouette of a yellow apple frames Bambi. The markings in white stand out nicely against the deep orange coat and are accentuated by the polka dot scarf and cap. Even the black hooves have been shaded in metallic gray to give depth. This print was also produced in blue.

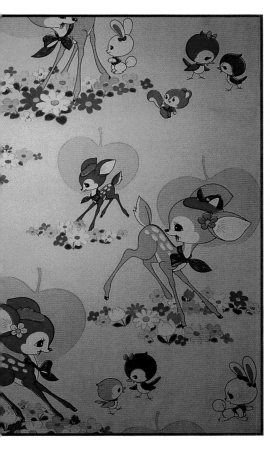

C.1970s, 23 x 14, $15-20. A yellow muslin futon remnant. Bambi, with a baseball cap, and Faline, with a bow, playfully skip through the flowers. Pink silhouettes of apples provide a backdrop for the pair.

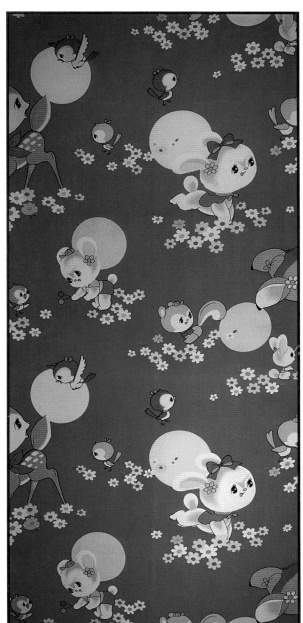

C.1970s, 40 x 18, $20-25. A blue synthetic futon remnant by Kurokawa Ltd. The pink Bambi image is unfortunately cut off, but Thumper is intact. The background is comprised of pastel flowers, chicks, and large polka dots.

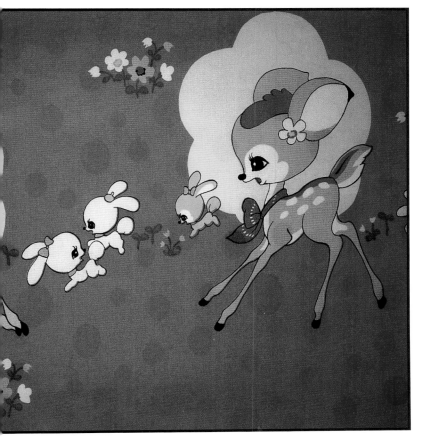

C.1970s, 35 x 11, $15-20. A pink cotton futon remnant from Kurokawa Ltd. This print was also produced in yellow. Kurokawa Ltd.'s signature embossed polka dot background is enhanced by large yellow cherry blossoms, which frame Bambi and Faline. Both figures are in motion, with limbs extended and mouths open.

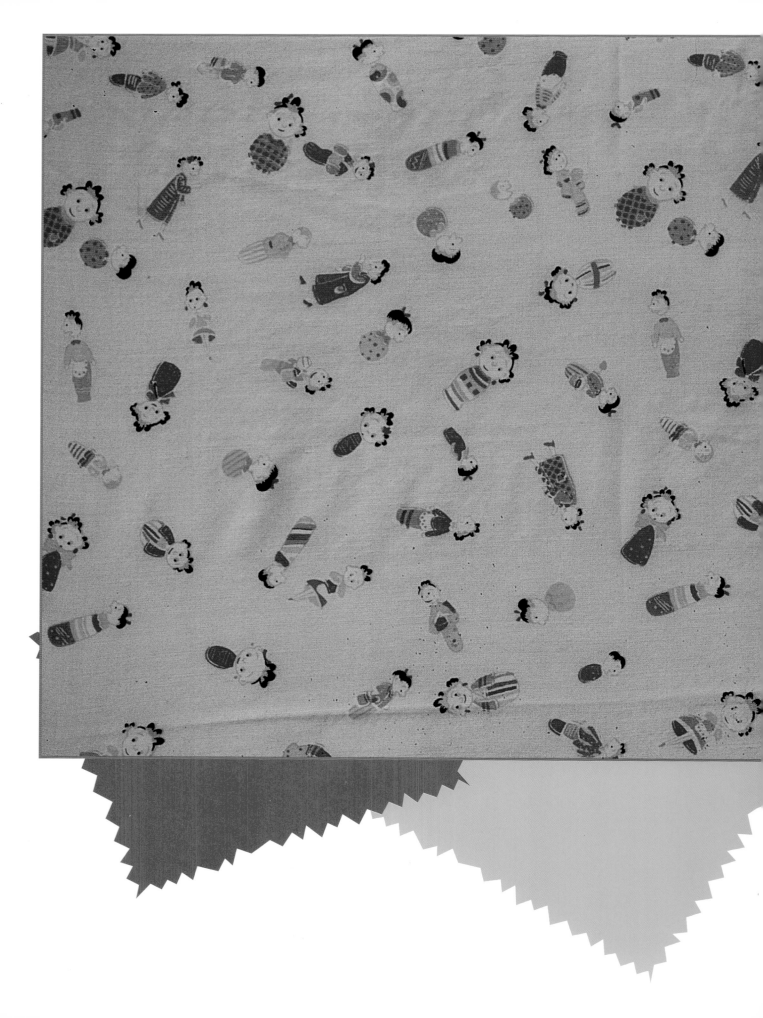

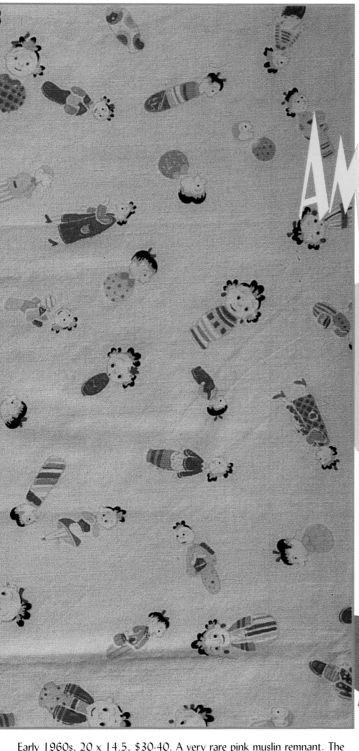

Amazing Animation

Early 1960s, 20 x 14.5, $30-40. A very rare pink muslin remnant. The Japanese classic *Sazae-san* by Machiko Hasegawa is featured here. *Sazae-san* ran in the *Asahi Newspaper* from 1949 to 1974 and then on television from 1969. With over 1600 episodes produced for Fuji television, it is the longest-running animation series to date. Stories centered around Sazae-san, a twenty-three-year-old housewife. All the principal characters are shown on the fabric: Sazae-san, Namihei (Grandpa), Fune (Grandma), Wakame (younger sister), Katsuo (younger brother), Masuo (husband), and Tarao (son).

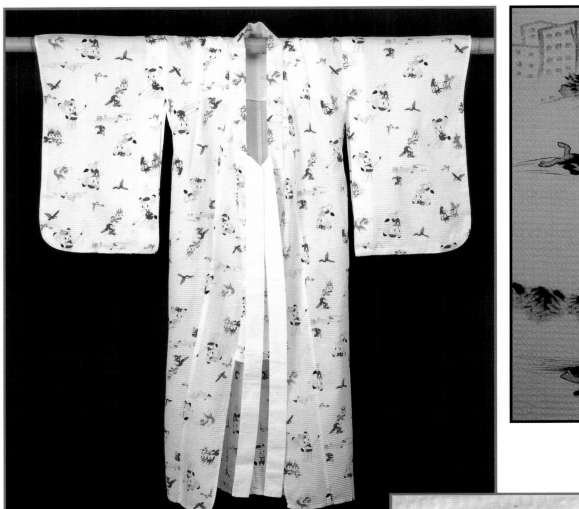

Early 1960s, 8- to 10-year-old size, $100-120. A cotton yukata with an Osamu Tezuka-inspired *Kimba the White Lion* character. Taking quite a few liberties with the story, the designer has Kimba playing golf. Dressed in jazzy red overalls and a green cap, he certainly looks the part. A small red squirrel acts as his caddy while two bunnies cheer from the sidelines.

A detail of the previous print, showing Kimba happily swinging a golf club.

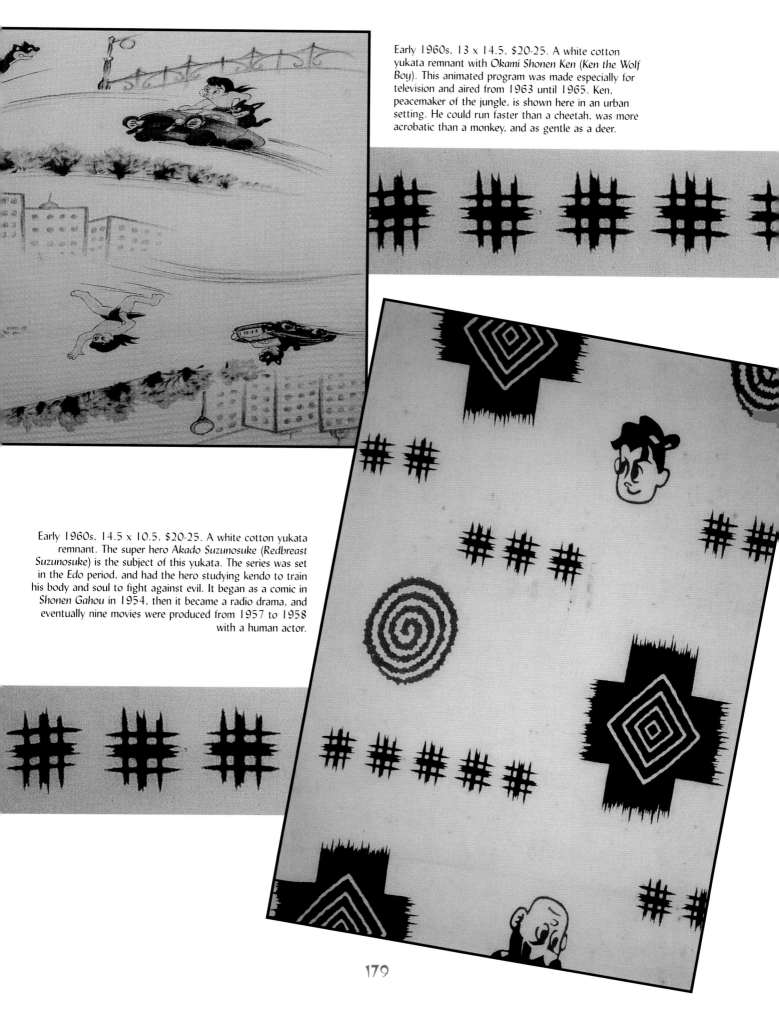

Early 1960s, 13 x 14.5, $20-25. A white cotton yukata remnant with *Okami Shonen Ken* (*Ken the Wolf Boy*). This animated program was made especially for television and aired from 1963 until 1965. Ken, peacemaker of the jungle, is shown here in an urban setting. He could run faster than a cheetah, was more acrobatic than a monkey, and as gentle as a deer.

Early 1960s, 14.5 x 10.5, $20-25. A white cotton yukata remnant. The super hero *Akado Suzunosuke* (*Redbreast Suzunosuke*) is the subject of this yukata. The series was set in the *Edo* period, and had the hero studying kendo to train his body and soul to fight against evil. It began as a comic in *Shonen Gahou* in 1954, then it became a radio drama, and eventually nine movies were produced from 1957 to 1958 with a human actor.

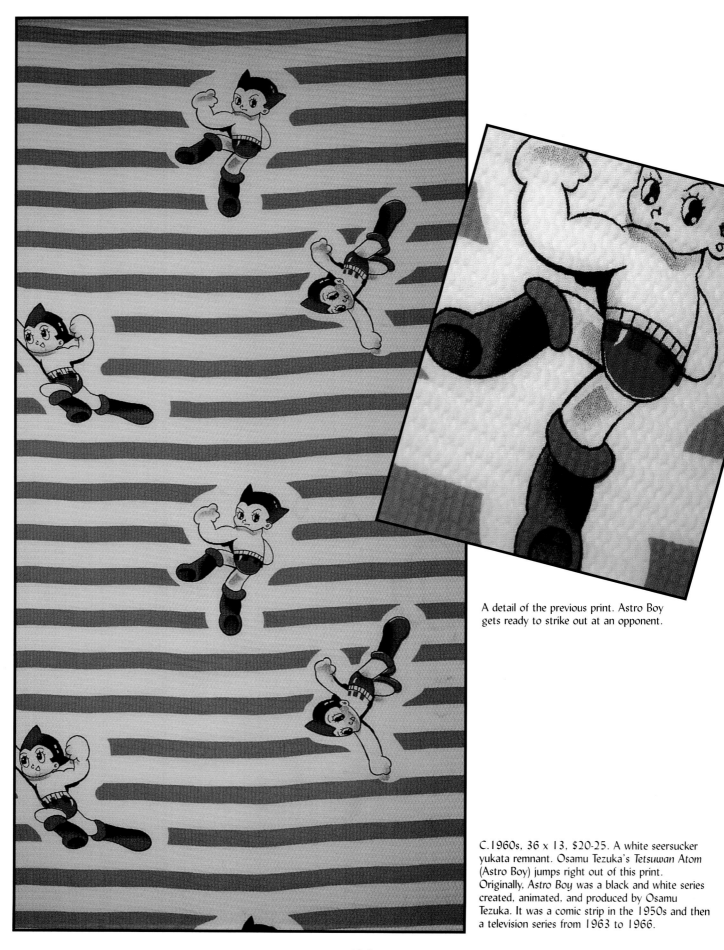

A detail of the previous print. Astro Boy gets ready to strike out at an opponent.

C.1960s, 36 x 13, $20-25. A white seersucker yukata remnant. Osamu Tezuka's *Tetsuwan Atom* (Astro Boy) jumps right out of this print. Originally, *Astro Boy* was a black and white series created, animated, and produced by Osamu Tezuka. It was a comic strip in the 1950s and then a television series from 1963 to 1966.

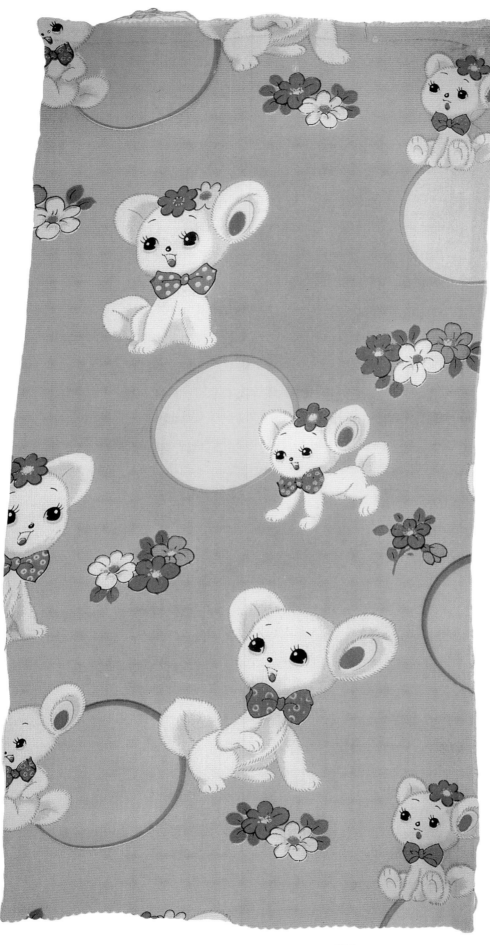

Mid-1960s, 23 x 11, $25-30. An orange muslin futon remnant. A beautiful print based on *Kimba the White Lion*, which was originally a comic series in the 1950s in the magazine *Manga Shonen*. Kimba is shown as a young cub, gracefully outlined in silver metallic thread.

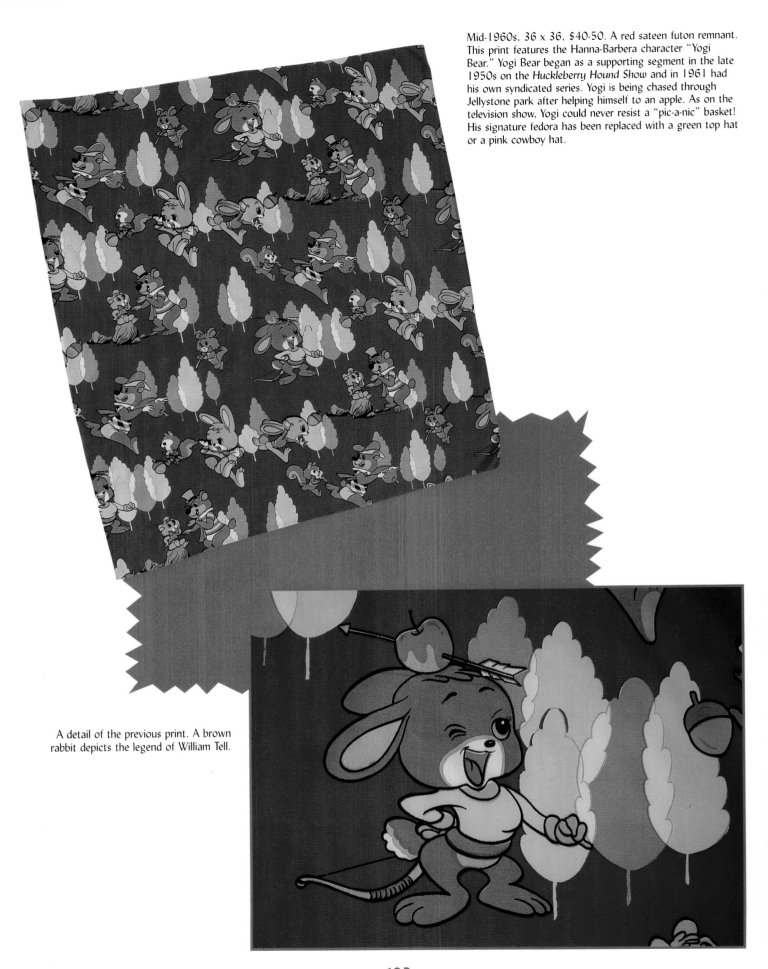

Mid-1960s, 36 x 36, $40-50. A red sateen futon remnant. This print features the Hanna-Barbera character "Yogi Bear." Yogi Bear began as a supporting segment in the late 1950s on the *Huckleberry Hound Show* and in 1961 had his own syndicated series. Yogi is being chased through Jellystone park after helping himself to an apple. As on the television show, Yogi could never resist a "pic-a-nic" basket! His signature fedora has been replaced with a green top hat or a pink cowboy hat.

A detail of the previous print. A brown rabbit depicts the legend of William Tell.

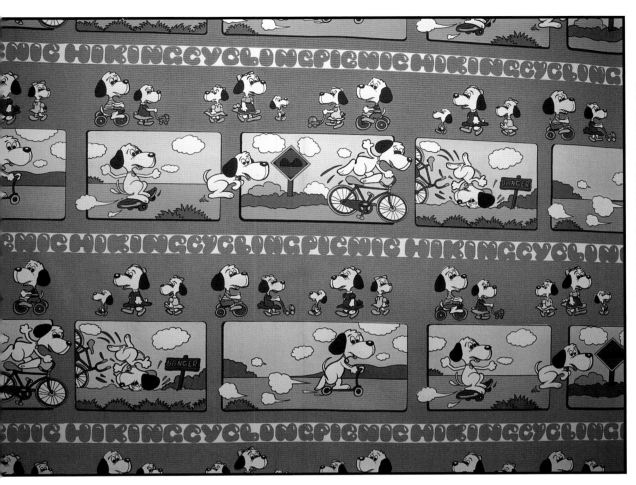

C.1970s, 36 x 36, $30-40. An orange cotton futon remnant. A beagle resembling "Snoopy," from the comic strip *Peanuts* by Charles M. Schultz, is shown in a number of adventures. The action sequences are designed to look like comic book frames. Large stenciled letters in between the frames spell out the words "picnic," "hiking," and "cycling."

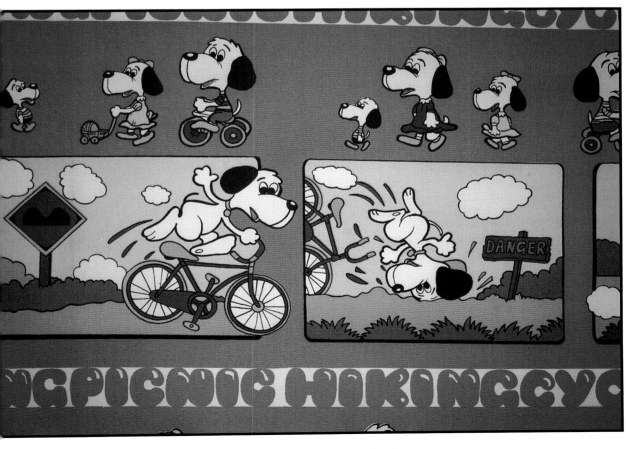

A detail of the previous print. Snoopy, not seeing the road signs warning of danger and bumps in the road, takes a tumble over his handle bars.

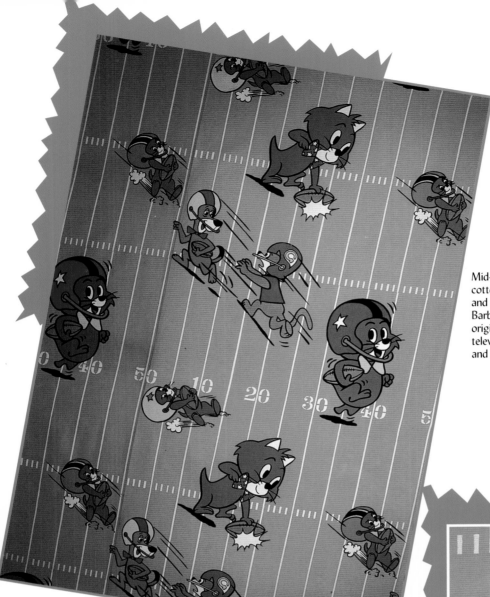

Mid-1970s, 36 x 20, $25-30. An orange polished cotton futon remnant. This fabric features a "Tom and Jerry" morph, and is marked copyright Hanna-Barbera Productions, Inc. Tom and Jerry were originally created as theatrical shorts, but came to television in 1965. This is a vibrant print of Tom and Jerry racing across a football field.

A detail of the previous print. Jerry runs with the football.

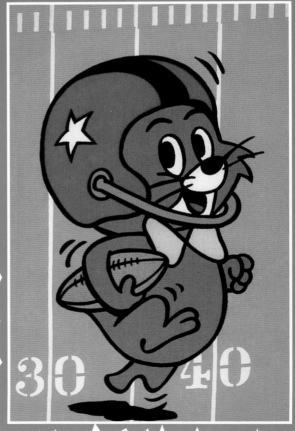

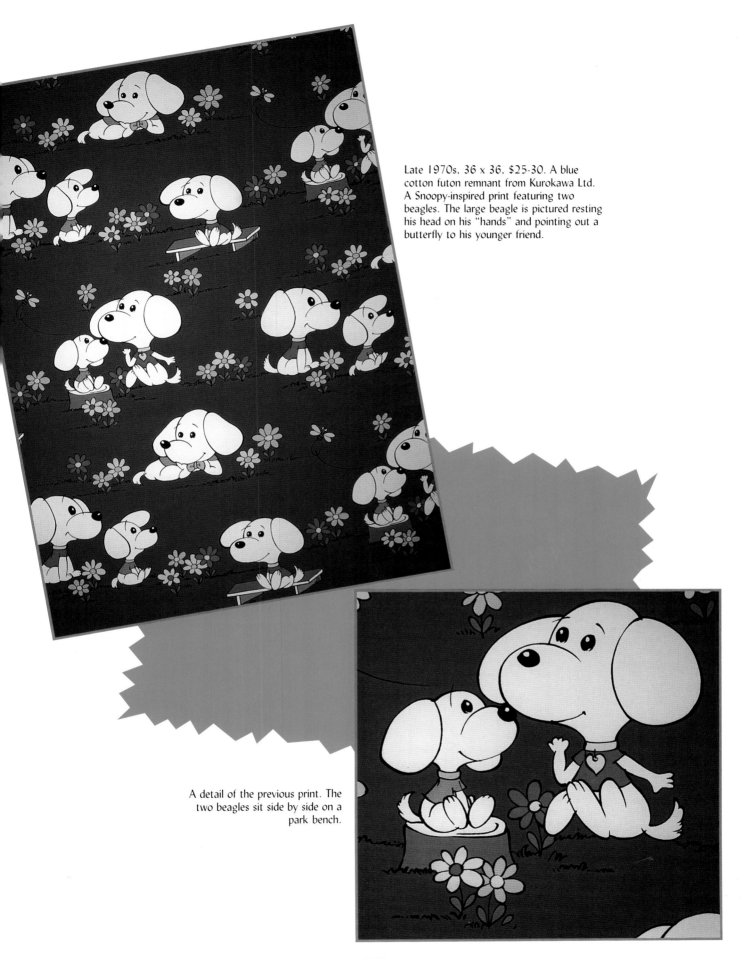

Late 1970s, 36 x 36, $25-30. A blue cotton futon remnant from Kurokawa Ltd. A Snoopy-inspired print featuring two beagles. The large beagle is pictured resting his head on his "hands" and pointing out a butterfly to his younger friend.

A detail of the previous print. The two beagles sit side by side on a park bench.

Late 1970s, 44 x 52, $50-60. A yellow cotton futon cover. It features scenes from the series *3000 Leagues in Search of Mother*, produced by Nippon Animation for Fuji TV in 1976. The series was based on *the book, Heart: An Italian Schoolboy's Journal* by Edmundo de Amicis. The animator was Yoichi Kotabe.

A detail of the previous print. The central character, Marco Rossi, is shown running with his friends through the streets of Buenos Aires.

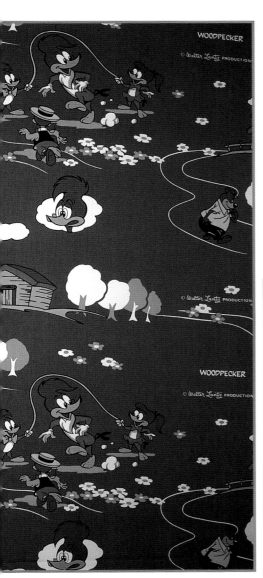

C.1970s, 36 x 36, $30-40. A blue cotton futon remnant. A "Woody Woodpecker" fabric, copyrighted A Walter Lantz Productions Inc. This woodpecker first appeared in short films and then television. Woody, his nephew Knothead, and his niece Splinter skip rope.

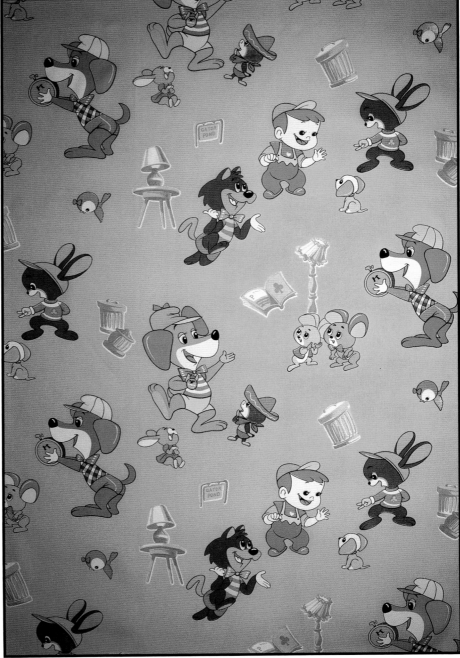

Late 1960s, 36 x 36, $30-40. A pink poly cotton futon remnant. A vibrant fabric with characters from *The Huckleberry Hound Show* created by Hanna-Barbera. The show originally aired in 1958 and then went into syndication. The fabric features Huckleberry Hound and the mice Pixie and Dixie, who in keeping with character, are outwitting Mr. Jinks, the cat. Gray silhouettes of trash cans, phone books, 'gator ponds, and side table lamps further enhance the fabric.

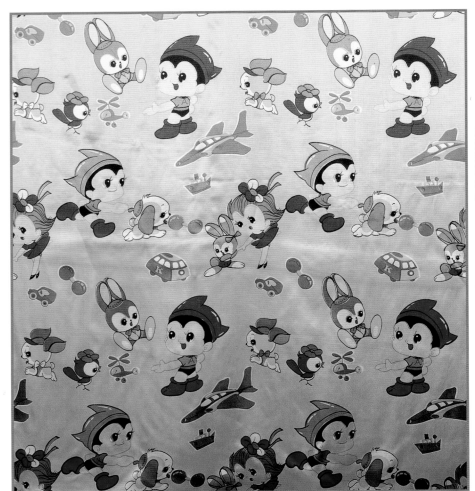

Late 1960s, 38 x 36, $60-70. A yellow sateen futon remnant. A fantastic print based on *Astro Boy*. Astro Boy is shown with Jump the dog and Uran, his sister. This is not a licensed print, therefore explaining the necessity to alter the characters slightly.

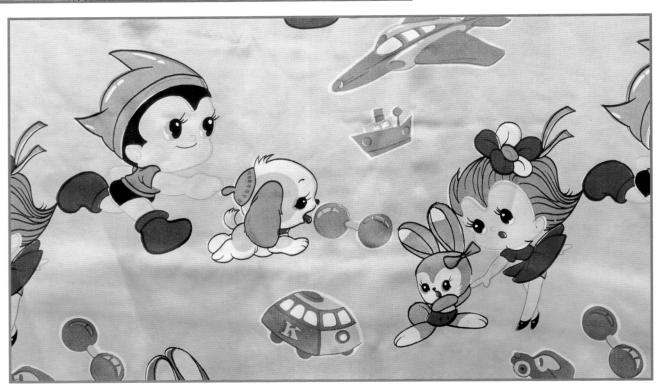

A detail of the previous print. Astro Boy runs to the rescue. His index fingers, which could turn into lasers, extend out in front of him. A rich design with jet planes, helicopters, and other vehicles that fly across the background.

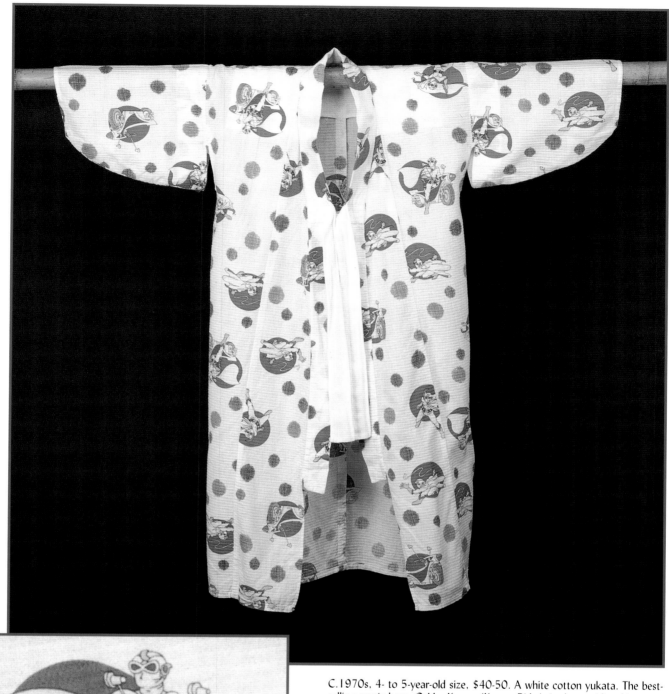

C.1970s, 4- to 5-year-old size, $40-50. A white cotton yukata. The best-
selling comic hero, *Gekko Kamen* (*Kamen Rider*), is shown riding his
motorcycle, brandishing a weapon, and in various action poses. In 1958,
the *Kamen Rider* series was the first black-and-white television series in
Japan for children. In 1972, it was a new series for Nihon Television
created by Yasunori Kawauchi and animated by Jiro Kutawa.

A detail of the previous print shows
Kamen Rider on his motorcycle.

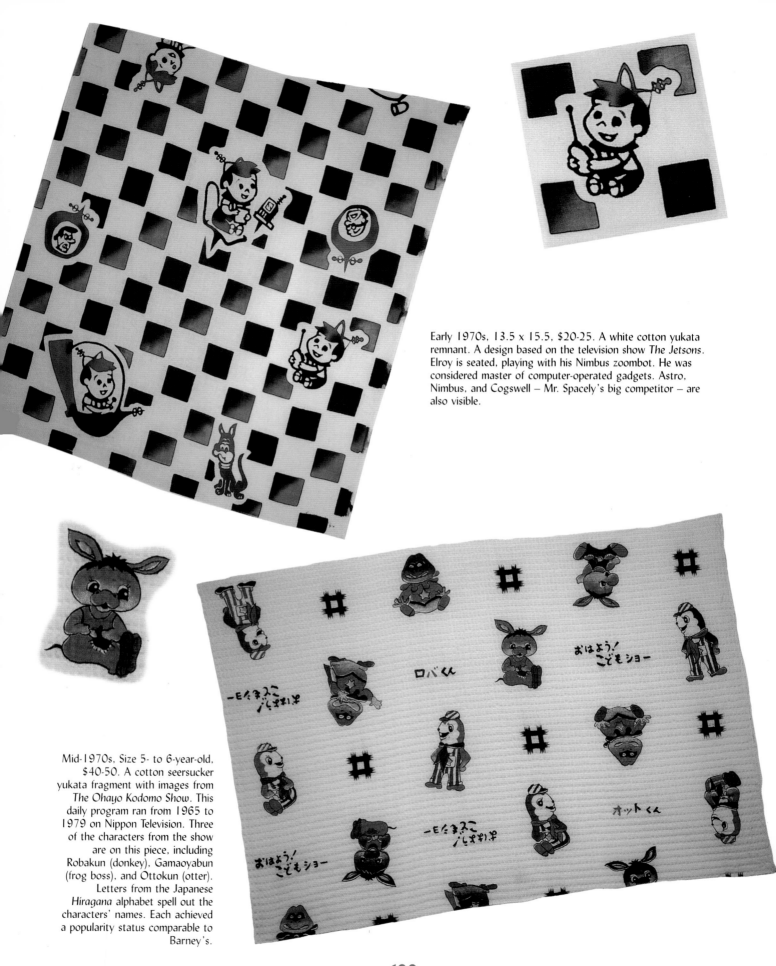

Early 1970s, 13.5 x 15.5, $20-25. A white cotton yukata remnant. A design based on the television show *The Jetsons*. Elroy is seated, playing with his Nimbus zoombot. He was considered master of computer-operated gadgets. Astro, Nimbus, and Cogswell – Mr. Spacely's big competitor – are also visible.

Mid-1970s, Size 5- to 6-year-old, $40-50. A cotton seersucker yukata fragment with images from *The Ohayo Kodomo Show*. This daily program ran from 1965 to 1979 on Nippon Television. Three of the characters from the show are on this piece, including Robakun (donkey), Gamaoyabun (frog boss), and Ottokun (otter). Letters from the Japanese *Hiragana* alphabet spell out the characters' names. Each achieved a popularity status comparable to Barney's.

190

Early 1970s, 3- to 4-year-old size, $40-50. A child's cotton sleeping robe with images from *The Jetsons*. The series aired in North America from 1962 to 1976. Elroy is shown playing with his Nimbus zoombot and flying in his space car. Elroy's faithful dog, Astro, also appears in the print.

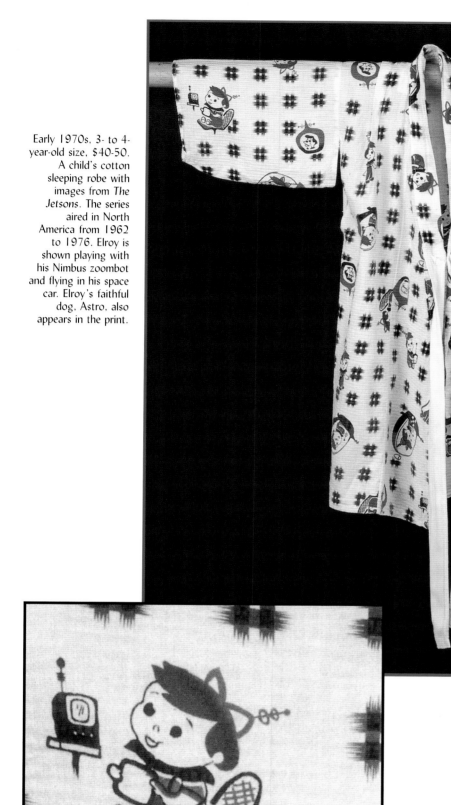

A detail of the previous print. Just as he was on the television series, Elroy is absorbed in the space adventures of Nimbus the Great.

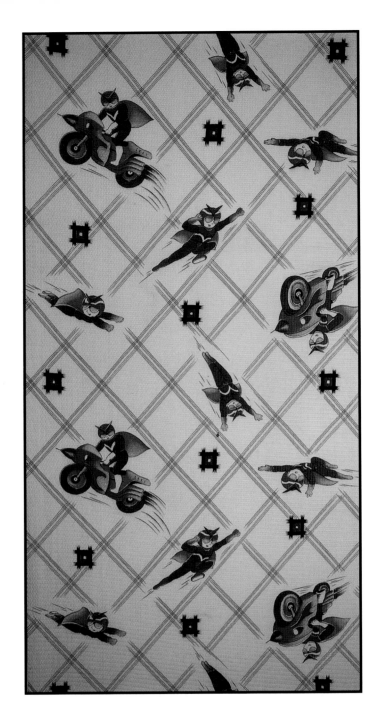

Mid-1970s, 36 x 14, $20-25. A white cotton yukata fragment. The superhero Kamen Rider is pictured here riding his motorcycle, "Cyclone," which could transform into an enhanced machine used to fight evil. The face on this image is slightly different from the original *Kamen Rider* series as this is not a licensed print.

A detail of the previous fabric. Kamen Rider demonstrates two of his famous moves, "Rider Kick" and "Rider Jump." Kamen Rider defeated the evil monsters on the series, using a variety of martial art moves, without the use of weapons.

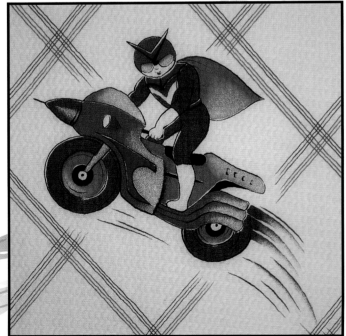

Mid-1970s, 36 x 23, $30-35. A blue cotton futon remnant. The animated series *Dog of Flanders* comes to life on this print. The program ran in 1975 and was the first *anime* produced by Nippon Animation. The series was based on the novel, *A Dog of Flanders and other Stories*, by Marie Louisa De la Ramee. The story is of an orphaned boy, Nello, who dreams of becoming a famous artist like Paul Rubens. Nello, wearing his trademark blue cap, is shown shouting to someone in the distance. His dog Patrasche is pulling the milk cart, and his friend Alois is by his side.

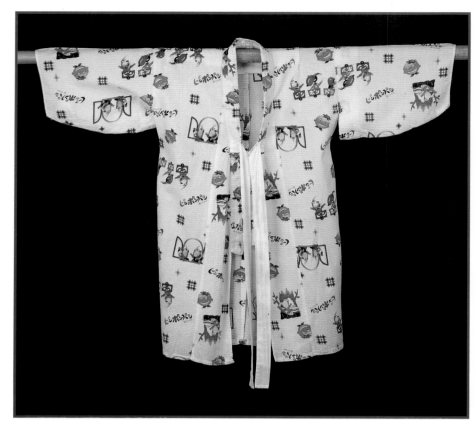

Late 1970s, 4- to 5-year-old size, $40-50. A white yukata features Pin Pon Pan, who was a character on a children's variety show called *Kappa*. The program ran on Fuji Television from 1966 until 1982. The Japanese Hiragana alphabet spells out Pin Pon Pan's name. From 1966 to 1971, the show was called *Everyone Let's Play Pin Pon Pan*, and from 1971 to 1982, *Let's Play with Mama Pin Pon Pan*. For sixteen years, children would appear on the program to sing and dance along with Pin Pon Pan.

A detail of the previous print shows characters from the show riding in a cart.

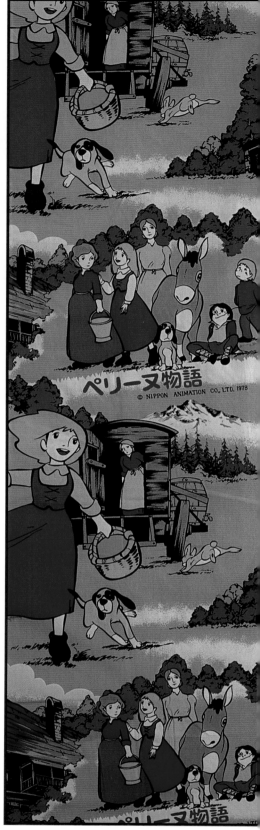

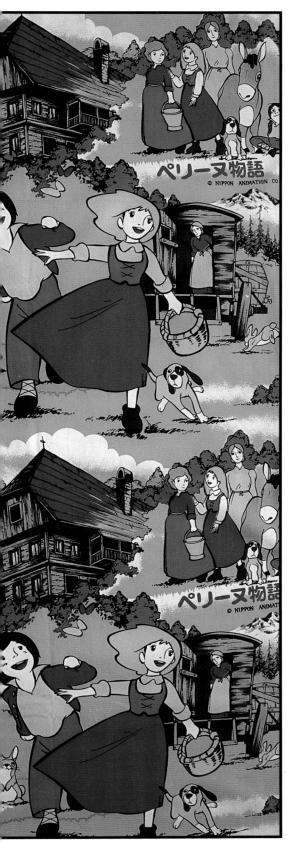

Late 1970s, 1.4 x 2.1 ,$25-30. A red futon cover. The fabric is inspired by *Perrine Monogatari* (*The Story of Perrine*), a historical drama set in France and based on Hector Malot's book, *En Famille*, written in 1893. The print is copyrighted Nippon Animation Co., Ltd. 1978. The program aired on Fuji television in 1978.

Perrine is shown running, with her friend Marcel and her dog Baron at her side.

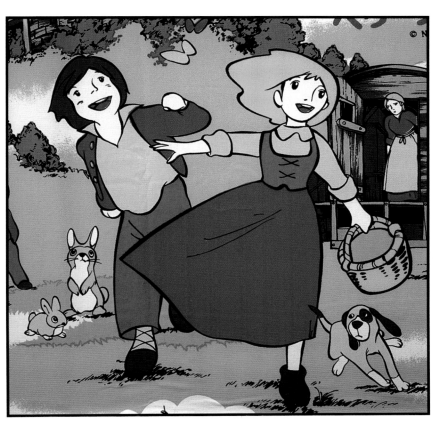

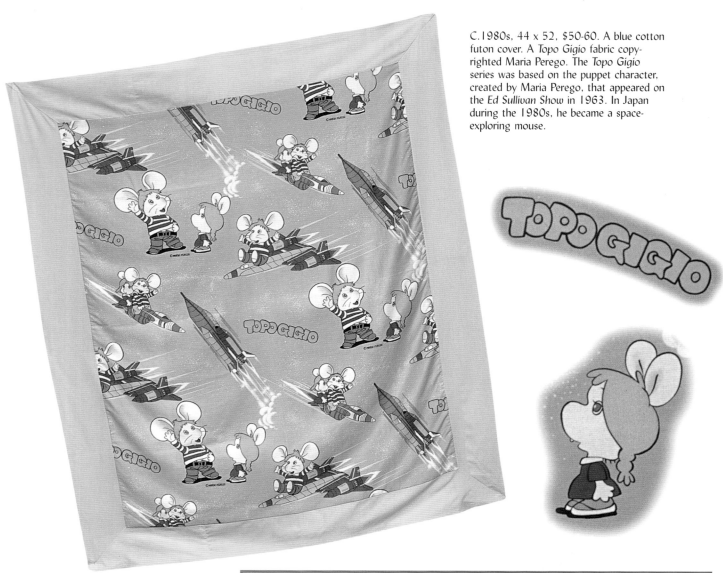

C.1980s, 44 x 52, $50-60. A blue cotton futon cover. A *Topo Gigio* fabric copyrighted Maria Perego. The *Topo Gigio* series was based on the puppet character, created by Maria Perego, that appeared on the *Ed Sullivan Show* in 1963. In Japan during the 1980s, he became a space-exploring mouse.

A detail of the previous print with Topo Gigio riding atop a rocket ship. Perhaps optimistically, the designer took liberties with the story and featured Topo Gigio finally fixing his ship and on his way back home.

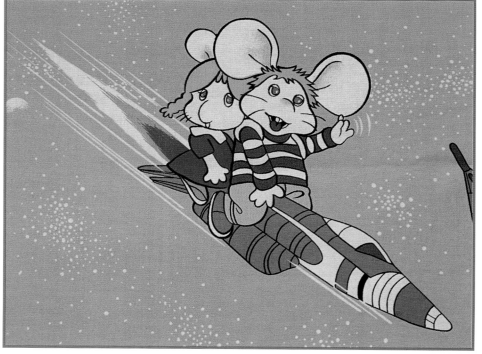

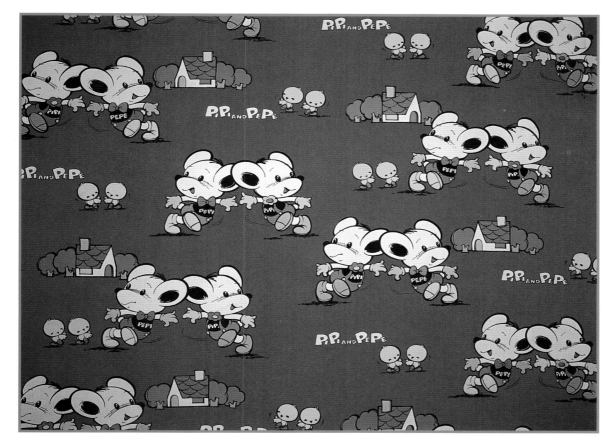

C.1980s, 44 x 52, $30-40. A red cotton futon cover. This is an *anime*-inspired fabric. Instead of paying out expensive licensing fees, the manufacturer has taken elements from other *anime* prints and incorporated them into this fabric. For example, the inclusion of made-up character names Pipi and Pepe, the bold, black outline, and Mickey Mouse-inspired white-gloved hands.

C.1980s, 36 x 36, $30-40. A blue cotton futon remnant. Another *Topo Gigio* fabric, copyrighted Maria Perego. Topo Gigio and Mimi – the small, white, female mouse – are going skateboarding in Santa Catalina, the city where Topo Gigio's space craft crashed. Topo Gigio was the first mouse to explore the Milky Way.

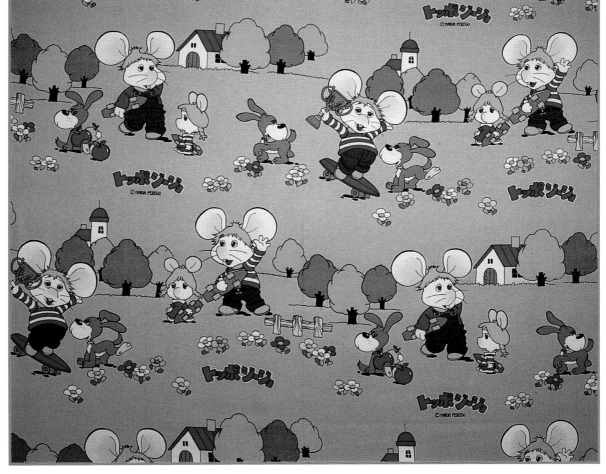

197

Examples of Manufacturers' Labels, Stamps, and Content Labels

A Toyobo Ltd. large, block-letter stamp from the 1970s on the selvedge. The symbol beside the 100% is for cotton. In the Japanese *Katakana* alphabet, the word *sarasa* is written.

A Kurokawa Ltd. paper label from the 1970s, 1.5 x 1. A small label in gold and white with rippled edges. The Kurokawa Ltd. symbol is centered at the top. Tiny flowers adorn each side and bales of cotton adorn below.

A Kurokawa Paper Label (damaged) from the late 1970s, 3 x 2. The Kurokawa Ltd. symbol, a partially open circle and inverted V, are intact. Below the company symbol is the fabric content, which is listed as 100% cotton.

A Kasugano Honzome Ltd. large paper label from the 1960s, 4 x 4. A simple label in black and red, it indicates that the fabric is muslin. Beside the word muslin is the term *Yuzen* dying. Here it refers to a style of print were the motifs are small and delicate.

A Shikibo Ltd. black stamp from the 1970s. The tree symbol indicates that this fabric is pure cotton.

A Kanebo Ltd. black stamp from the 1970s, the company's label remains unchanged to the present day. Unlike other fabric manufacturers, Kanebo Ltd. did not write the fabric content beside their name.

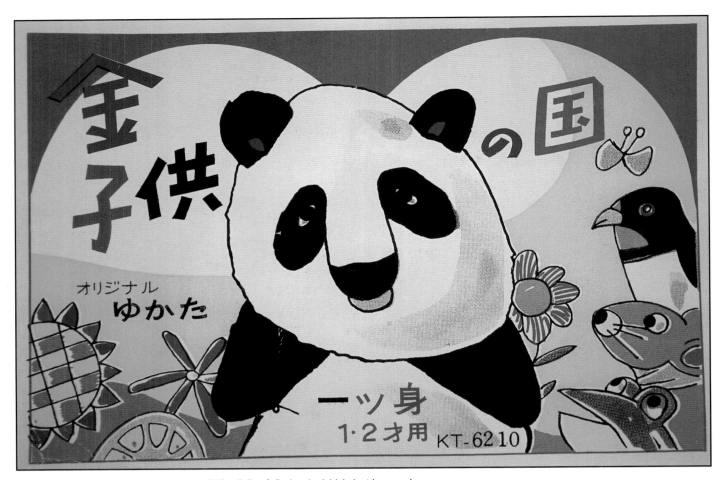

A Kodomo No Kuni paper label from the 1970s, 5.5 x 3.5. A colorful label with a panda bear in the center. The label states that this is an original yukata and sized for a one- to two-year-old child. The paper label was attached to a yukata by a fine string and not a sticky background, so as not to damage the fabric. The company's name translates as "Children's World" in English.

A Kodomo No Kuni paper label from the 1970s, 2.5 x 4.5. This label gives the exact measurements for the yukata in centimeters and names the fabric content, which is 100% cotton. The small green symbol within the circle on the right indicates that this design was intended for a girl.

Many of the exceptional fabrics pictured in this book were made by the following manufacturers. The majority of these companies are still in the textile business. Some of the companies listed were not possible to trace. They were perhaps merged into other companies or simply went out of business.

Hamada Shoten ~ Unable to trace.

Kanebo Ltd. ~ The textile division started in 1887 as a cotton trading company named Tokyo Cotton Trading Company. The company spun cotton, wool, and silk. In 1934, it ventured into synthetic fibers. It was renamed Kanebo, Ltd. in 1972.

Kasugano Honzome ~ This company was not possible to trace even though its label existed. The *Sennshoku Kougyo Kumiai* (Dyeing Industry Association) thought that the label probably referred to a small company which had now gone out of business.

Kodomo No Kuni ~ A manufacturer of children's yukatas.

Nakajima Hiroshi Sangyo ~ Unable to trace.

Nemoto ~ Unable to trace.

Kurokawa Industry Co., Ltd. ~ A domestic dyer and printer of fabric established in 1920 that still produces fabric.

Shikibo Ltd. ~ A large company with textile production and sales representing only one of their divisions. Kurokawa Dying and Printing Co. Ltd. is one of their domestic companies.

Shinbido ~ Unable to trace.

Toyobo Ltd. ~ In 1882 it began as a spinning mill with equipment imported from England. By 1931 it had become one of the world's largest spinning companies. From 1957 through the 1960s Toyobo Ltd. ventured into synthetic fibers. This company is still producing today.

Yamanashi Silk Center Co., Ltd. ~ Shintaro Tsuji established this company in 1960. In 1973, it was renamed Sanrio Company, Ltd.

Caring For Your Collection

Storage

Here are just a few tips for keeping your fabric in wonderful condition. The most common problems I have come across are permanent fold lines on the fabric due to incorrect storage. The best way to store your fabric is laid out flat in acid-free boxes between museum quality acid-free tissue paper. By following these simple steps, handling will be kept to a minimum, and your fabric will be safely stored away from sources which cause deterioration, such as light and pollution.

If you have to fold large items, it is best to put layers of crumpled-up tissue in all the critical areas which could potentially crease. It is also very important to unfold these fabrics periodically and change the direction of the folds. Failure to do this will weaken the fabrics' fibers at the folds, resulting in unsightly lines that often become black over time, eventually wearing so thin that holes appear.

The fabric should never be weighted down with heavy objects. Avoid direct sunlight and store your fabric in a room with a consistent temperature. Watch out especially during the summer months for moths and other insects.

Pressing

My most fragile silks from the 1940s and 1950s are never washed and were only gently steamed for this project. Any further stress to these antique fabrics would probably cause some of them to disintegrate.

The muslin fabrics can be pressed from the wrong side. It is best to just go over each print briefly. Due to age and wear, the threads of many fabrics relax, and a smooth, symmetrical piece is impossible to achieve.

The sturdier broadcloths will take a direct hot iron from the wrong side of the fabric. When in doubt, it is best to use a towel between your fabric and any heat source. I like to use a steamer on my fabrics to avoid potential mishaps such as water spotting or scorching.

Laundering

I prefer to use a very gentle soap and only hand-wash my fabric. The majority of the futon covers from the 1970s are very sturdy and can take a machine-washing, but of course, over time this will cause wear. These fabrics were meant to be used, so enjoy them and consider some of the wear adding to their beauty.

Do not put any of your fabric in a dryer. I always lay fabric out flat on soft towels and shape it. I hang larger pieces on a clothesline out of direct sunlight. Never hang any muslin fabrics as they will warp out of shape on the line.

If there are marks or stains on the fabric, I rub a bit of soap on the offending spot and let it sit awhile before rinsing it clean. For stains on futon covers, I use either Biz™ or just plain old sunlight. If you lay out your futon cover in the sun, be sure to keep an eye on it to avoid over-exposing the fabric and, consequently, bleaching it out. For marks on silk pieces, I do not even attempt to get them out. I look upon these imperfections as adding to, not detracting from, their beauty.

When in doubt, please consult a professional fabric care guide.

Glossary

anime ~ The Japanese word for animation.

batik ~ A method of resist-dyeing.

Betchin Maskot ~ A popular line of toys filled with wood shavings. They were manufactured by Nagano Gangu Seisakusho and R. Daykin.

Bungo ~ A region on the island of Kyushu.

chanchanko ~ A Japanese child's vest.

Children's Day ~ Formally called Boy's Day Festival, today it celebrates all children. It is held on the fifth of May.

chirimen ~ A Japanese silk crepe fabric.

Daruma ~ Originally representing the Indian priest Bodidharma, who founded Zen Buddhism in China. He lost the use of his arms and legs after sitting for nine years meditating in a cave. Today, Daruma dolls are used as charms to fulfill wishes.

Edo ~ The last feudal period in Japan between 1600 and 1860.

futon ~ A mattress usually placed on the floor.

haiku ~ Traditional Japanese poetry consisting of a 17 syllable verse.

Gosho Ningyo ~ Ceramic court dolls from the Edo period (1600-1868). The unisex dolls are characterized by white skin, a cute face, small limbs, and a big head.

gyoji ~ A referee at a Sumo match.

hagoita ~ A wooden paddle used in a traditional game played during the New Year. holidays. One or both sides of the paddle may have symbols of good luck.

happi coat ~ A short-length coat worn over a Japanese robe. Traditionally worn by shop keepers.

Hiragana ~ A phonetically based Japanese writing system consisting of 46 letters.

hyotan ~ A gourd used as a container for sake.

ikat ~ A resist-dye technique in which the yarn is tied and dyed before weaving.

jyuban ~ A slip worn under a kimono.

kagami mochi ~ Sacred rice cakes prepared at New Year's and other celebrations. They are said to bring good health and good fortune.

kakibuton ~ A duvet.

kanoko-shibori ~ A fabric pattern which imitates the white pattern on a deer's coat. *Ka* means child, and *ko* means deer.

Katakana ~ A Japanese writing system consisting of 46 letters; it is used primarily for writing words borrowed from other languages.

Kendo ~ A Japanese martial art in which participants fence with a bamboo sword.

Kiichi Tsutaya ~ An illustrator responsible for a series of coloring books depicting a girl affectionately called Kichan.

kokeshi ~ A wooden doll. Many kokeshi have a girl's face and body without limbs or hands. Originally a folk toy of the Tohoku district (Northeastern Japan). Today, they are given as gifts or valued by collectors.

koinobori ~ Flags representing carp, inspired by the phrase *koi no taki nobori*, meaning a carp leaping up a waterfall. Koinobori are symbolic of success in life and are flown over homes on Children's Day. They were once made of paper, but today they are made of cloth.

koma ~ A spinning top made of wood or metal in a variety of sizes; it can be spun by hand or with a string.

komainu ~ A mythical lion-like dog used to guard shrines.

Makoto Takahashi ~ A 1950s illustrator whose designs were used on children's clothes.

manga ~ A type of Japanese literature, resembling graphic novels or comic books.

muslin ~ A light-weight, woven cotton fabric.

omikoshi ~ A portable Shinto shrine.

origami ~ The art of folding paper.

Osamu Tezuka ~ A prolific writer and illustrator of manga and anime.

otoso ~ A drink made of sake with medicinal herbs. This special sake is drunk to gain strength and prevent sickness during the New Year.

Rune Naito ~ An illustrator responsible for a number of character products including "Pandachan."

samurai ~ A class of warriors.

sarasa ~ A dyeing technique usually applied to silk or cotton. First imported to Japan via China in the fifteenth century.

sasarindo ~ A gentian (a perennial herbaceous plant).

sashing ~ A quilting term used to describe the horizontal and vertical strips of fabric between quilt blocks.

sateen ~ A cotton fabric with a satiny, lustrous finish.

seersucker ~ A woven fabric with a puckered stripe effect in the fabric.

shibori ~ Describes a way of shaping fabric (crumbled, twisted, etc.) and securing it before the dyeing process.

shinkansen ~ High-speed trains (Bullet Trains) used in Japan.

Shinto ~ The indigenous faith of Japan.

sumo ~ A type of Japanese wrestling.

takeuma ~ Bamboo stilts with foot rests.

tako ~ A traditional kite made of painted paper stretched over a bamboo frame.

temari ~ Traditionally hand-crafted thread balls made from silk kimono remnants. They are thought to bring good fortune.

tomoe ~ A symbol composed of three twirling commas.

Tsukimi ~ Moon-viewing celebration held on the fifteenth of August.

Uyama Ayumi ~ The author of a pop culture book about the '60s and '70s, who is responsible for a new wave of interest in this time period.

wadaiko ~ A large Japanese wooden drum.

yukata ~ A traditional summer kimono designed for hot weather or after a bath. It is made of cotton and relatively inexpensive.

Yukinko ~ A spirit in fairy tales said to emerge when it snows.

yuzen ~ A dyeing technique which uses stencils, developed by Yuzen Miyazaki.

Fabric Resources

Museums

Here are a few museums in Japan which have collections showcasing Japanese life, a variety of textiles, and other collectibles from the 1950s, 1960s, and 1970s. They may have curators who can assist you in your own area of study. For more museum listings, please see the Museum Information Japan website at: http://www.dnp.co.jp/museum/icc-e.html.

Edo Tokyo Museum
1-4-1 Yokoami
Sumida-ku, Tokyo
130-0015
03-3272-8600

Retro Museum of Packaging from the Showa Era
65 Suminoe-cho, Aoume
Aoume, Tokyo
0428-20-0234

Matsudo Museum
671 Sendabori, Matsudo
047-34-8181

Shikatsu Historical and Folklore Museum
53 Osakaki, Kumanosho Aza
Owaza, Shikatsu-cho, Nishi-Kasugai-gun Aichi
0562-25-3600

Kobe Fashion Museum
2-9-1 Koyo-cho naka, Higashinada-ku
Kobe, Hyogo
658-0031 Japan
81-78-858-0050

Antique Markets In Japan

This is a short list of some major antique markets held in Japan which always have dealers of vintage textiles. It is best to check with your travel coordinator or an online resource before setting off to one, as the dates and times do change. For more information please see the following Internet resources:

www.paperlantern.net
www.japantoday.com
www.weekender.co.jp/

Kotto Jamboree
• Held twice a year at the Tokyo Big Site.
• Near Tenjijo Seimon Station, Ariake Station (New Transit Yurikamome Line), Kokusa Tenjijo Station (Rinkai Fukutoshin Line).
• Some of my favorite dealers come to this fair.

Heiwajima Antique Festival
• Held at the Tokyo Ryutu Center.
• Near Tokyo Ryutu Center Station.
• It is one of the biggest markets and definitely worth a visit.

Yokohama Kotto World
• Held annually in the Pacifico Yokohama Exhibition Hall.
• Close to Sakuragicho Station.
• A wonderful selection of antiques.

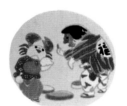
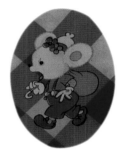
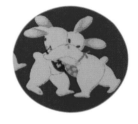

Endnotes

1. Ayumi Uyama, *Shojyo Style Techo* (Tokyo, Japan: Kawade Shobo Shinsha, 2002), 30.

2. The Japan Fashion Color Association, *Color History* (http://www.jafca.org).

3. Ibid.

4. Ibid.

5. Rune Naito, *Naito Rune – Shoujyotachi no Charisma Artist* (Tokyo, Japan: Shobo Shinsha, 2002), 112.

6. Ibid., 18.

7. Ibid., 18.

8. Hiroaki Ikeda, *The King of O.T.* (Tokyo, Japan: Shueisha, 2002), 34.

9. Ibid., 34.

10. Kurokawa Industry Co., Ltd., *Outline of Company* (http://www1.odn.ne.jp/~aam37650/kurokawa/e-outline.htm).

11. Toyobo, *Toyobo History* (http://www.toyobo.co.jp/e/annai/3.htm).

12. Kanebo – The Lifestyle Company. *History of Kanebo.* (http://www.kanebo.co.jp/english/company/e_enk.htm).

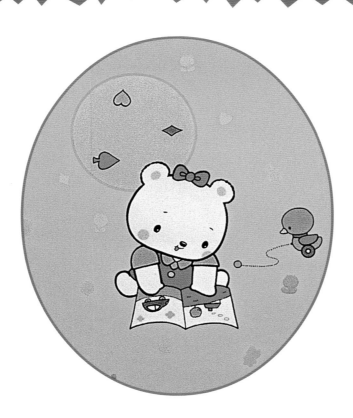

Bibliography

Akiyama, Masami. *Visual Showa No Kodomotachi*. Tokyo, Japan: Kyoiku Shuppan Centre, 1997.

Baricordi, Andrea, Massimilano de Giovanni, Andrea Pietroni, Barbara Rossi, and Sabrina Tunesi. *Anime: A Guide to Japanese Animation, 1958-1988 (Anime, Guida Al Cinema D'Animazione Giapponese)*. Trans. Adeline D'Opera, ed. Claude J. Pelletier. Montreal, Canada: Protoculture, 2000.

Clements, Jonathan, and Helen McCarthy. *The Anime Encyclopedia: A Guide to Japanese Animation Since 1917*. Berkeley, California: Stone Bridge Press, 2001.

Craig, Timothy, ed. *Japan Pop! Inside The World of Japanese Popular Culture*. Armonk, New York: M.E. Sharpe, 2000.

Fairbank, John K., Edwin O. Reischauer, and Albert M. Craig. *East Asia Tradition & Transformation*. Boston, Massachusetts: Houghton Mifflin Company, 1978.

Fuji Television Home Page. (http://www.fujitv.co.jp/b_hp/sazaesan/).

Ikeda, Hiroaki. *The King of O.T.* Tokyo, Japan: Shueisha, 2002.

Ishikawa, Hiroyoshi. *Taishu Bunka Jiten*. Tokyo, Japan: Kobundo, 1991.

James, Grace. *Japanese Fairy Tales*. London, G.B.: Macmillan and Co., Ltd.,1979.

Kanebo – The Lifestyle Company. *History of Kanebo*. (http://www.kanebo.co.jp/english/company/e_enk.htm)

Kindan o Hybrid Maniac. 1998. (http://www.geocities.co.jp/hollywood-Miyuki/2049/ohayou.html).

Kurokawa Industry Co., Ltd. *Outline of Company*. (http://www1.odn.ne.jp/~aam37650/kurokawa/j_outline.htm).

Llewellyn, Richard. *List of Anime Television Series*. 8 June 2003. (http://www.public.iastate.edu/~rllew/anitv.html).

Naito, Rune. *Naito Rune – Shoujyotachi no Charisma Artist*. Tokyo, Japan: Shobo Shinsha, 2002.

Nakamura, Takafusa. *The History of Showa Japan, 1926-1989*. Trans. Edwin Whenmouth. Tokyo, Japan: University of Tokyo Press, 1998.

Nemu. *Yume no Hotori*. 16 February 1998. (http://www2s.biglobe.ne.jp/~nem/perrine/perrine.html).

Ota, Masao. *Kokoku Character Ningyokan*. Tokyo, Japan: Chikuma Shobo, 1995.

Shilling, Mark. *The Encyclopedia of Japanese Pop Culture*. New York, NewYork: Weatherhill Inc., 1977.

Takahashi Makoto. *Shojyo Romance*. Tokyo, Japan: Parco, 1999.

Toyobo, *Toyobo History*. (http://www.toyobo.co.jp/e/annai/3.htm).

Tsutaya, Kiichi and Kamimura Kurumi. *Watashi-no Kiichi*. Tokyo, Japan: Shogakukan, 1997.

The Japan Fashion Color Association. *Color History*. (http://www.jafca.org).

The Sansiro World. 1 January 2001. (http://www.ne.jp/asahi/sansiro/takahashi/ken.html).

Uchida no Sekai. December 2002. (http:www.asahi-netor.jp~ki2s-ucd/tokusatsu/rider/).

Uyama, Ayumi. *Shojyo Style Techo*. Tokyo, Japan: Kawade Shobo Shinsha, 2002.